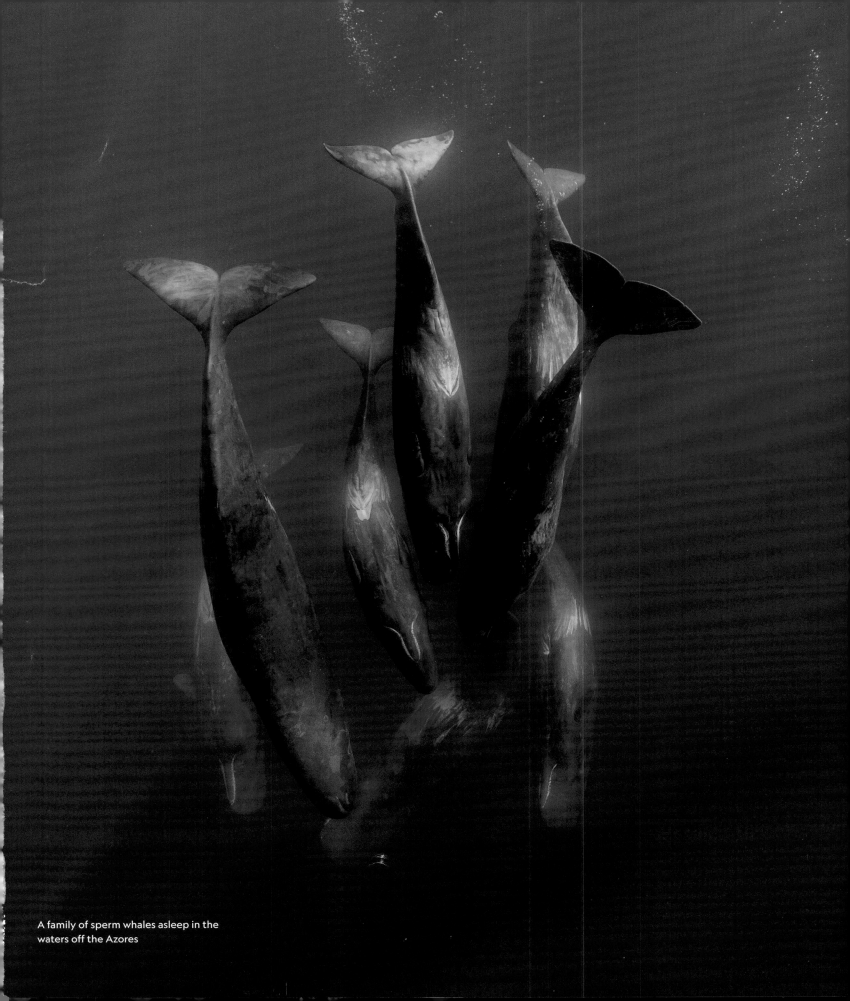

A family of sperm whales asleep in the
waters off the Azores

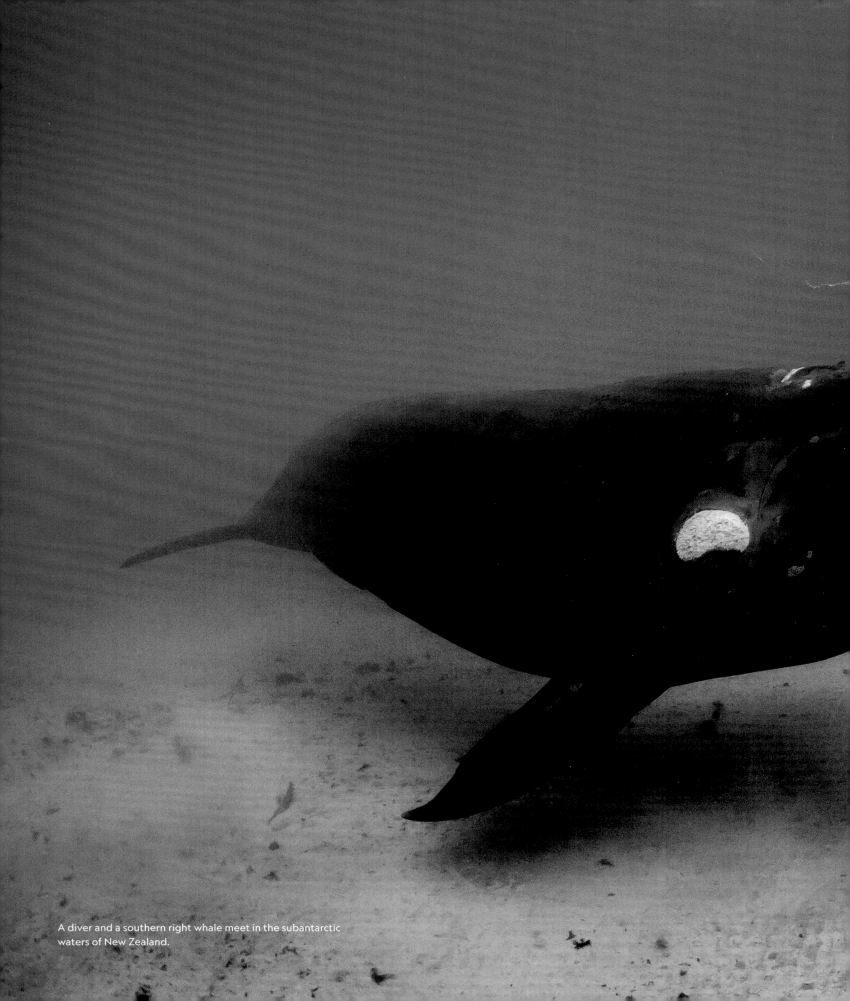

A diver and a southern right whale meet in the subantarctic waters of New Zealand.

# SECRETS OF THE
# WHALES

## BRIAN SKERRY

### WITH LIBBY SANDER

WASHINGTON, D.C.

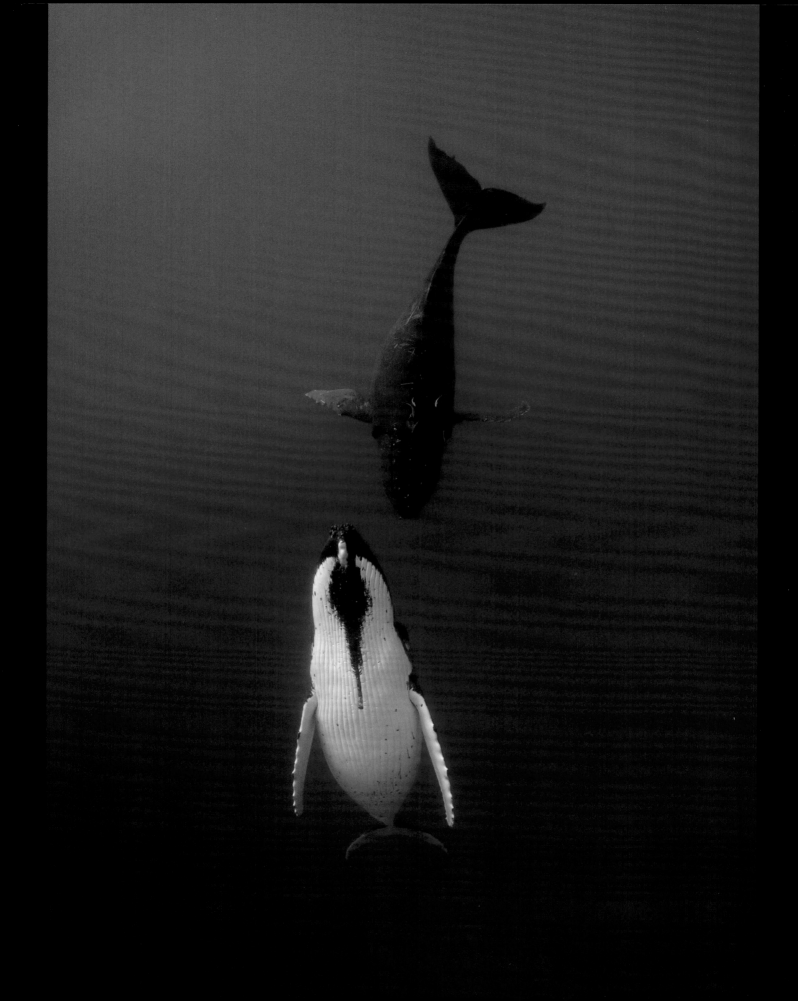

This book uses the classifications for a species' risk of extinction monitored by the International Union for Conservation of Nature:
Extinct (EX), Extinct in the Wild (EW), Critically Endangered (CR), Endangered (EN), Vulnerable (VU), Near Threatened (NT),
Least Concern (LC), Data Deficient (DD), and Not Evaluated (NE).

---

Humpback whale yin and yang in the Cook Islands of the South Pacific

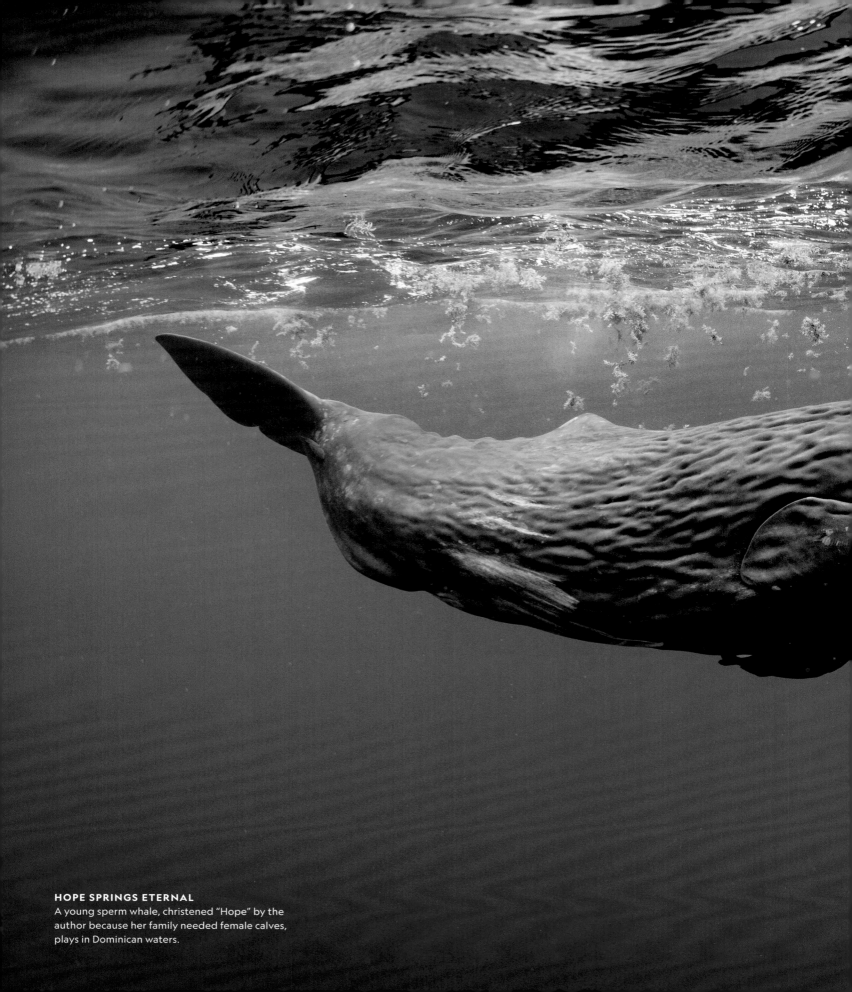

**HOPE SPRINGS ETERNAL**
A young sperm whale, christened "Hope" by the author because her family needed female calves, plays in Dominican waters.

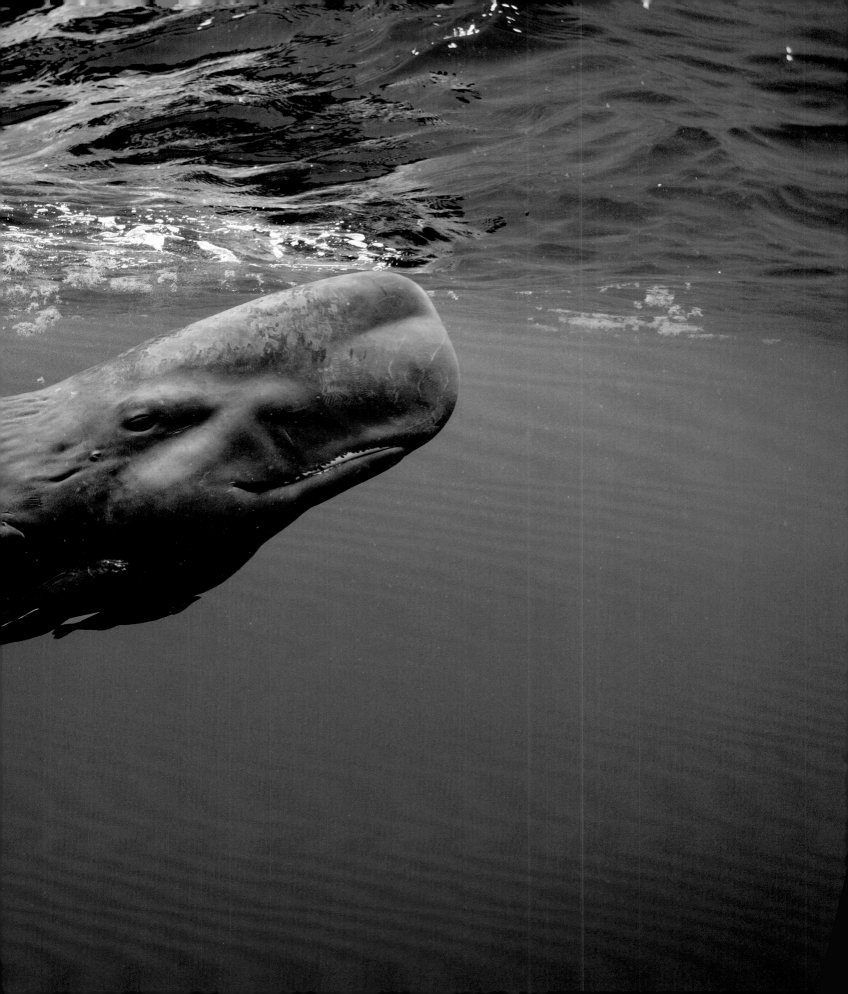

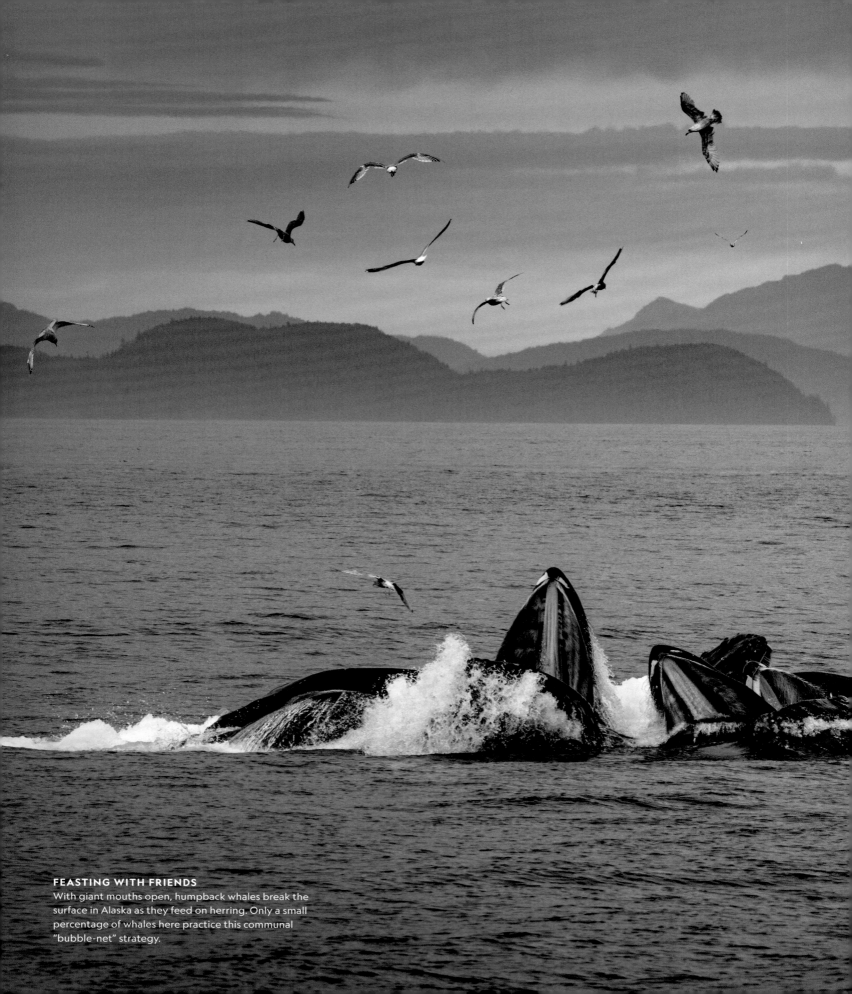

**FEASTING WITH FRIENDS**
With giant mouths open, humpback whales break the surface in Alaska as they feed on herring. Only a small percentage of whales here practice this communal "bubble-net" strategy.

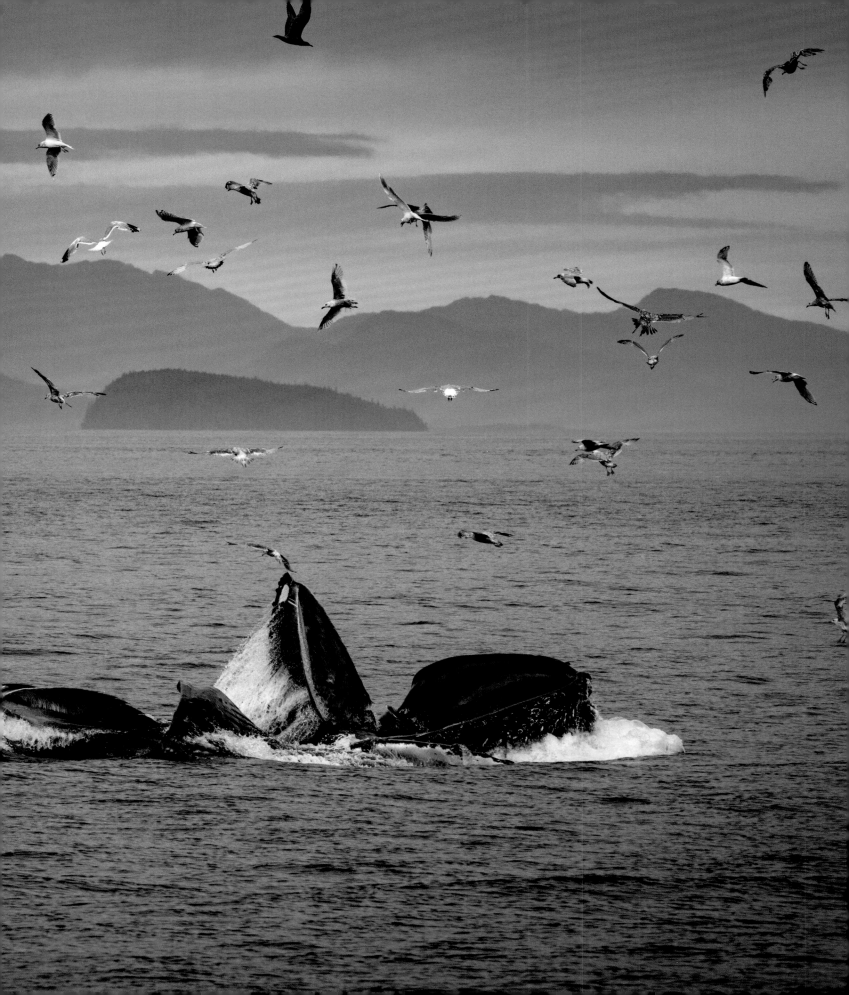

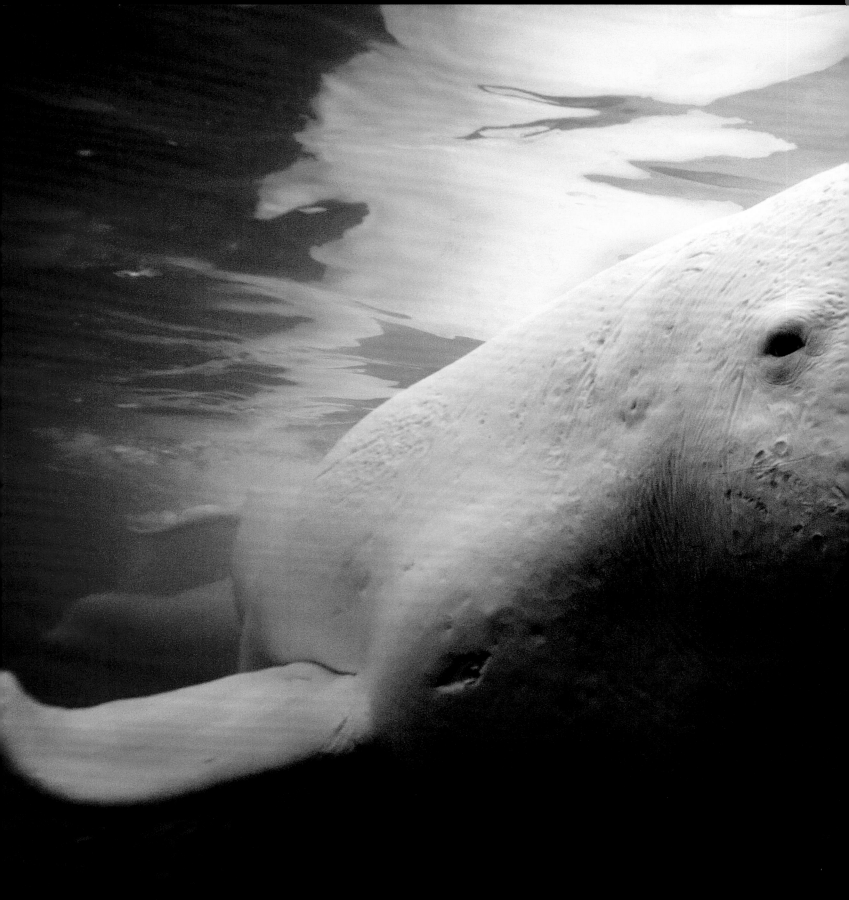

**BELUGA SPA**
Having traveled long distances through the Northwest
Passage in the Canadian Arctic, beluga whales enjoy days
at this "spa" in a shallow water estuary.

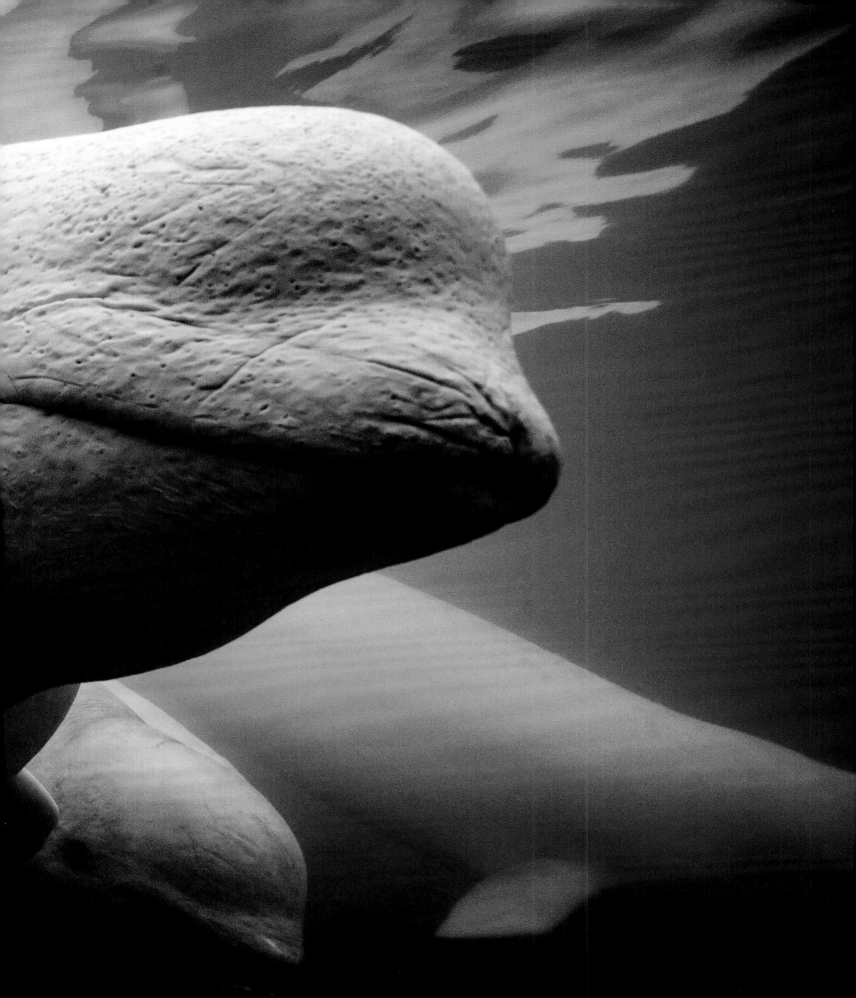

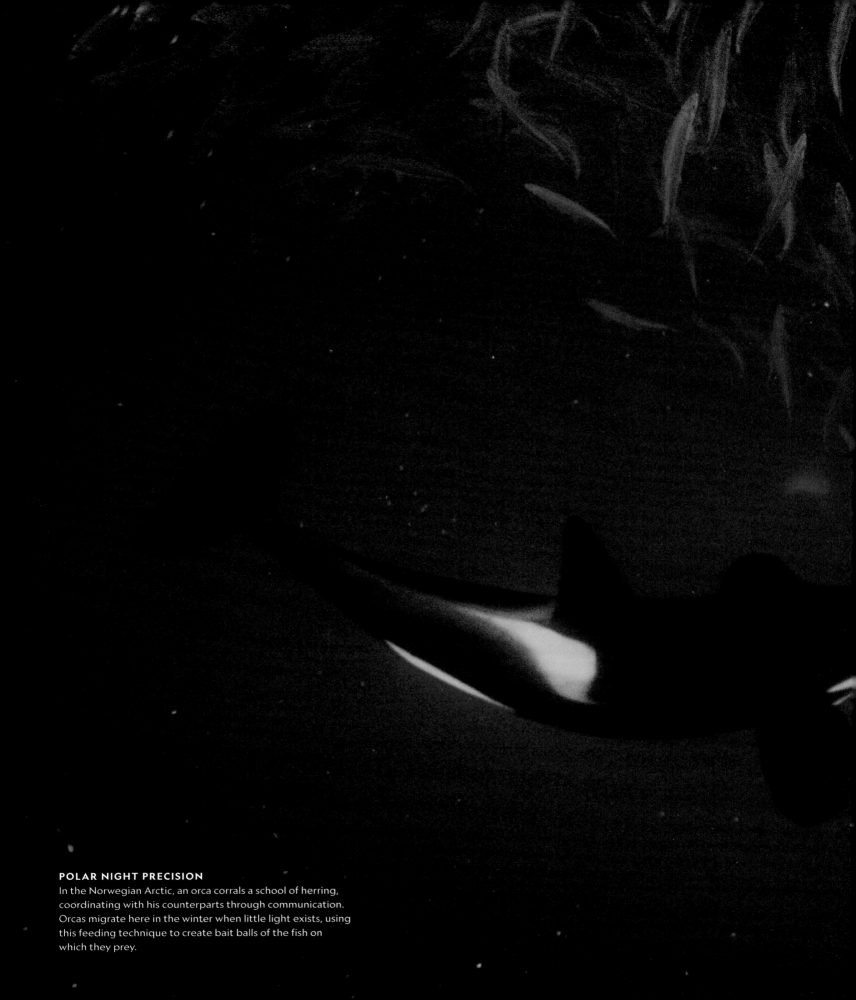

**POLAR NIGHT PRECISION**
In the Norwegian Arctic, an orca corrals a school of herring, coordinating with his counterparts through communication. Orcas migrate here in the winter when little light exists, using this feeding technique to create bait balls of the fish on which they prey.

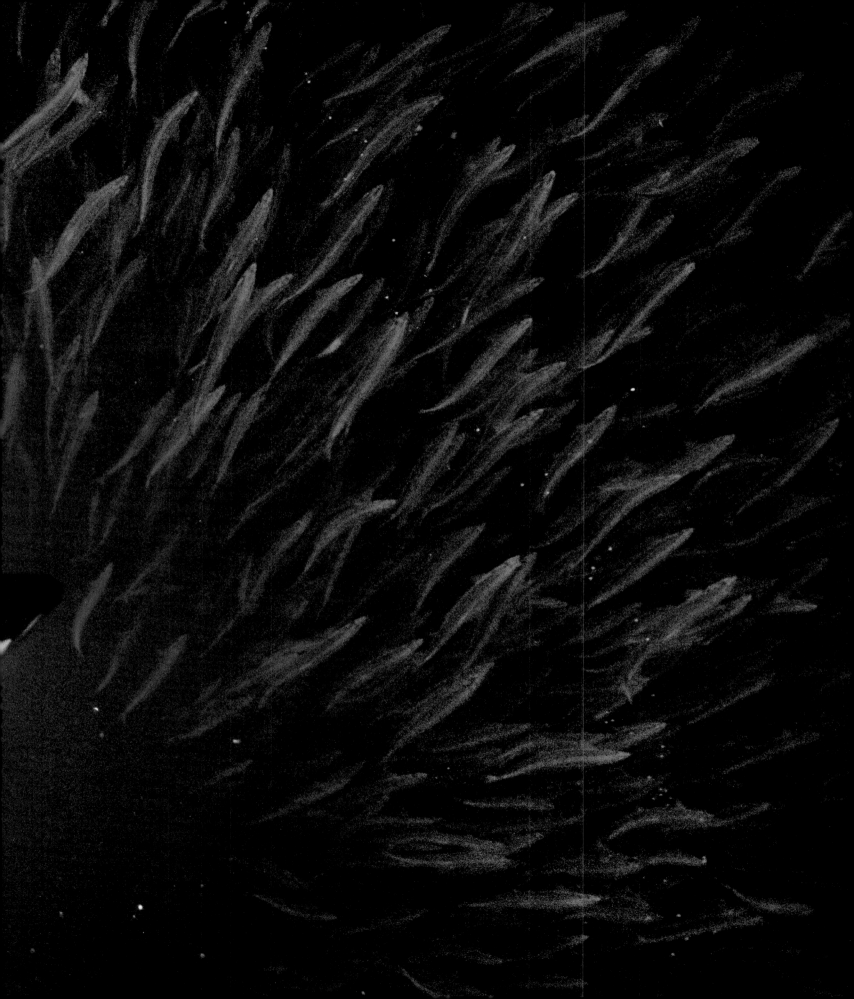

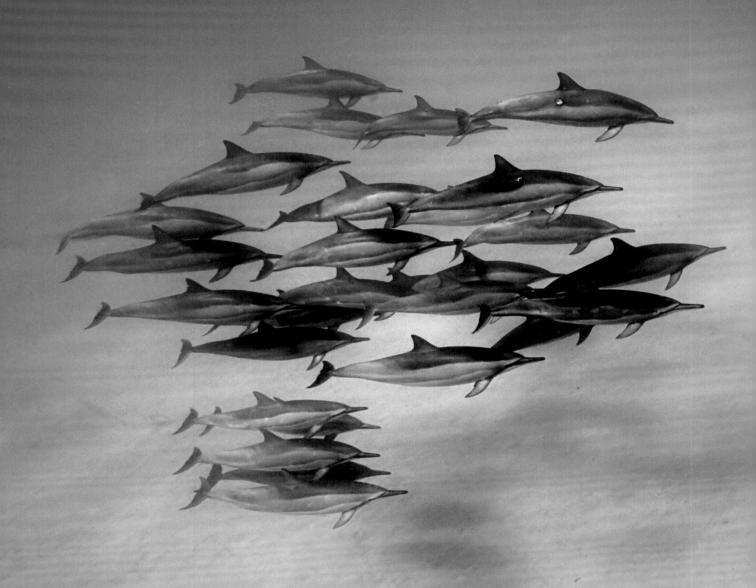

**HAWAIIAN SOCIAL CLUB**
Among the most social species of dolphins, a pod of
spinners rests and plays in coastal waters of Oahu after
a night of foraging offshore.

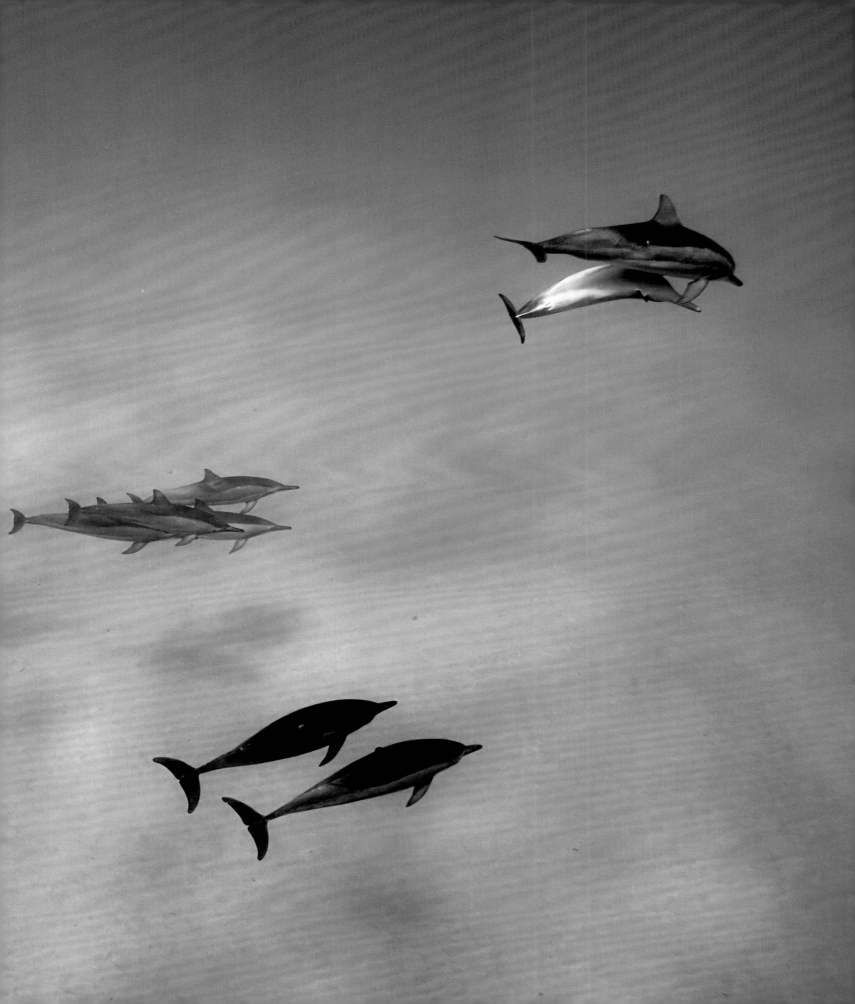

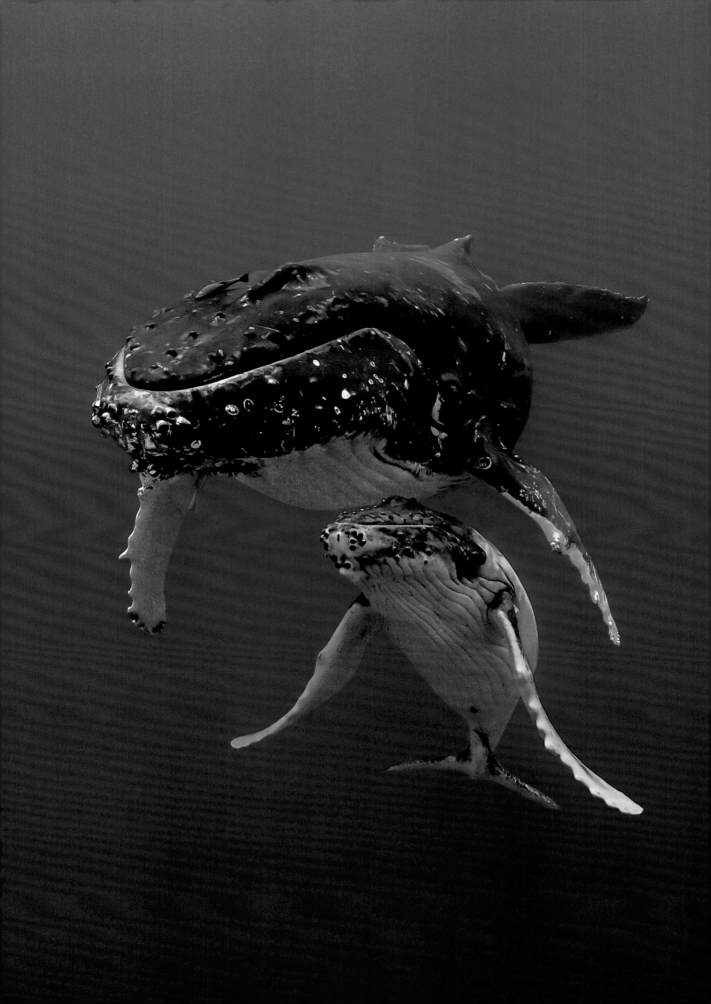

# FOREWORD **JAMES CAMERON**

## SECRETS OF THE WHALES

Imagine an ocean world—a series of interconnected habitats filled with tropical gardens in wild and varied color; steep canyons, boiling vent sites, and ice-covered mountain realms. In this vivid place vibrating with life, the mammoth and the microscopic all play a vital role, each dependent on the other.

Add to this world a highly cognitive species possessing a huge brain, a sentient nation of tribes, each maintaining its own rich culture. These are animals that celebrate identity and teach their young the skills they need to survive, pass on ancient traditions, mourn their dead, and revel in new birth.

This magical world is not science fiction. It's our world, Earth: an ocean planet where whales roam the seas and live complex lives that few have witnessed.

If we're to truly appreciate these enigmatic animals, the ocean giants, we need great stories. And Brian Skerry is a whale storyteller. Grounded in science, he's spent four decades capturing the poetry of these beautiful animals as a National Geographic photographer. He's been accepted into whales' lives, and shares with us what he has seen: the secrets of the whales.

As a National Geographic Explorer at Large, I understand Brian's drive to explore and create, and I share the same passion. We both grew up in landlocked, working-class towns, but were drawn to the sea. We both got our scuba certifications in YMCA pools (for me, in the dead of winter in freezing Buffalo when I was 16). And we both believe you have to continue to push further—to seek, to understand, and to produce visuals that reveal our world in new and inspiring ways.

*Secrets of the Whales* is a portal to another dimension on our ocean planet. These photographs transport us into the sea, where we feel the tenderness between whale mothers and calves, the drama of a hunt, and the joy of playing games. Brian's work illuminates "whalekind." And as a result, we are enlightened.

---

A female humpback whale keeps her two-day-old calf under her wing in the Cook Islands. Humpback mothers invest heavily in their calves, teaching them the behaviors necessary to survive.

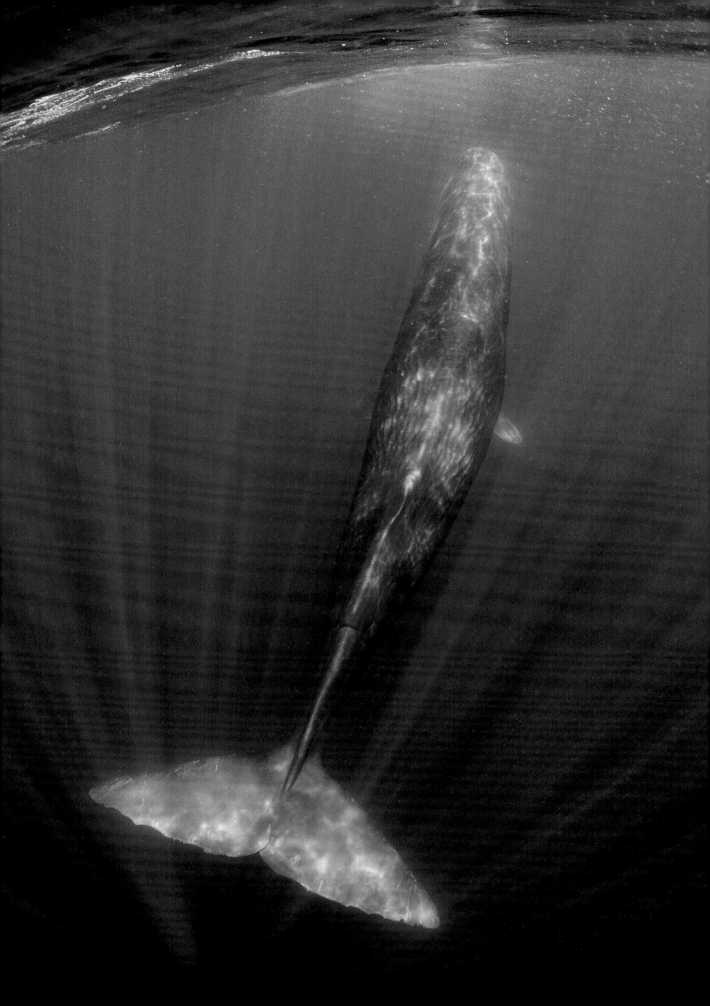

# INTRODUCTION **BRIAN SKERRY**

t was an experience I'll never forget. I had just finished a dive on the shipwreck *Pinthis* in Cape Cod Bay, and was climbing onto my friend's boat when a message came over the marine radio: A lobsterman was reporting that a whale was entangled in his trawl line (a device that connects multiple lobster traps). He was heading back to port, he said; there was nothing he could do.

It was 1985—the days before GPS—so we entered the coordinates the lobsterman had transmitted into our boat's LORAN C (navigation system), plotted the course, and fired up the engines. Arriving at the location, I expected to see a giant whale floating on the surface—but other than a few lobster buoys, nothing could be seen. We turned off the engine and drifted for a few minutes. Suddenly, we heard the sound of a whale blow and spray. Off the port side I saw it, wrapped in line and dragging buoys. Still wearing my dry suit, I jumped into the sea.

Disentangling a whale is a highly specialized skill—one that requires training and, often, certification. It is typically done by an experienced crew working from a boat. The protocol, when possible, is to snag a trailing section of the line that's entangling the whale and cleat it to the vessel. If the whale calms down, the animal is slowly pulled closer while lines are strategically cut, eventually setting it free.

The risks are high: If the process is not conducted correctly, the animal or the disentanglement crew could be harmed (and indeed, tragic accidents have occurred in which well-meaning rescuers have been killed by a strike from the flailing whale's tail). The prevailing wisdom, however, is that no one would be foolish enough to attempt a disentanglement in the water.

I was 23, and knew nothing of all this; my only thought was to save this whale. Wearing a bulky old blue Unisuit and a mask, snorkel, and fins, I swam toward the little humpback—not with a camera in hand, but bearing my old Buck knife.

"Little" is, of course, a relative term, because the calf trapped before me was at least 20 feet in length and probably weighed 15 tons. I slowly approached it on the surface, scanning the position of the lines around its body and calculating how to proceed. As I drew closer, the calf thrashed briefly, its pectoral fin knocking the wind out of

Zeus, a male sperm whale estimated to be nearly 50 feet in length, rises toward the surface in Sri Lanka.

me as it hit my midsection. It dove into the dark water, and I was alone on the surface.

When it reappeared, I realized that the whale was essentially on a leash. It was wrapped in the lobster trawl and could swim around somewhat, but the traps on the seafloor kept it from going very far.

I swam toward the calf again, this time managing to get my hand under a section of line. I lifted it up from its body to slip my knife underneath and cut it off. The calf dove once again, surfacing less than a minute later. And so, it continued like this for well over an hour, me cutting a section of line and the calf diving.

With each piece of line I cut, I sensed the little humpback was becoming aware that I was not a threat and was trying to help. No longer was he agitated; instead, he allowed me to approach, and lay still while I sawed through ropes.

Having removed all lines from around his tail and body, only one piece remained on the left side of the calf's bloody mouth, where the rope sliced into his flesh. Moving in ever so slowly, I saw his eye staring at me for what felt like an eternity, but in reality was probably seconds.

I grabbed the line firmly and gently pulled it from the calf's mouth. Now that he was free of all lines, I expected him to race away immediately. Instead, he stayed on the surface, looking at me for a time, then gracefully submerged in a shallow dive, leaving me drifting in his wake. Bobbing on the surface, I watched him swim away, listening to his blows and watching his shape vanish in the haze of the horizon.

The book you hold in your hands is filled with experiences like this, documenting decades in the field photographing some of the world's most majestic animals. Whales are the quintessential ambassadors of the sea, but most people have only fleeting views of them and little is understood about their lives. I have been awed by the "humanity" of these animals and hope the images in this book will help to illuminate their important role in our world. After all, people protect what they love, and we can ignite those passions by sharing stories that capture their imaginations.

The photographs in these pages portray the culture and wisdom of whales, presenting what I hope will be a layered view of the world's largest animals and their complex societies. As you'll see, these majestic creatures share an amazing ability to adapt to new opportunities. There is also evidence of deeper, cultural elements of whale identity, from unique dialects to matriarchal societies to organized social customs like annual, communal feeding events. My hope in these pages is to reveal these creatures in all their glory—and if even one picture or one story speaks to you, then I will consider my work a success.

Growing up in Massachusetts, I recall some of my fondest memories as time spent at the beach. Our family vacationed in places like New Bedford, where I roamed through the Whaling Museum, studying the pages of sailors' logbooks and oil paintings of life at sea. I walked the cobblestone streets that Melville had walked more than a century before and sat in a pew at the Seamen's Bethel, where the preacher's pulpit was built like the bow of a ship.

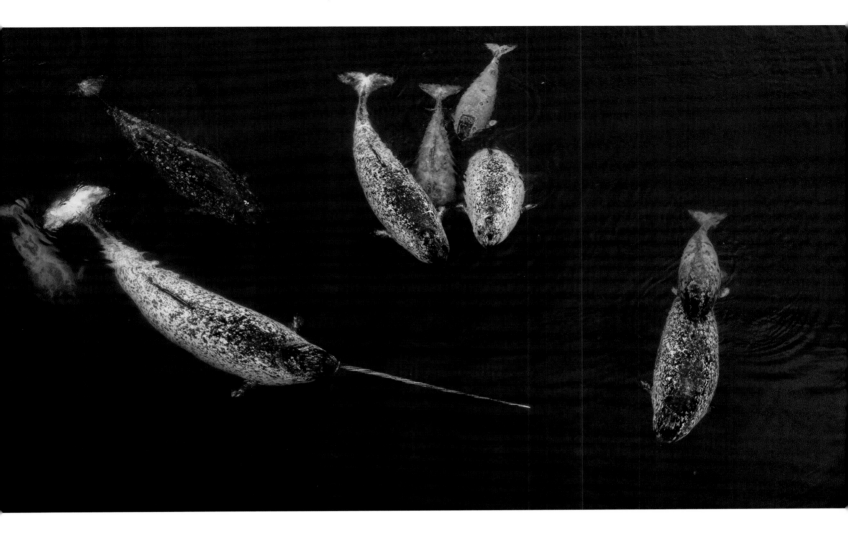

For a boy from a small mill town, the mysteries of whales and the romance of ocean adventures spoke to me like a siren's song. Although the thought of killing one of these magnificent animals was abhorrent, the notion of wild, primordial megafauna serenely roaming the seas stirred my soul. These were not dinosaurs that lived millions of years ago; they were out there right now—and I had to see them.

Decades would pass before I saw my first whale underwater—and, even then, it was one that had suffered anthropogenic stresses, entangled in fishing gear. The reason I journey out to whales is to photograph them, but the magic is being allowed into their world. I am not interested in petting wild animals or getting closer than necessary to make a picture. But gaining their acceptance—or even a validation that I am welcome to share their space—

matters to me. And to be accepted by whales is to ascend to a rarefied plane.

Such moments have happened many times throughout my career: days spent with a wild dolphin in Ireland, a family of sperm whales in the Azores, or with an orphaned beluga whale in Nova Scotia. Many of these experiences were more than simply being accepted by these animals; I was interacting with them, and they were choosing to engage with me. And with each of these encounters, I yearned for more.

National Geographic gave me that chance. I began fieldwork on my first whale story in 2006, spending two

A family of narwhal gathers on the surface in the Canadian High Arctic. A calf rides on its mother's back, and a tusked male—the mythical unicorn of the sea—swims below. (Photo by Brian Skerry and Nansen Weber)

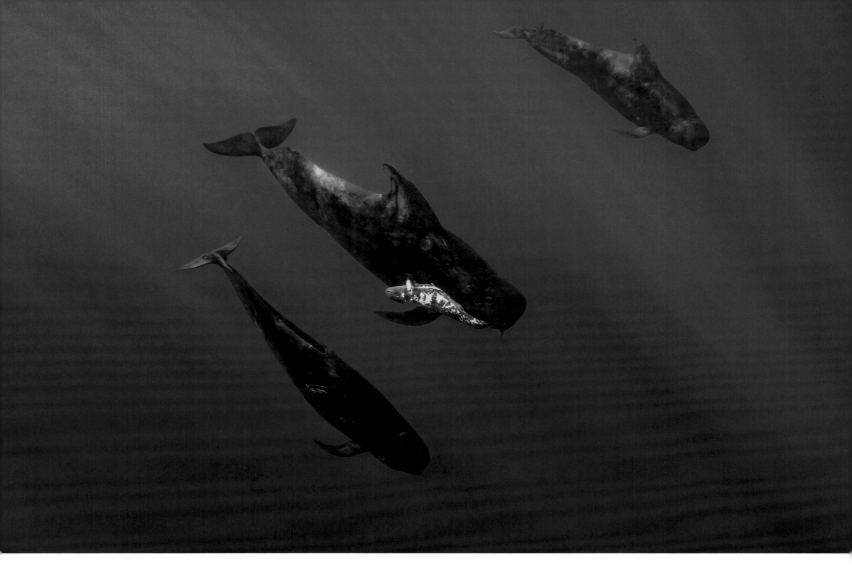

years with right whales. In 2013, I embarked on a two-year assignment, photographing five species of dolphins (which are smaller whales) in nine locations worldwide, resulting in a cover story in 2015. From these experiences I learned two things: that I could be happy working only with cetaceans for the rest of my life, and that, even if I chose to pursue such a path, I would at best grasp only a small portion of their lives. Whales, I learned, were complex creatures—with much remaining unknown.

Around this time, I met Shane Gero, a biologist studying sperm whales in Dominica. He described whales he's come to know: generations of families led by older, wiser females. He explained that identity was important to

these animals, and that families belonged to clans, which shared a common dialect. Even within families, he said, sperm whales had different parenting techniques, some using babysitters and even wet nurses.

The picture that Shane painted was one of culture, of traditions passed down through generations. Different groups within a single species behave differently depending on where they live, what they have been taught, and the wisdom they have acquired from eons in the sea.

And then it hit me: Viewing whales through the lens of culture was the key to understanding them. Cognition is the foundation; dolphins and whales have large brains relative to body size. But more interesting is how these animals use their brains. Humpback whales conduct singing competitions; orcas seek out ethnic foods; belugas travel each summer to their favorite beach resort. I am, of course,

A trio of pilot whales swims off Kona, Hawaii, with one adult carrying a dead calf in what appears to be a mourning ceremony.

anthropomorphizing, but only somewhat. Categorizing whale behavior in human terms (singing competitions and beach resorts) may be rather unscientific. But these activities are also more than behavior: They are culture.

As a storyteller, I have learned the value of shared experiences as a way of relating to others. Shane describes the distinction this way: "Behavior is what we do; culture is how we do it." He gives the example of people eating with utensils, which is behavior. Whether you use forks and knives or chopsticks, however, is culture.

To conclude that orcas prefer ethnic foods is to humanize them with semantics we understand. But the truth is that these animals *do* have geographical preferences when it comes to feeding. And in some places, their cultural food is so important that when it's not available, they would rather die than eat something else.

Excited by these revelations, I set out in 2017 on a three-year odyssey to build on previous work, to learn more from whales, and to photograph specific behaviors and moments in their lives. This was the most ambitious effort of my career, and I took my first steps with both anticipation and trepidation.

Whales can be especially challenging to photograph, and I knew going in that there would be a high probability of failure. The vast majority of my work with whales is done by free diving, not scuba. This means that the time I have to make pictures is limited to how long I can hold my breath and swim into the sea. It also means that the whale must let me close. Plus the sun must be shining, or the image will lack color and detail. If all these elements fall into place, *and* the whale is doing something interesting, it is an especially good day.

The Venn diagram of whale photography is daunting; great results usually require an abundance of time in the field. This book is the result of many voyages. It is also the result of valuable help from talented people and a generous dose of luck (or as I prefer to believe, divine intervention).

In his book about Cape Cod, Henry Beston wrote:

For the animal shall not be measured by man. In a world older and more complete than ours, they move finished and complete, gifted with the extension of the senses we have lost or never attained, living by voices we shall never hear. They are not brethren, they are not underlings: they are other nations, caught with ourselves in the net of life and time, fellow prisoners of the splendour and travail of the earth.

Such a description seems especially fitting for whales. I have indeed come to see them as "other nations" or as tribes of the sea. Today, the dreams of a young boy who wanted to swim with whales have been realized a thousandfold—and the more time I spend among them, the more they stir my soul.

In time, I hope we will understand whales more fully, and that no secrets will remain between our nations. And perhaps somewhere, a humpback whale plies the deep, telling stories of his days as an errant calf, when he got into a jam and a human being lent a helping hand. ■

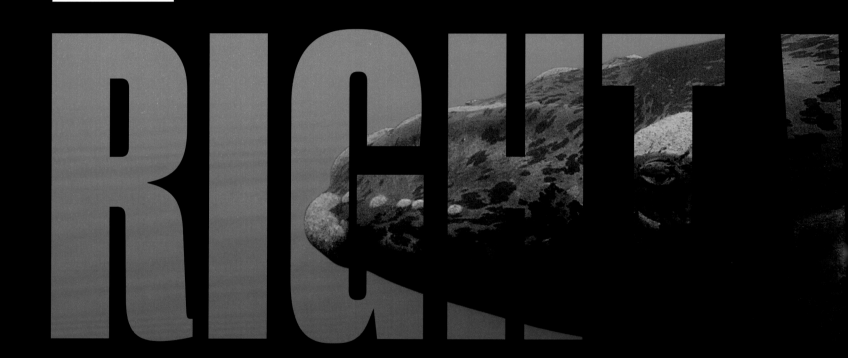

# RIGHT

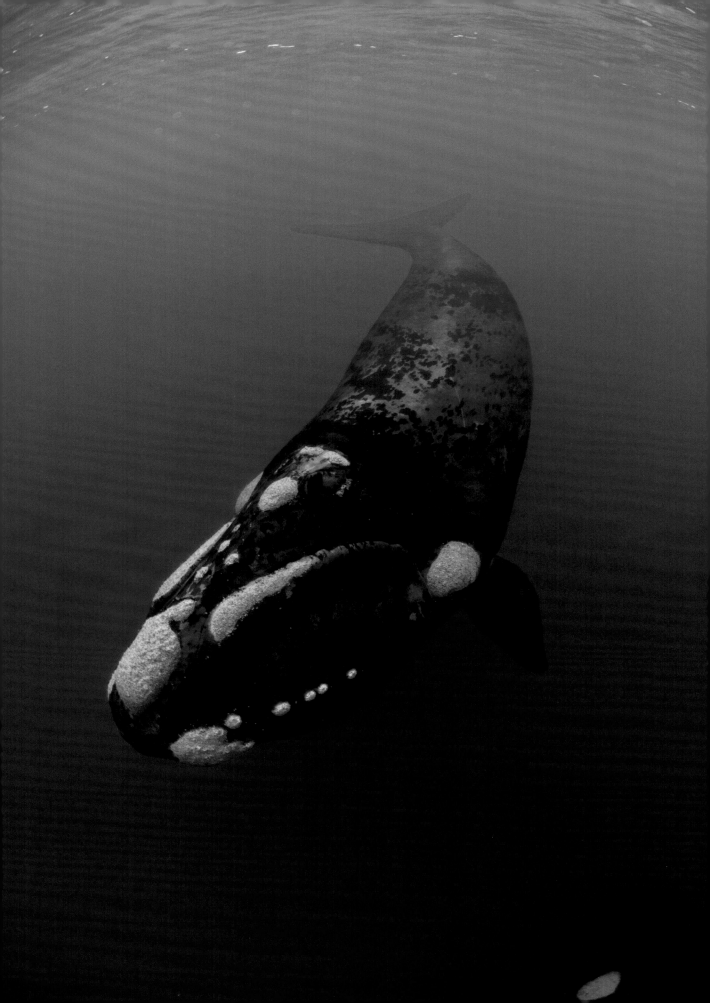

# A TALE OF TWO WHALES

T he North Atlantic right whale left Cape Cod Bay in the spring and set off across the Atlantic Ocean. For five months he swam. Finally, he stopped in an unexpected spot thousands of miles from home: a fjord along the coast of Norway.

Researchers on both sides of the ocean scratched their heads. A right whale hadn't turned up in Norway for at least 100 years. Why had this one traveled here?

It's not so unusual for right whales to wander; every now and again one that should be in New England will turn up in Iceland or the Azores. The animal in question—dubbed "Porter" by researchers at the New England Aquarium who track the world's North Atlantic right whales—eventually made his way back to Cape Cod. The scientists figured it was just another bizarre sighting. Whales have a flair for the unexpected.

Several years later, a German historian published a scholarly paper that cast the incident in a mysterious new light. The very stretch of Norwegian coast where Porter

**RIGHT WHALES**
*Eubalaena*
**AVERAGE SIZE:** 50 feet
**AVERAGE WEIGHT:** 70 tons
**NORTH ATLANTIC IUCN STATUS:** CR
**SOUTHERN IUCN STATUS:** LC

had turned up, the paper reported, was a historical whaling ground in the 1400s. And the species hunted was the right whale.

The discovery sent chills up the scientists' spines. It also raised new questions about Porter's voyage. Was it serendipity? Was there a genetic component to the journey? Or had Porter, driven by some cultural impulse, swum across the ocean to visit the spot where his ancestors had died?

The only thing we know for certain: When it comes to right whales, or any other whale species, we generally have little clue about what goes on in their worlds. Even scientists who spend their entire careers scrutinizing whale behavior only get to see a tiny percentage of the animals' lives.

North Atlantic right whales—so named because the whaling industry deemed them the "right" whale to catch—are among the most endangered whale species on the planet; only 400 or so remain. But it hasn't always been this way. New England lore holds that at one time,

A curious southern right whale approaches the author in the Auckland Islands of New Zealand. White-colored callosities on its head are rough patches of skin clustered with barnacles and tiny crustaceans called cyamids.

a person could walk across Cape Cod Bay on the black backs of these massive animals. But the right whales, who swam slowly, stuck close to shore, and floated when dead, were hunted to the brink of extinction by the 18th century.

As long as school buses and weighing in at 70 tons apiece, North Atlantic right whales tend to spend the winter in Florida, spring in Cape Cod Bay, and summer in the Bay of Fundy. But in recent years, researchers have theorized that warming seas may be pushing them farther north in their foraging. The species is always on the move in search of their preferred food: tiny crustaceans the size of grains of rice called copepods. With so few whales left, scientists have constructed elaborate family trees for the animals, and can identify each individual by sight.

Although killing a North Atlantic right whale has been illegal since 1935, humans are nevertheless destroying the animals' lives. Slow to reproduce and living in a highly industrialized stretch of the Atlantic from Florida to Canada, the animals have still not been able to recover from the devastating effects of the whaling industry.

They probably never will. Their ocean is polluted with chemicals, agricultural runoff, sewage, and deafening noise. Shipping lanes, fishing lines, and recreational boat use create a lethal matrix impossible for the whales to avoid. Eighty-five percent of North Atlantic right whales bear scars from being caught in fishing equipment; more than half have been entangled twice.

Although the life expectancy for North Atlantic right whales is 70 years, they rarely live that long; in the last decade none have died of natural causes. Some scientists say that within 20 years, the species could go extinct.

What would life be like for right whales if human activity weren't such a menace? To find out, all we have to do is travel south. In the quieter seas below the Equator, far from crowds, ships, and industry, southern right whales lead peaceful lives. Scientists marvel at their good health: They are fat, thick, and robust. They have no scars.

By the 1900s, centuries of hunting had left North Atlantic right whales and southern right whales in similarly dire straits. (A third species, the North Pacific right whale, was also pushed to the brink.) But southern right whales have steadily rebounded since global protections took effect decades ago. Stronger and stress-free, they live longer and can more easily bear calves; in some areas, their populations are growing by more than 7 percent each year.

I've long been fascinated by the heartbreaking contrast between these two closely related species. In 2007, I went to the Auckland Islands to photograph a newly discovered population of southern right whales. It was a speculative trip in the dead of winter; I had no idea what the water visibility would be, whether I'd see any whales, or whether the whales would let me near them.

As we approached the coast of Enderby Island, I could clearly see the sandy seafloor, 60 or 70 feet down, as the water glowed in the sun. All of a sudden four or five right whales swam toward our boat. They seemed inquisitive and interested in who we were.

# THE SOUTHERN RIGHT WHALES WERE MORE CURIOUS WITH ME THAN ANY WHALE I'VE EVER ENCOUNTERED. WHEN THEY BUMPED ME, IT WAS LIKE BEING NUDGED BY A BLOCK OF CEMENT...ON THAT TRIP, EVERY DAY IN THE WATER WAS LIKE GOING TO MEET FRIENDS; I KNEW THE WHALES WOULD COME OVER TO BE WITH ME.

I jumped into the water, and the whales came right up. Each felt like a city bus swimming right toward me. Up close, I could see rough patches of skin where tiny crustaceans and barnacles had taken hold. Scientists use these distinctive markings, called callosities, to identify individual whales.

The southern right whales were more curious with me than any whale I've ever encountered. When they bumped me, it was like being nudged by a block of cement. But as friendly as they were, I learned years ago not to touch wild animals. (It's a problem if they don't like it, and sometimes even if they do.)

On that trip, every day in the water was like going to meet friends; I knew the whales would come over to be with me. I felt like a little kid who couldn't wait to wake up in the morning to go play with my dog.

In contrast to their southern cousins, North Atlantic right whales are so endangered, and under such strict protections, that the closest I've ever come to one is from the deck of a boat. Even if I could get in the water with them, I doubt the whales would let me get close, let alone crowd me like eager puppies. They'd be justified in their wariness.

Whales keep their secrets close. We'll never know why Porter swam to the spot where others of his kind were killed centuries ago. But suppose it's not a coincidence. What if he holds some small piece of knowledge, passed down through generations, about that particular patch of ocean? We may lose his species before we ever have the chance to find out. ■

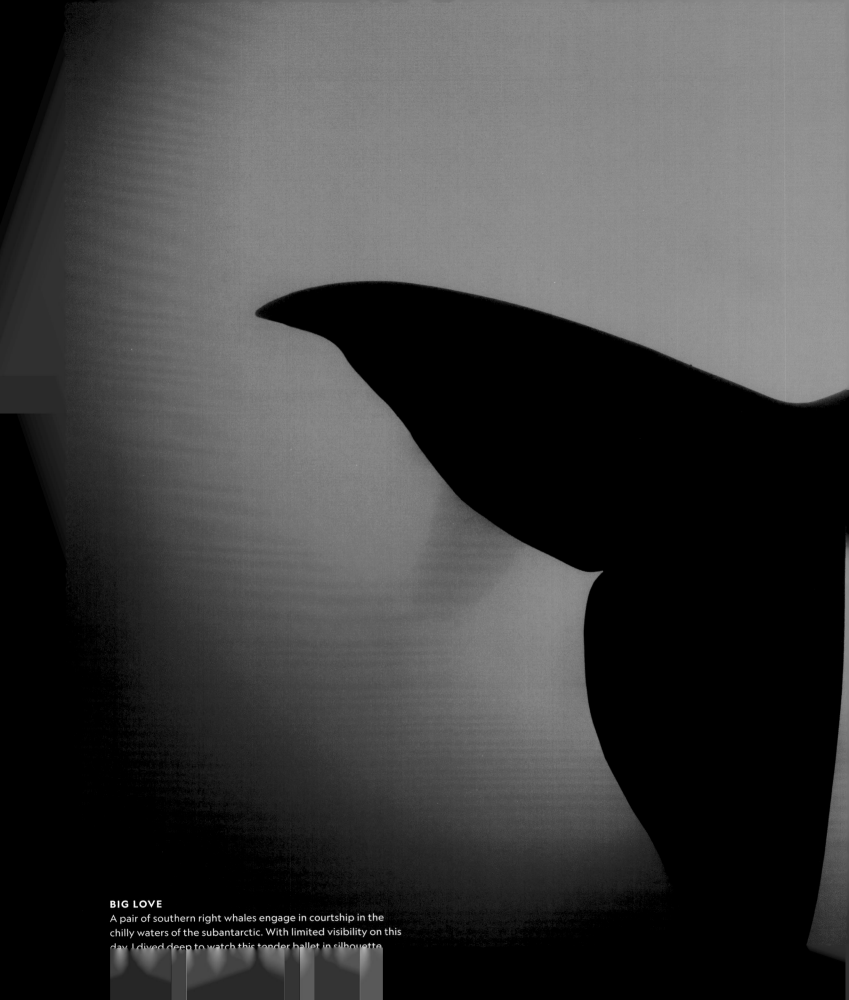

**BIG LOVE**
A pair of southern right whales engage in courtship in the chilly waters of the subantarctic. With limited visibility on this day, I dived deep to watch this tender ballet in silhouette.

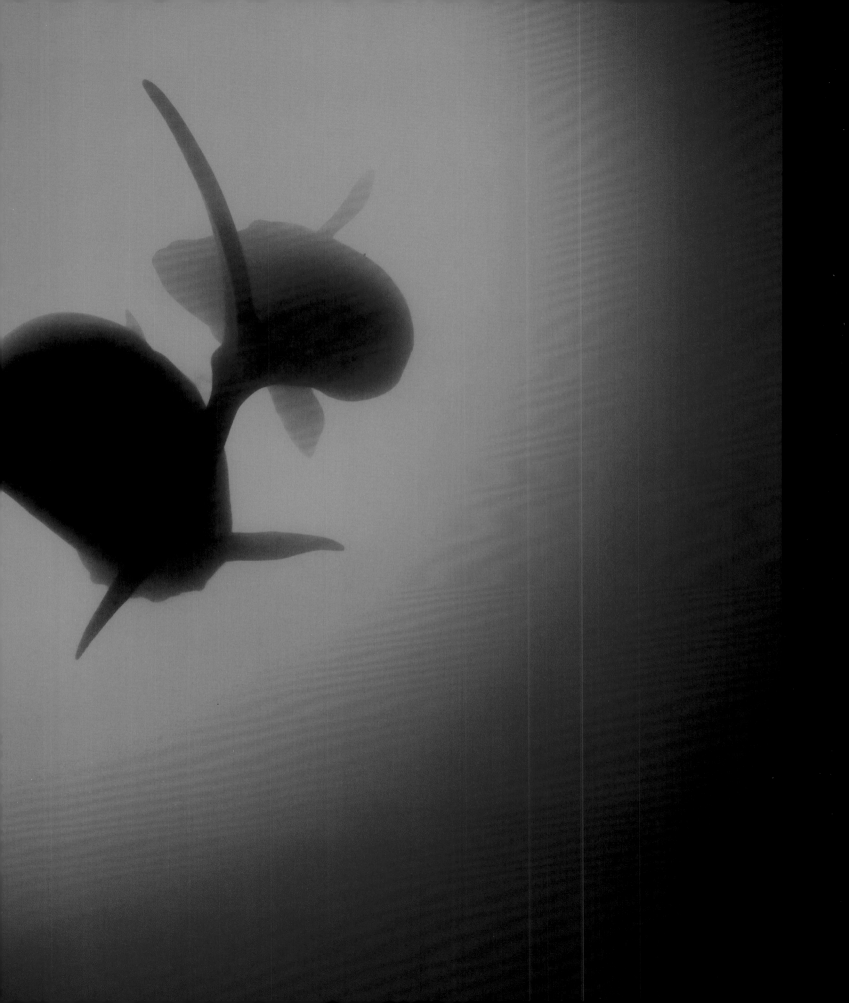

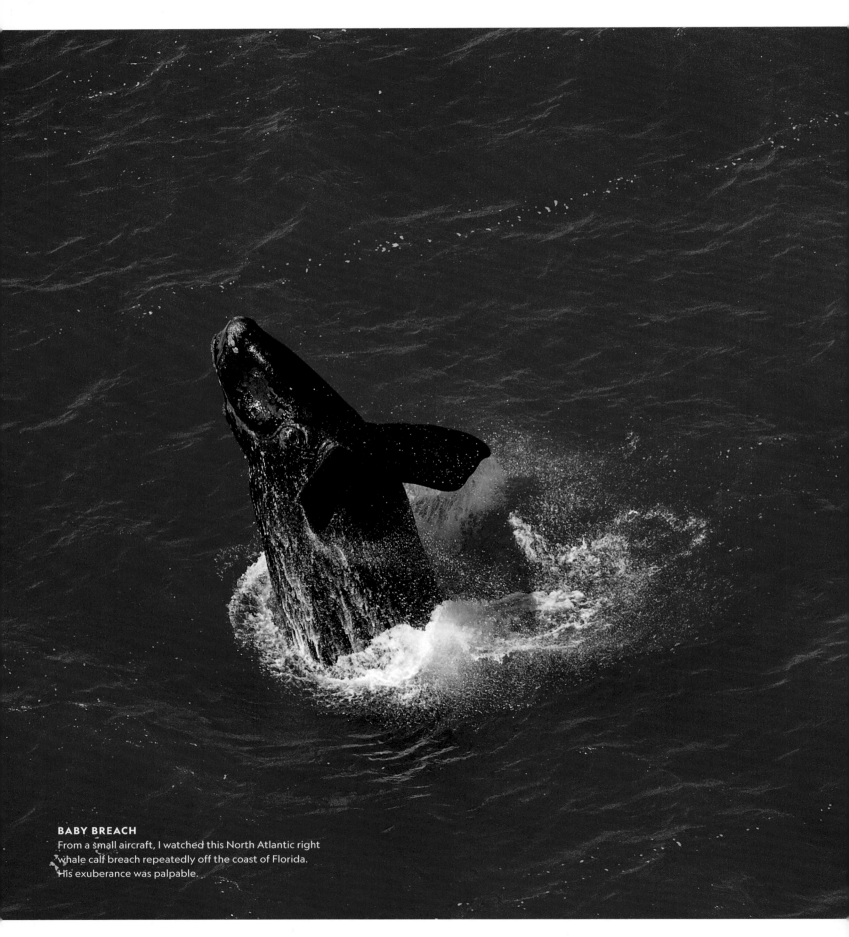

**BABY BREACH**
From a small aircraft, I watched this North Atlantic right whale calf breach repeatedly off the coast of Florida. His exuberance was palpable.

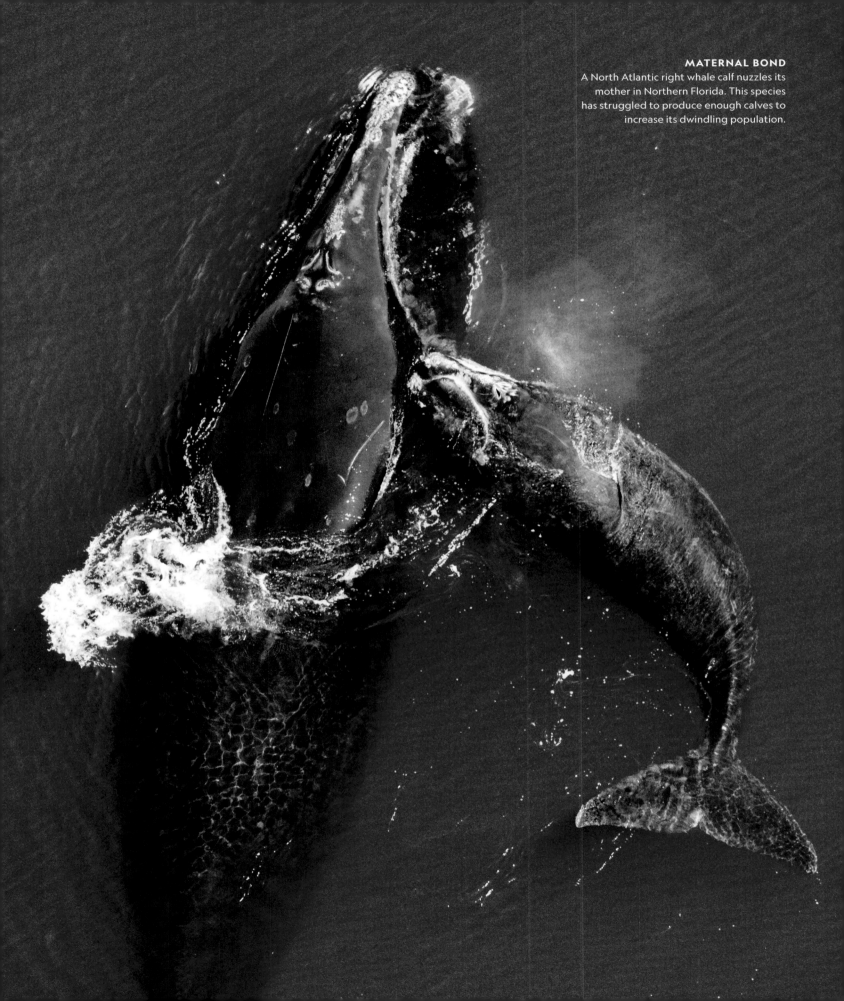

**MATERNAL BOND**
A North Atlantic right whale calf nuzzles its mother in Northern Florida. This species has struggled to produce enough calves to increase its dwindling population.

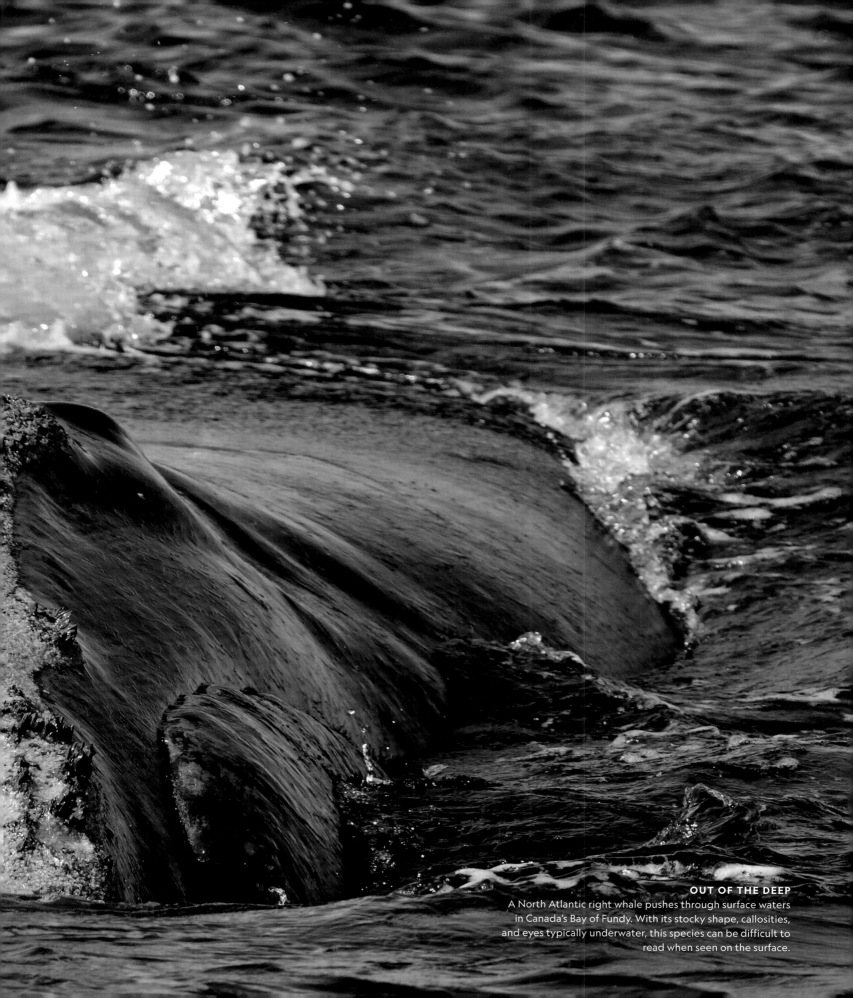

**OUT OF THE DEEP**
A North Atlantic right whale pushes through surface waters in Canada's Bay of Fundy. With its stocky shape, callosities, and eyes typically underwater, this species can be difficult to read when seen on the surface.

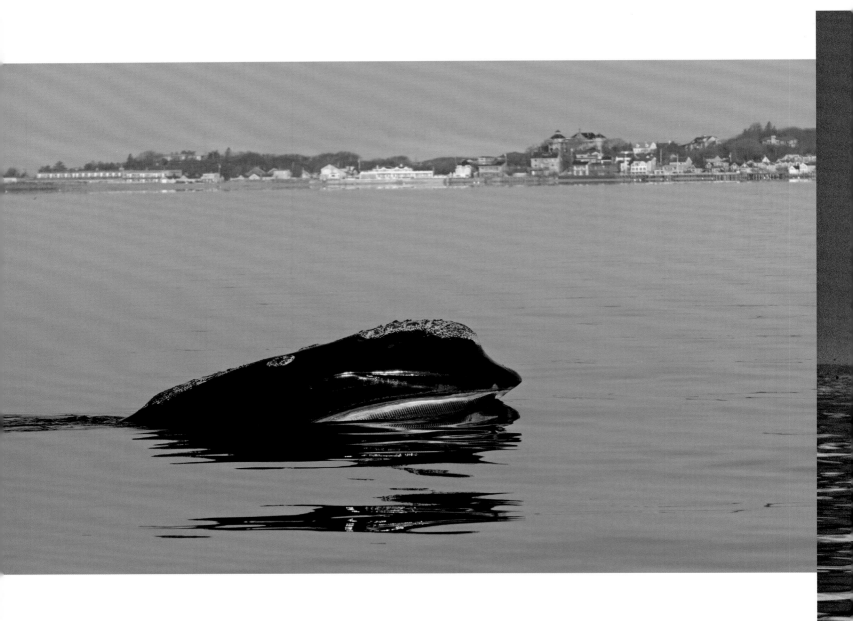

**BREAKFAST OF CHAMPIONS**
To consume copepods that sometimes cluster near surface waters in springtime, a skim-feeding whale off Provincetown, Massachusetts, opens its mouth and skims along the surface, straining the tiny organisms with its baleen.

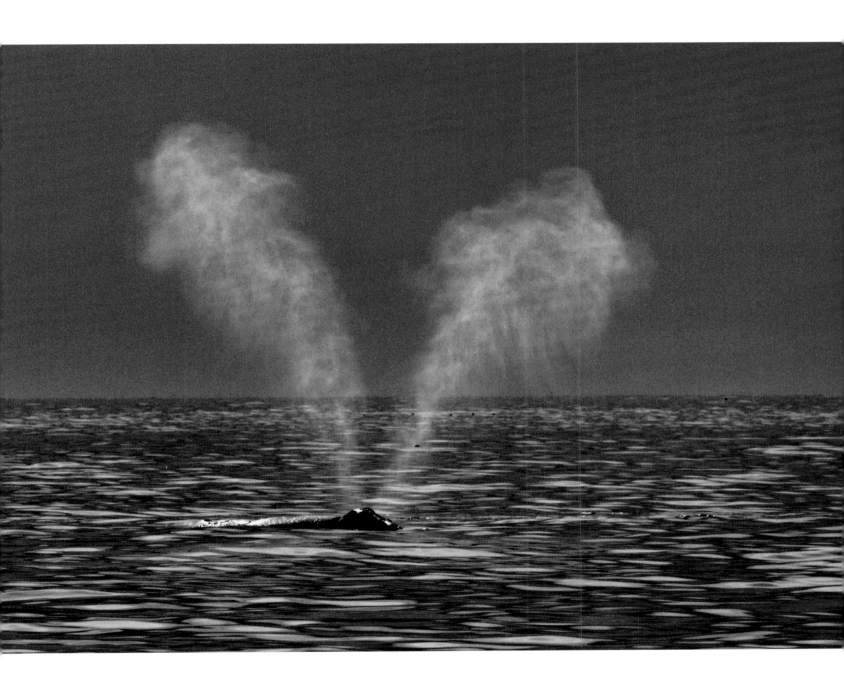

**VICTORY LAP**
Like all baleen whales, right whales have two blowholes, angled in such a way that their blows create a noticeable V shape.

**EYEWITNESS**

Close-up view of a southern right whale in New Zealand. Barnacles and cyamids form the callosity over the eye, like an eyebrow on humans. The whales I met here had never seen humans before and were very curious about me; I felt they were trying hard to make sense of what they were seeing.

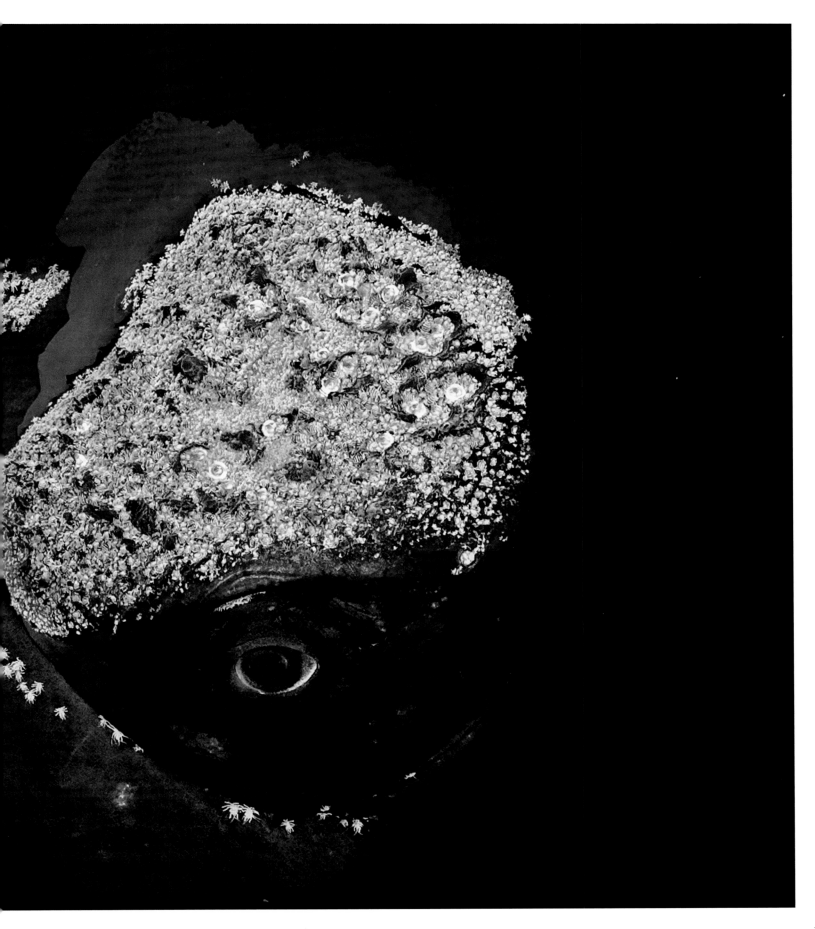

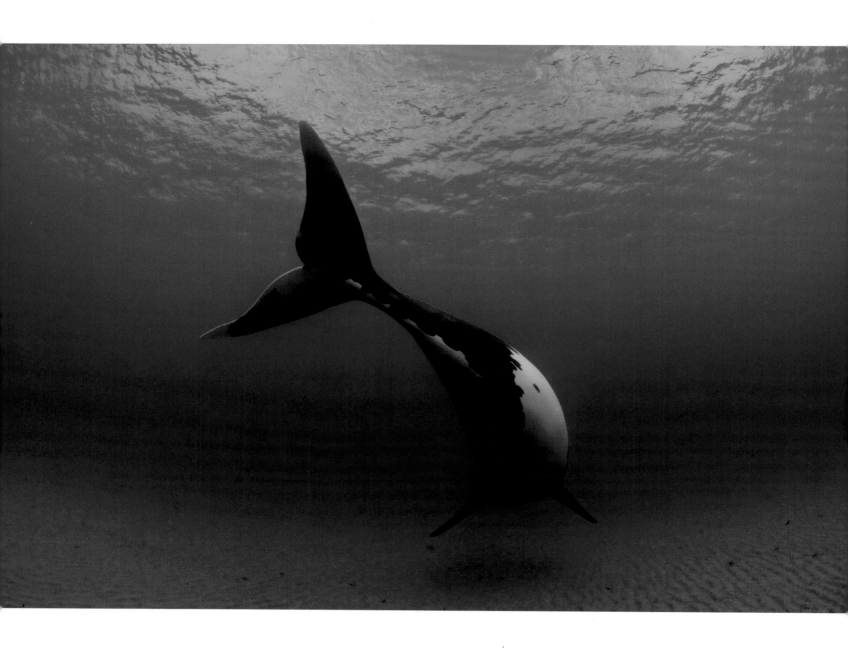

## BRAVE NEW WORLD

For photographers to make pictures of marine mammals, the animals must allow you into their lives, even if only for a few moments. My time with the whales in the Auckland Islands was pure magic, alone underwater in this remote corner of the world with stunning and welcoming whales.

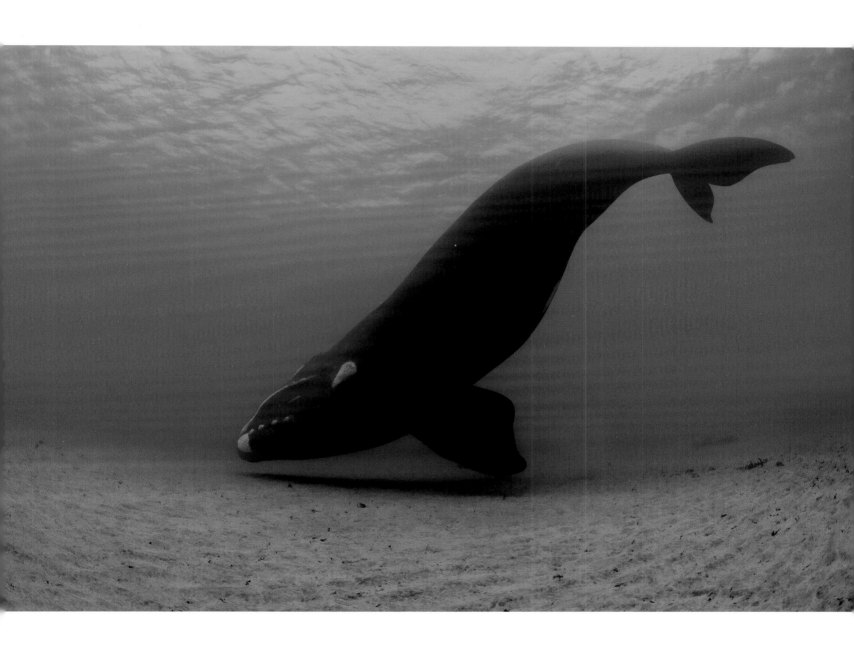

**POETRY IN OCEAN**
Kneeling at a depth of 70 feet, I watched this whale gracefully arch its body into almost an S shape and hover motionless, inches from the sandy seafloor. To see a 45-foot-long, 70-ton animal move so delicately is a profound experience.

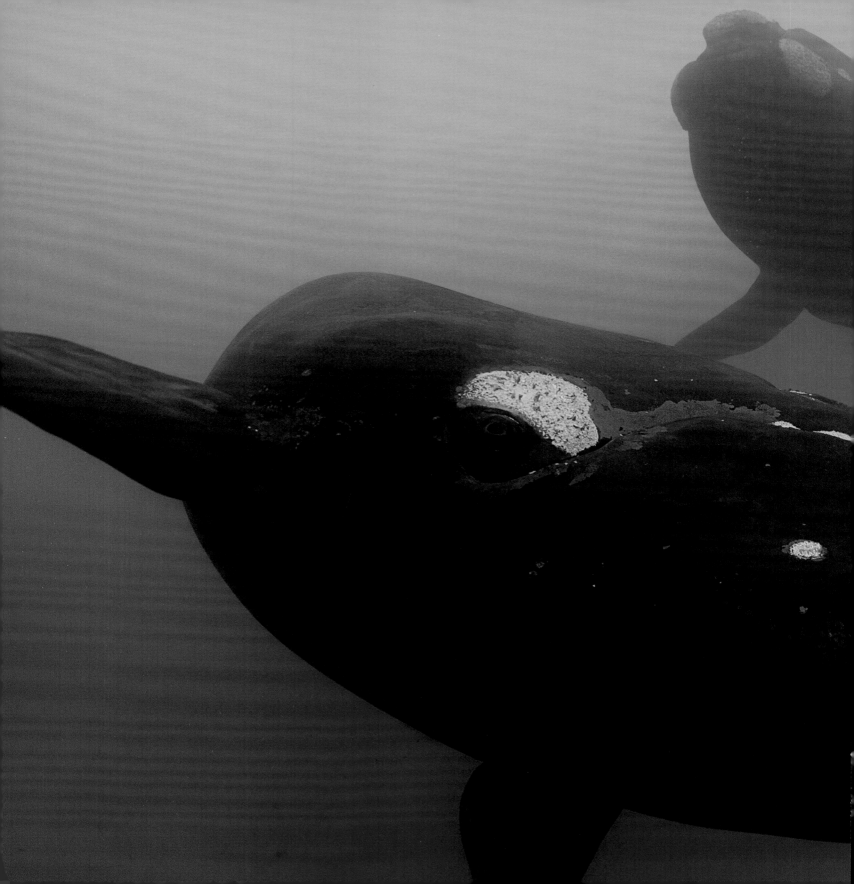

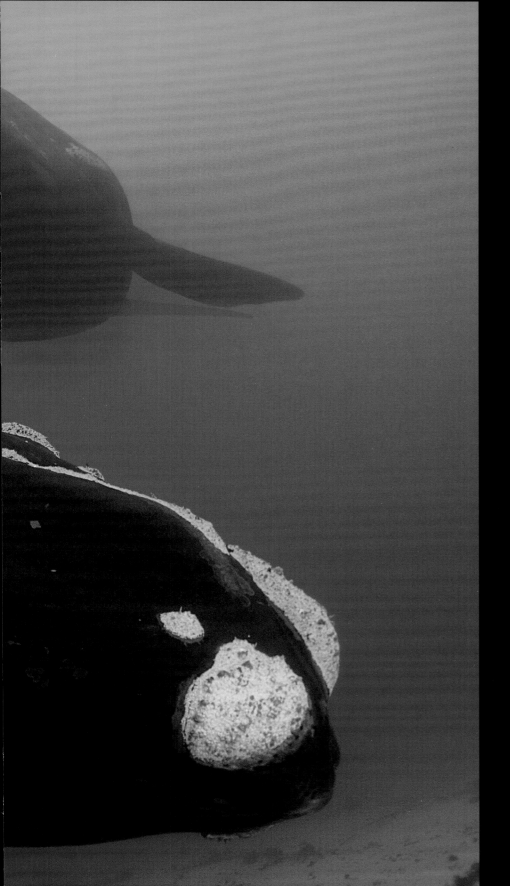

# BEHIND THE SHOT

I was bent over backward, my shoulders almost touching the seafloor. I could have been in an ambitious yoga pose, but for the fact that I was wearing a dry suit and was 65 feet beneath the ocean surface. My scuba tank was scraping the sand—and three feet in front of my mask was a 45-foot-long, 70-ton southern right whale.

He was angled at about 45 degrees in the water column, and rotated his body so that he could get a good look at me. I held my camera housing to my eye, but there was not enough light for a picture, because my subject was filling the frame and blocking the sunlight from above. With a slight flick of his tail, the whale could have squashed me. But he just hovered, studying me.

During my first several days in New Zealand's Auckland Islands, I dove alone, worried the animals I met wouldn't allow one diver close, never mind two. But from the moment we arrived, the right whales welcomed us into their world. The researchers on the boat with me believed that these whales had never seen a human before, which led them to believe they might be trusting and curious.

In the time since I made these images, I think about those days often, swimming in the cold sea alongside my newfound friends. Were it not for my photographs, I would be certain it was a dream.

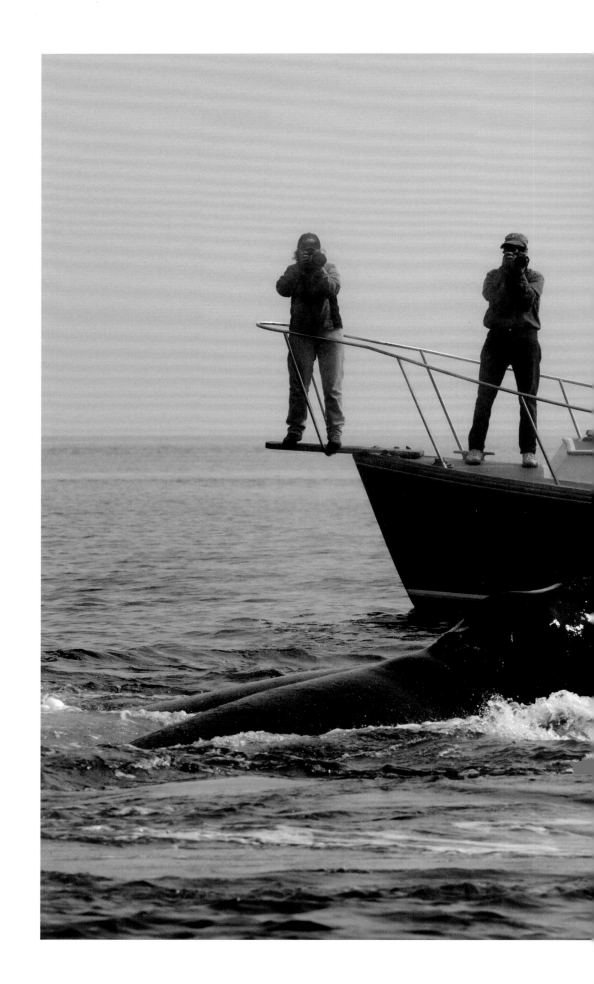

**LIFE OF THE PARTY**
A team of researchers from the New England Aquarium observes a surface-active group of North Atlantic right whales in Canada's Bay of Fundy. During these rambunctious gatherings, the whales make a variety of vocalizations described by scientists as upcalls, gunshots, and screams.

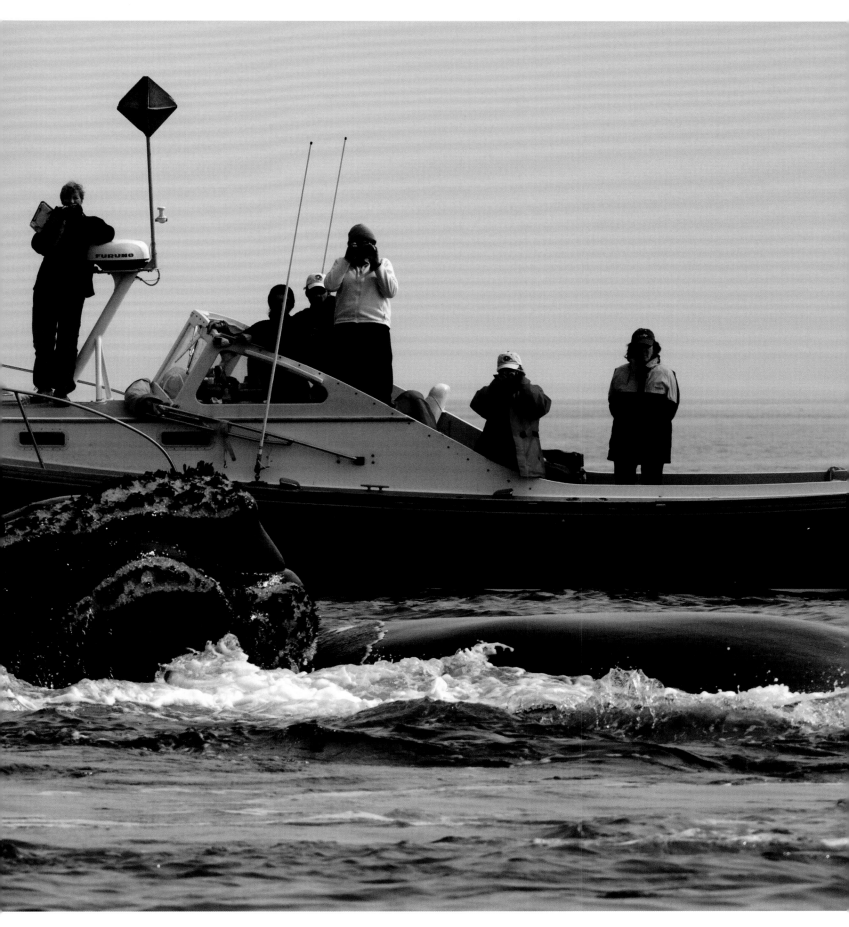

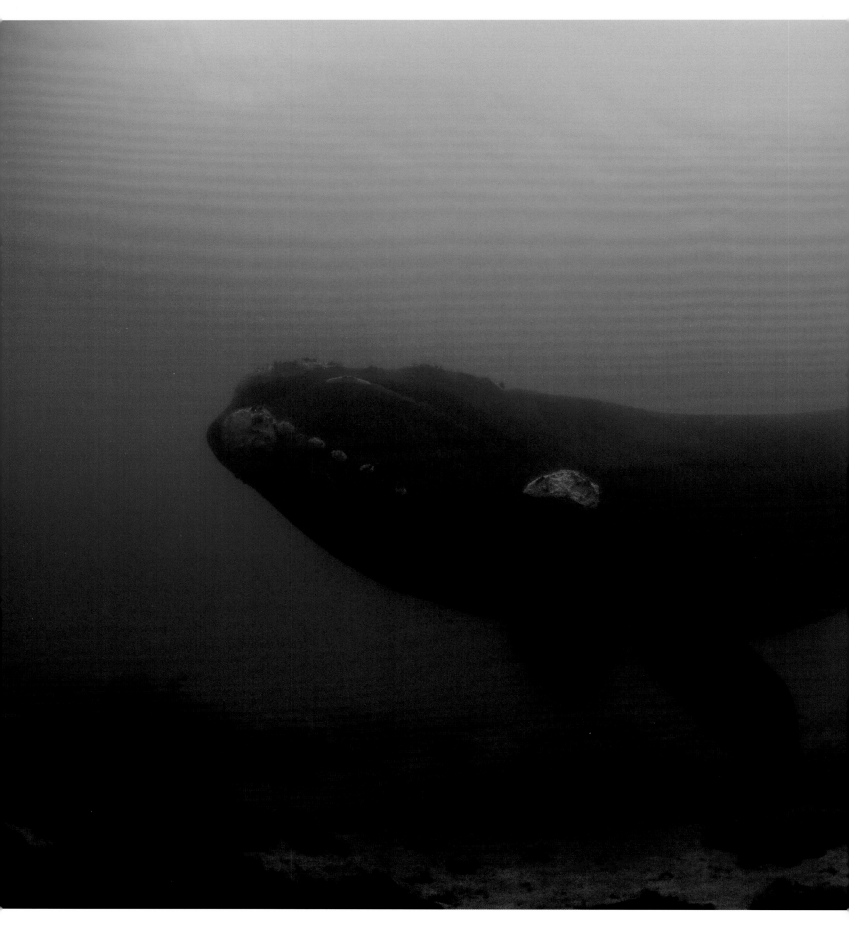

**SURPRISE VISITATION**
Visibility varied greatly in the Auckland Islands, and on this day, when conditions were murky, I was exploring the bottom alone only to be startled by this southern right whale. Highly curious, these whales frequently choose to engage.

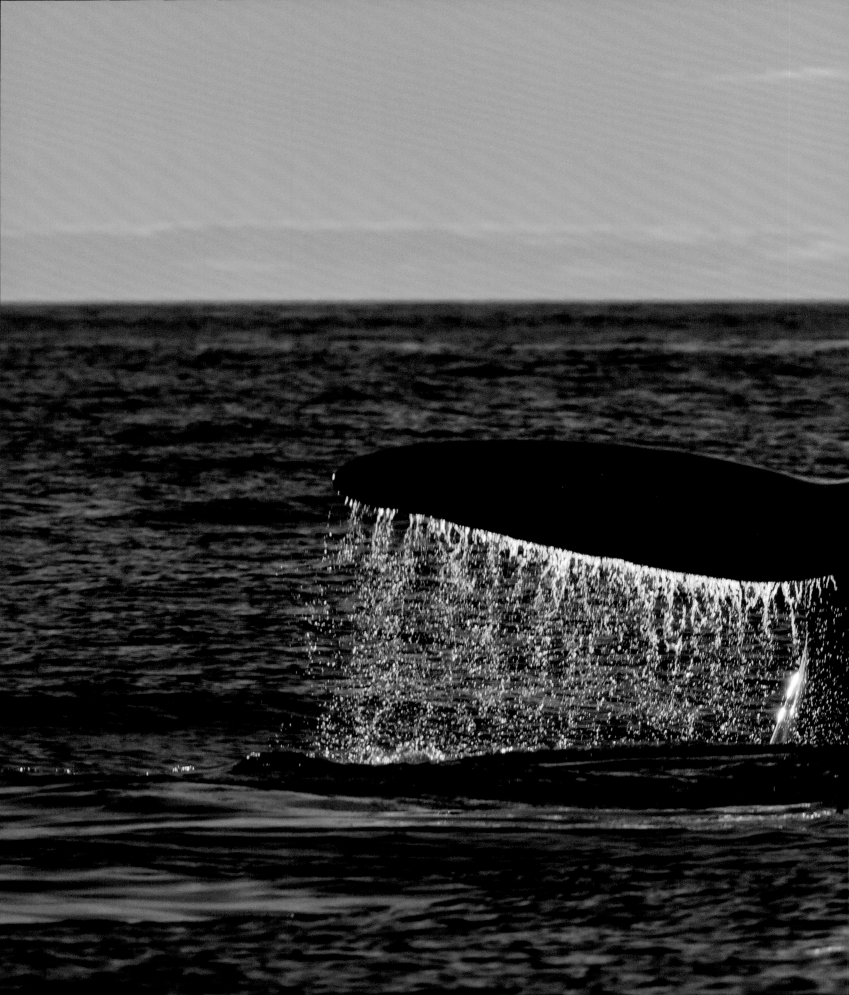

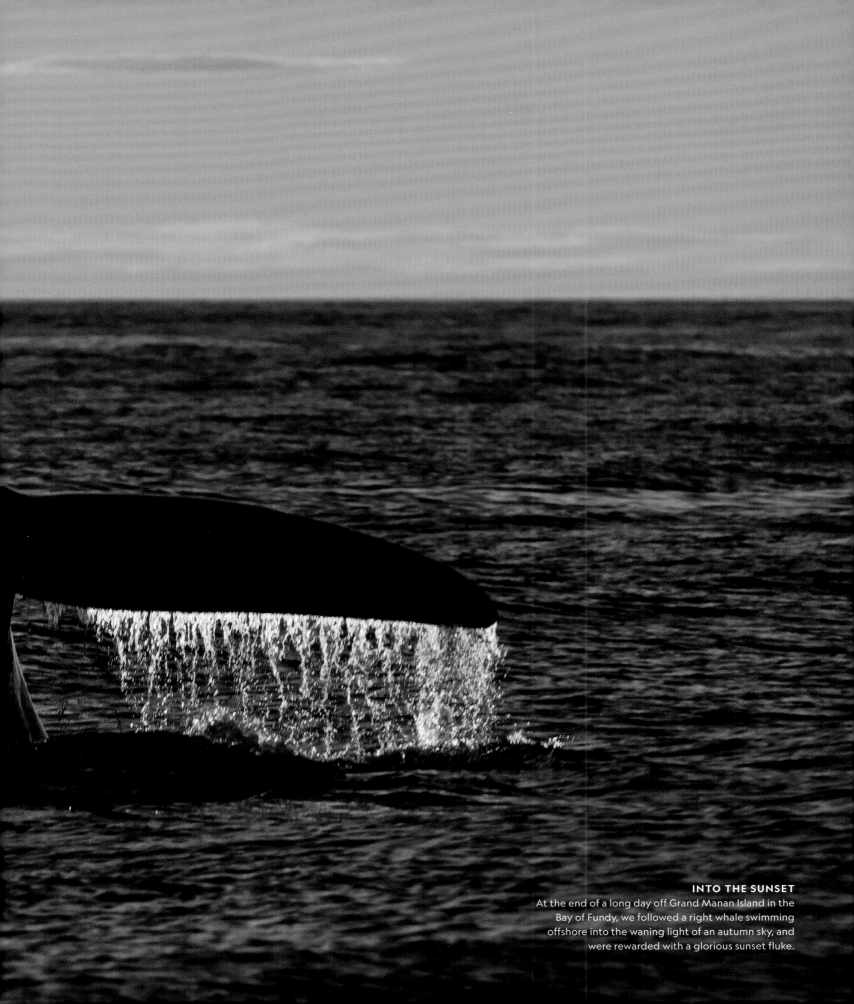

**INTO THE SUNSET**
At the end of a long day off Grand Manan Island in the
Bay of Fundy, we followed a right whale swimming
offshore into the waning light of an autumn sky, and
were rewarded with a glorious sunset fluke.

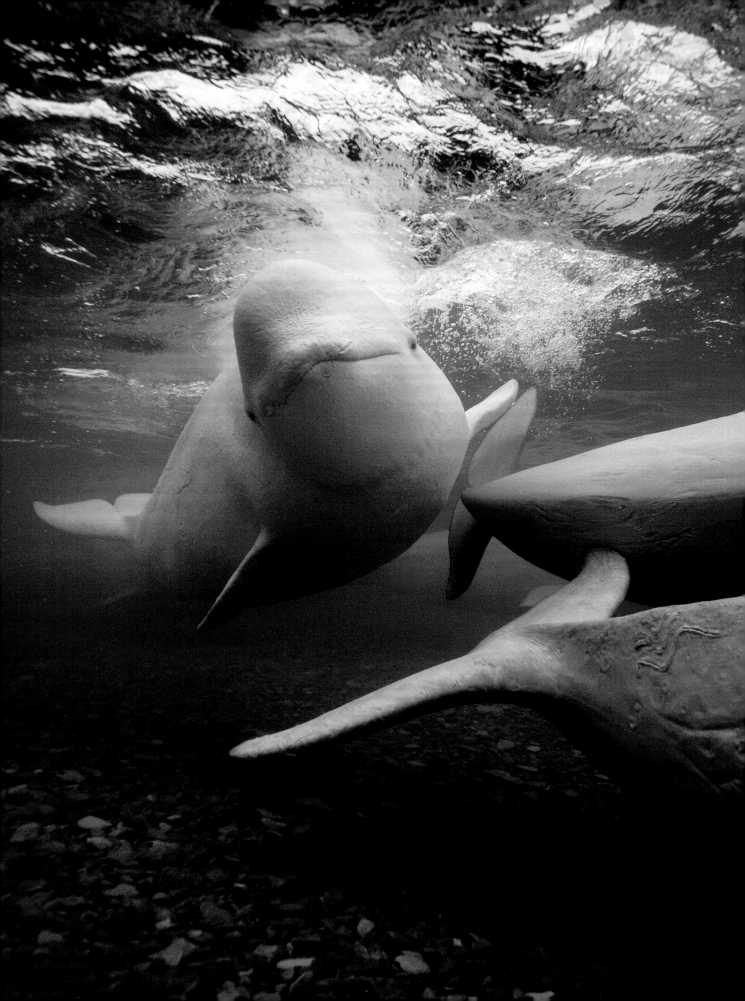

# THE SOUND **OF SILENCE**

The journey begins every summer in the Arctic. After spending the long, dark winter in Canada's Baffin Bay, hundreds of beluga whales swim together through the Northwest Passage and make their way among the breaking, shifting ice to a small inlet on Somerset Island. It's only a speck on the map, farther north than most people ever go. But to the belugas, Cunningham Inlet is a sacred spot.

As many as 2,000 whales will spend the summer here, giving birth and nursing their calves. It's a sheltered place, and relatively gentle as Arctic conditions go; river water flows out several degrees warmer than the ocean, and the water depth is very shallow. It's perfect for newborn whales who don't yet have the blubber they'll need to keep warm in the world's coldest ocean. Beluga Beach, as I like to call it, is a vacation spot, a maternity ward, and a day spa. There's nothing quite like it in the animal kingdom.

The white whales seem to glow in the vivid green-blue sea. They twirl and spin about, slapping their tails and

**BELUGA WHALE**
*Delphinapterus leucas*
**AVERAGE SIZE:** 13–20 feet
**AVERAGE WEIGHT:** 1–1.5 tons
**LIFE SPAN:** 35–40 years
**IUCN STATUS:** LC

using stones like loofahs to rub off dead skin. The gray calves—they won't turn white until they're older—play with pebbles in the shallow water and ride around on their mothers' backs. Every now and again, an adult will lie on its belly as the tide goes out, tail arched and head poking out of the water, like a giant banana.

Belugas, like humans, clearly have a blast at the beach. And yet this idyllic setting is also a window into their rich culture. They chatter and sputter in clicks, whistles, and pops; these sounds make up a vocabulary of hundreds of words. The whales have distress calls, place-names, and even give names to one another. Mothers and calves go by the same name for quite some time before a young whale eventually gets its own call.

The whales' social structures are so close-knit that when a mother gives birth, other females also start producing milk to help nurse the infant. Newborn calves make barely audible sounds within hours of being born. During their first two years of life, they conduct the whale

Like white apparitions in a green-colored sea, beluga whales play in the shallow water of Cunningham Inlet in the Canadian High Arctic.

# BOBBING THEIR HEADS, THE BELUGAS AMPLIFIED THEIR SONAR TO FIGURE OUT WHAT THE REMOTE CAMERA WAS. THE REAL SILLINESS BEGAN ONLY AFTER THEY REALIZED THE DEVICE WOULDN'T HARM THEM. THEY MOUTHED THE ENTIRE CAMERA DOME, FLIPPED IT UPSIDE DOWN, AND WATCHED THEIR OWN REFLECTIONS.

equivalent of babbling, experimenting with sounds and basic phrases. Eventually they move beyond simple calls to their mothers to perfect and expand their vocal repertoire.

At Cunningham Inlet, the young whales learn and grow together. They form what scientists call kindergarten groups: 10 to 15 youngsters playing together as a handful of adults supervise, everyone gabbing nonstop the whole time. These chatterboxes don't even have vocal cords: They make their sounds through nasal sacs near their blowholes.

Culturally significant to indigenous communities in the Arctic, beluga whales are some of the most charismatic creatures of the Arctic. Reaching 13 to 20 feet long and weighing more than a ton, they are one of the smaller species of whale. They can move between freshwater and salt water and often swim in large rivers; they feed on salmon, herring, and other fish, as well as shrimps, mollusks, and worms. The absence of a dorsal fin allows them to swim beneath ice.

Unlike most other cetaceans, belugas have flexible necks and can turn and nod their large heads. Slightly upturned mouths make them look as though they're grinning. But the unique shape of their foreheads, known as "melons," serves an important purpose: to facilitate their sonar abilities, among the most sophisticated of any whale species. Bouncing screeches and clicks off shifting ice floes, belugas move their melons to modulate those vocalizations and figure out where to go.

This intense reliance on sound makes belugas highly sensitive to noise—and unfortunately, their tranquil spot

at Cunningham Inlet is only getting louder. Just a few years ago, the Northwest Passage was completely ice-bound; today, boats pass through during the summer, just when all the whales have gathered in search of shelter. It doesn't take much to spook them: If you put even a toe in the water, they'll flee.

For just that reason, I've never swum with beluga whales at Cunningham Inlet. The only way I was able to create images of them there was to use remote under-water camera systems. At certain times of day, when the tide was right and the cameras were positioned just so, I was able to make a set of pictures of newborn calves with their mothers.

The remote cameras beautifully captured the belugas' personality. First of all, these whales are frequently upside down. Scientists believe their sonar works better from this position; maybe their stereoscopic vision is also more precise that way. Whatever the reason, it only adds to our sense of them as curious, playful animals.

The belugas would often swim up close to the camera, and I could see their melon shapes changing. Bobbing their heads, they amplified their sonar to figure out what the camera was. The real silliness began only after they realized the device wouldn't harm them. They mouthed the entire camera dome, flipped it upside down, and watched their own reflections.

One day, standing next to the river, I saw a big ship in the distance. Two small boats launched from the ship and moved into the bay. There is typically no boat traffic near Cunningham Inlet; occasionally, visitors to the local lodge will kayak around. But these boats powered into the bay with their outboard motors, creating what must have sounded like a thunderous racket to the sensitive whales. Within minutes, at least 700 belugas stampeded out of the inlet.

Four or five days passed before some of the whales came back. They may have gone out into the Northwest Passage and farther west to settle their nerves; we don't know. Other estuaries nearby could meet their needs, but this is their preferred bay. This is where they've been coming for centuries. And all that time, it's been free of noise.

For highly acoustic animals like beluga whales, noise is a devastating threat. It complicates their efforts to feed and makes communicating with one another impossible. As the Arctic melts, their world will only get louder: Drilling for oil and gas, along with more shipping traffic through areas once frozen solid, will make it harder for these animals to maintain their vital relationships. Newborn whales' soft calls to their mothers are only the start of what will be lost amid the growing din. Any disruption is especially costly in Cunningham Inlet, where mothers and calves experience their earliest days of bonding. Among belugas, the mothers teach the next generation and pass down the cultural keys: where to go, how to get there, what to eat, and how to catch it.

If ship propellers and motors drown out their language, these whales lose their culture. And in the Arctic, culture is not just a fun day at the beach. It's the key to survival. ■

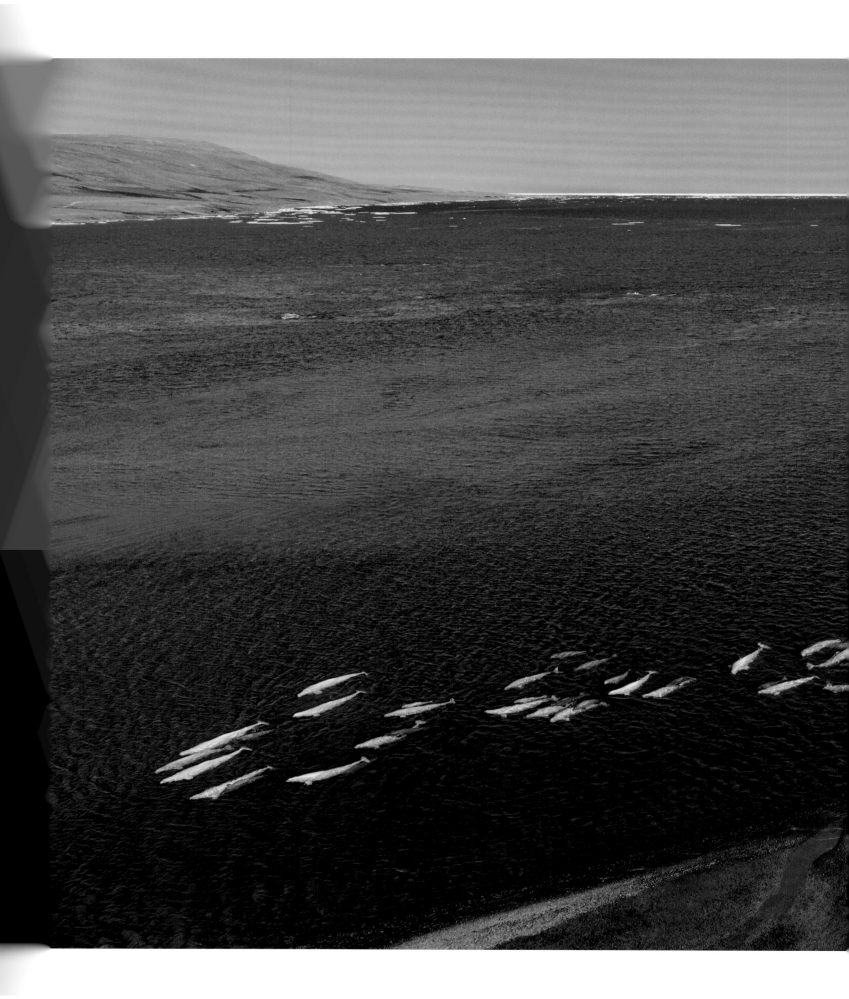

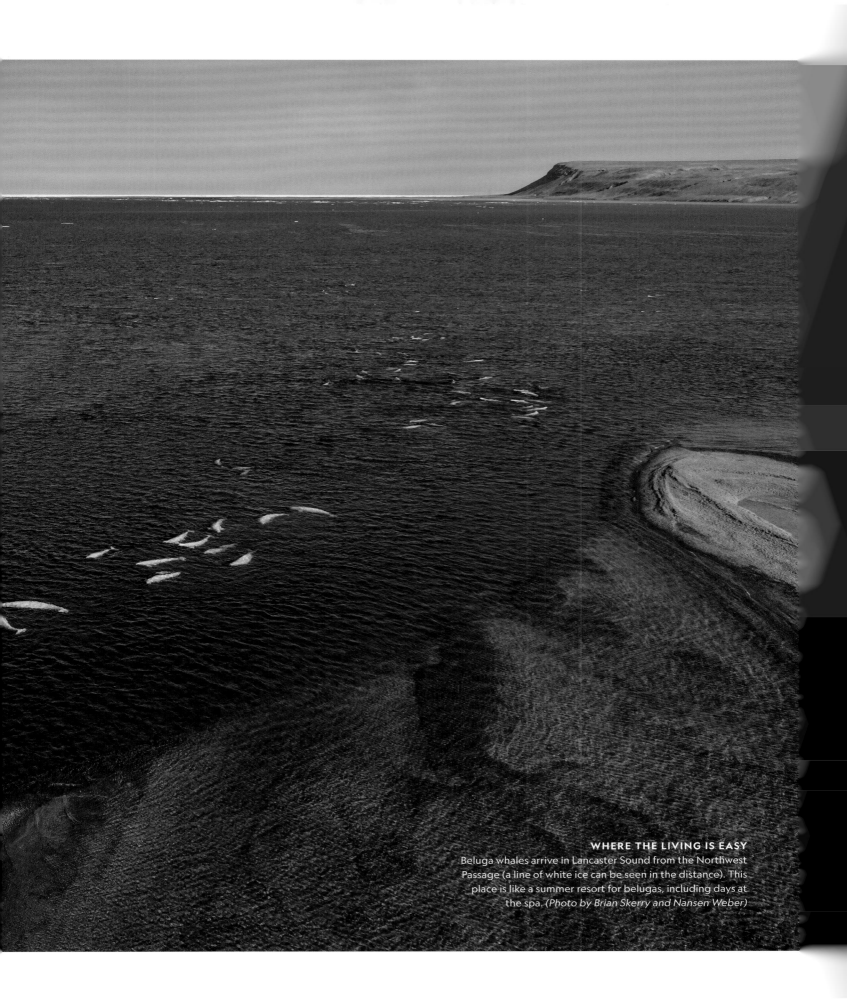

**WHERE THE LIVING IS EASY**
Beluga whales arrive in Lancaster Sound from the Northwest
Passage (a line of white ice can be seen in the distance). This
place is like a summer resort for belugas, including days at
the spa. *(Photo by Brian Skerry and Nansen Weber)*

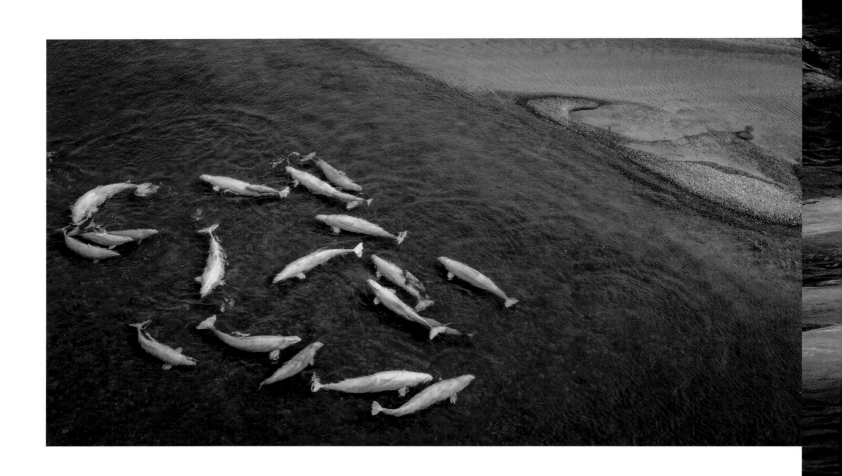

**MATERNITY WARD**
In the shallow, slightly warmer waters of this estuary habitat, female belugas give birth and nurse their calves. Thousands of whales can be seen here, with a high percentage of mother-calf pairs.

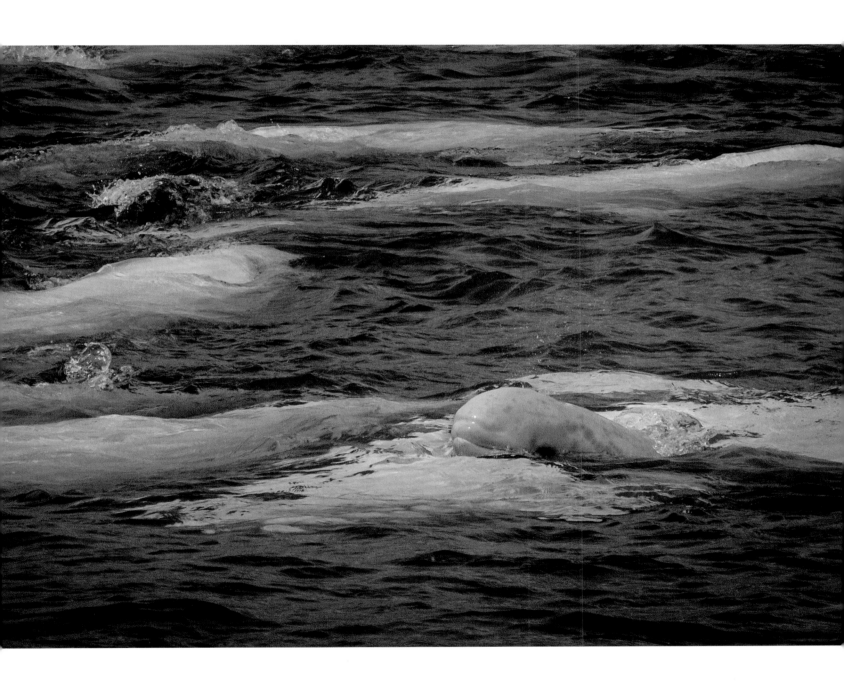

**HIYA, SMILEY!**
Looking a little like E.T., a newborn beluga whale rides its
mother's back on the surface. Most belugas are born dark
in color, with their skin becoming whiter with age.

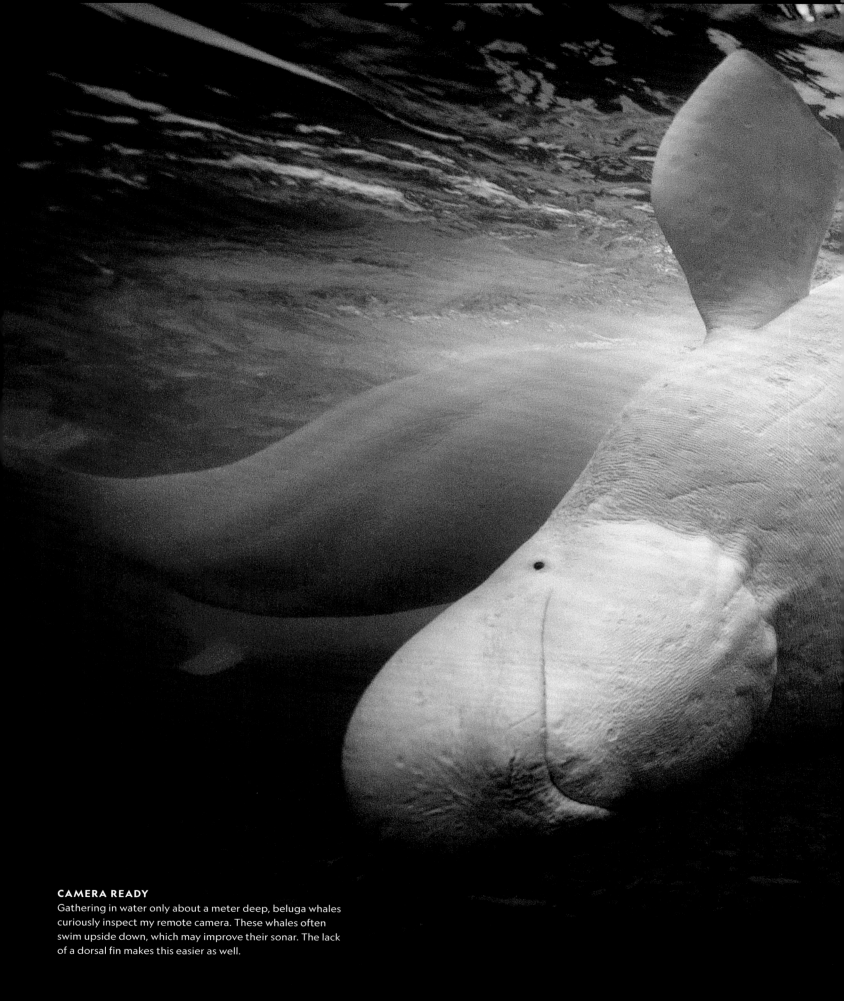

**CAMERA READY**
Gathering in water only about a meter deep, beluga whales curiously inspect my remote camera. These whales often swim upside down, which may improve their sonar. The lack of a dorsal fin makes this easier as well.

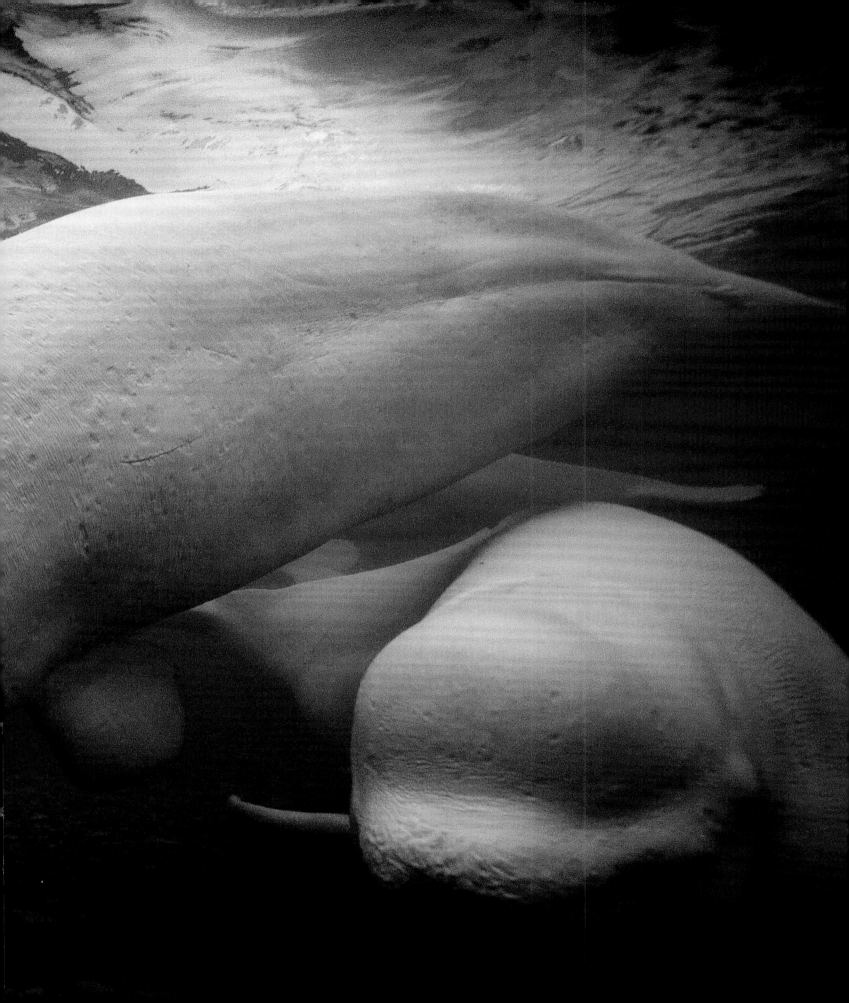

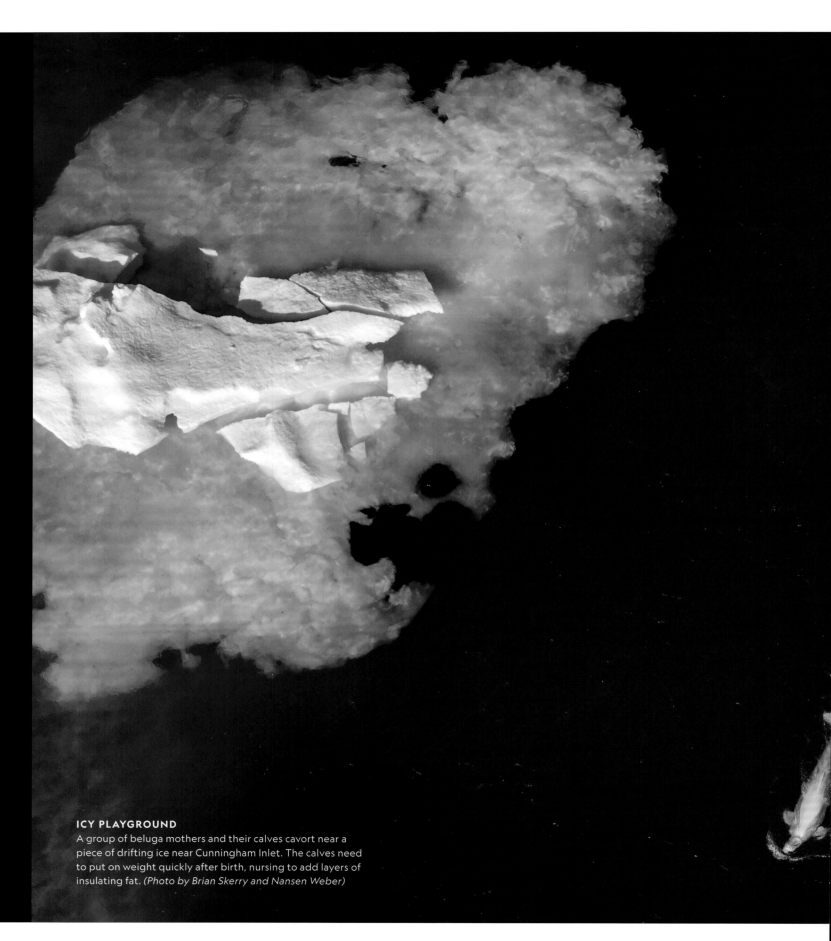

**ICY PLAYGROUND**
A group of beluga mothers and their calves cavort near a piece of drifting ice near Cunningham Inlet. The calves need to put on weight quickly after birth, nursing to add layers of insulating fat. *(Photo by Brian Skerry and Nansen Weber)*

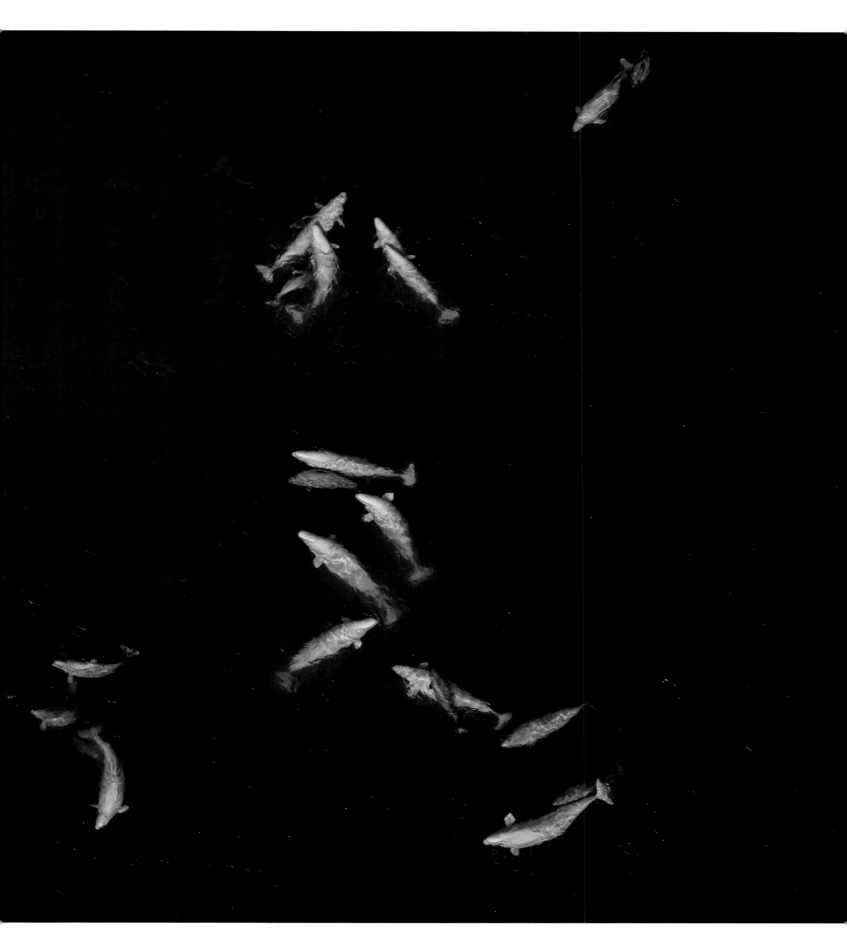

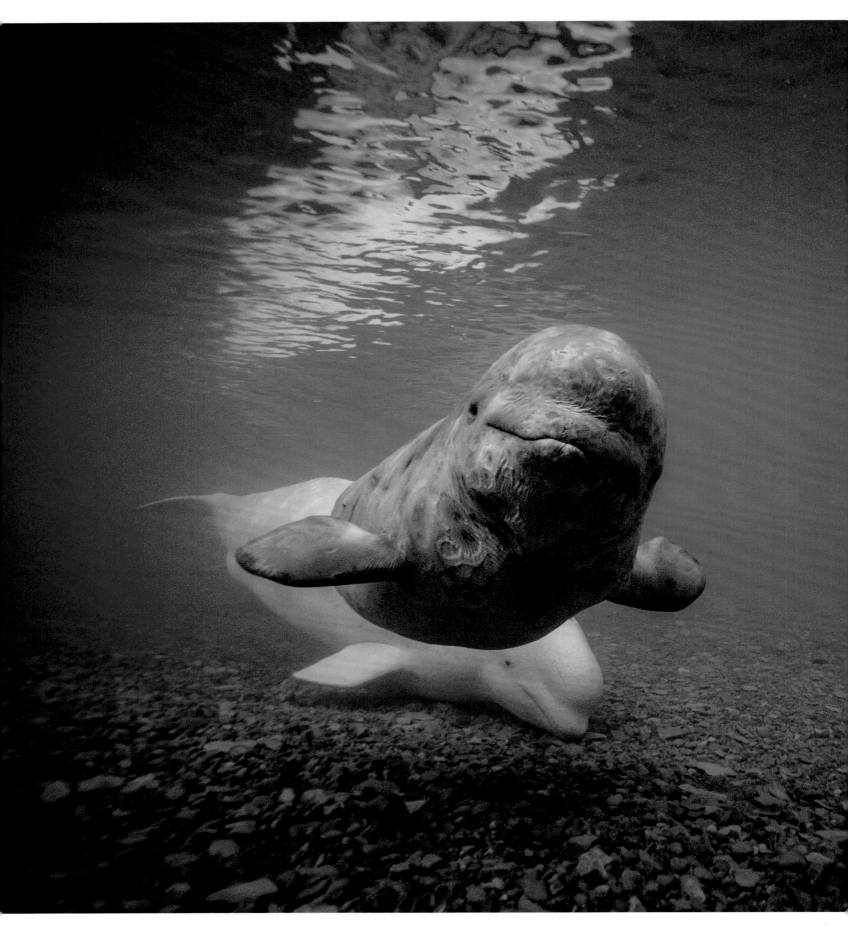

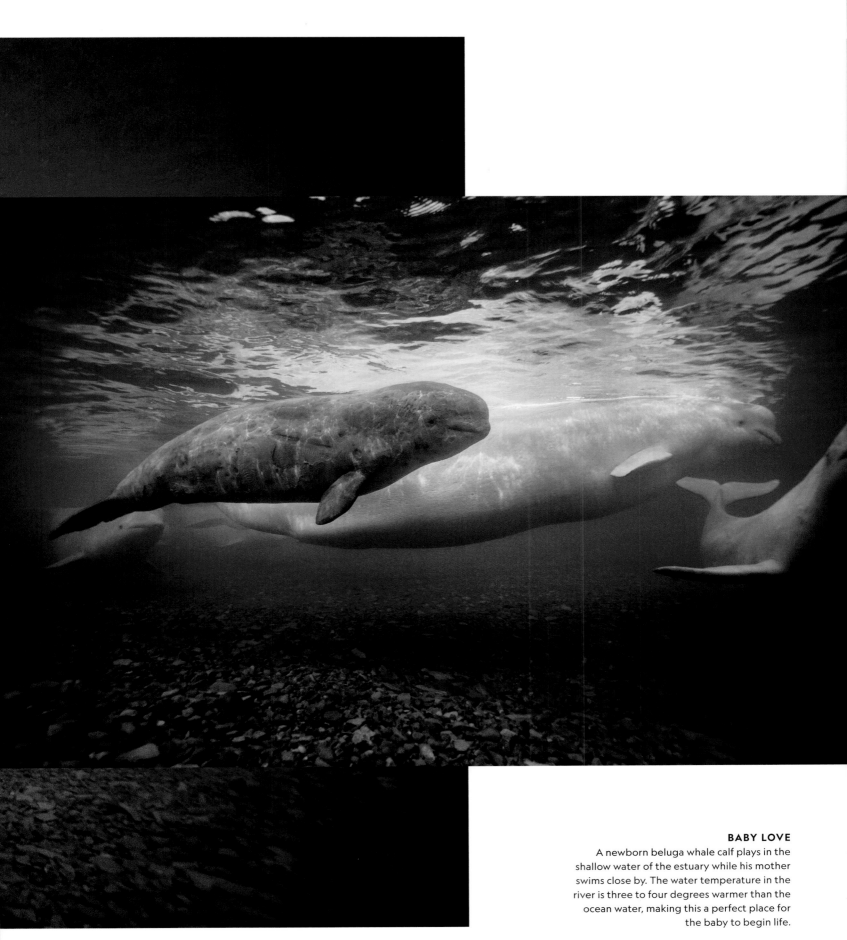

**BABY LOVE**
A newborn beluga whale calf plays in the shallow water of the estuary while his mother swims close by. The water temperature in the river is three to four degrees warmer than the ocean water, making this a perfect place for the baby to begin life.

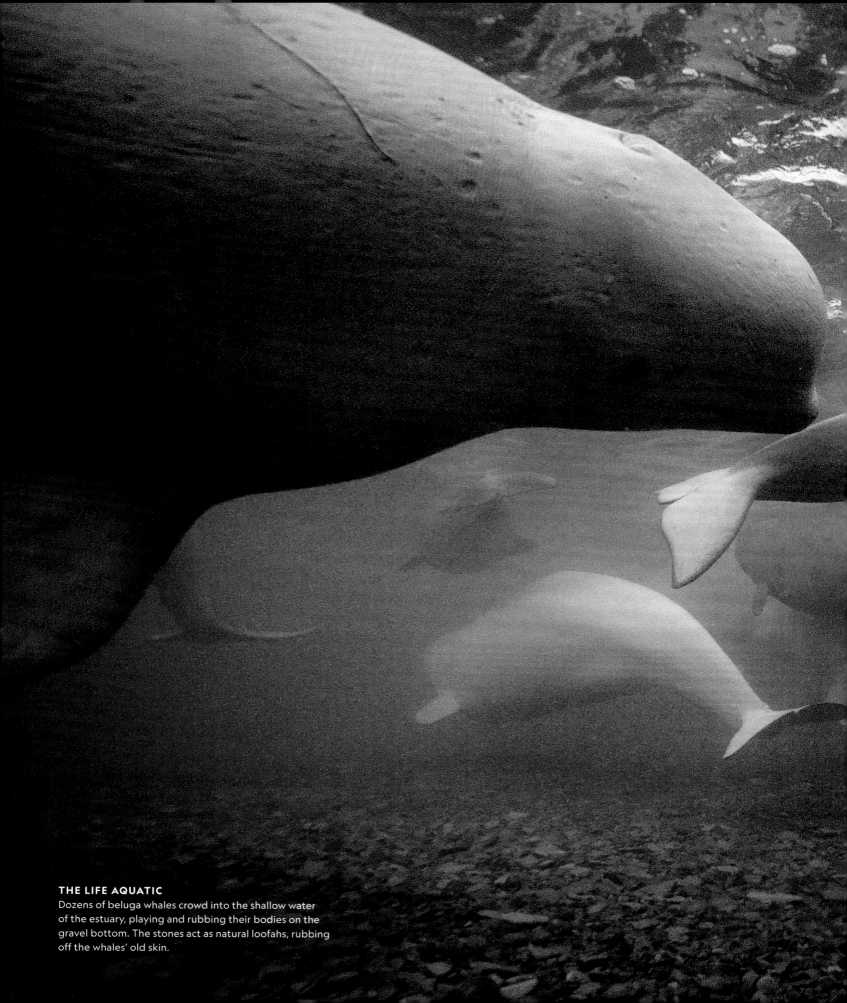

**THE LIFE AQUATIC**
Dozens of beluga whales crowd into the shallow water of the estuary, playing and rubbing their bodies on the gravel bottom. The stones act as natural loofahs, rubbing off the whales' old skin.

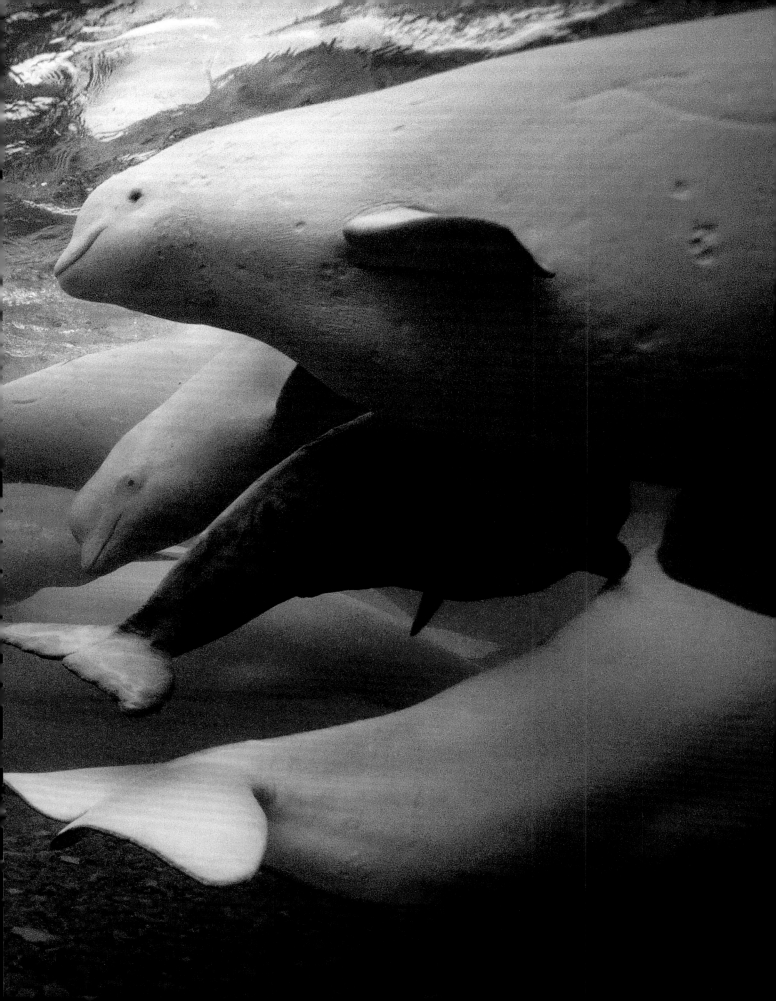

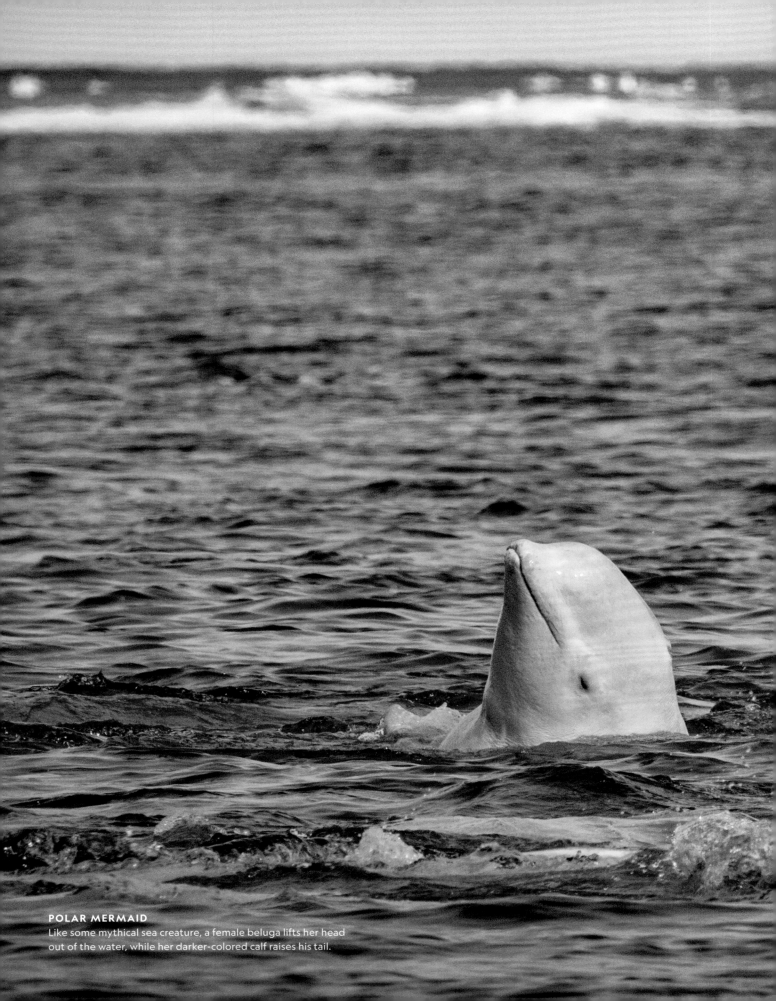

**POLAR MERMAID**
Like some mythical sea creature, a female beluga lifts her head out of the water, while her darker-colored calf raises his tail.

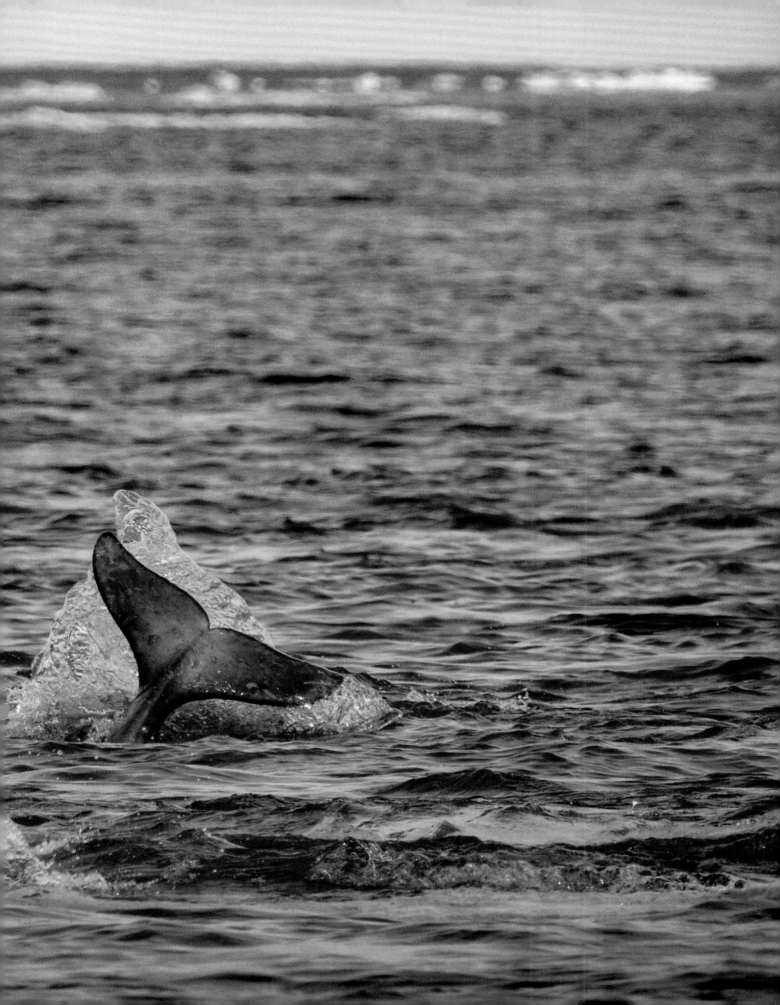

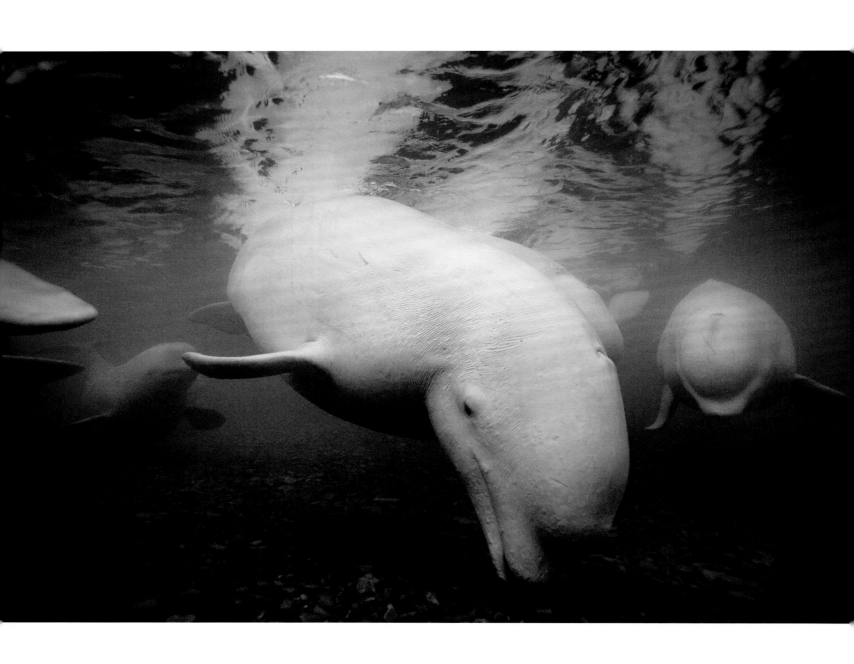

**GAME OF STONES**
An adult beluga delicately picks up a small rock from the gravel bottom in game play never before photographed underwater.

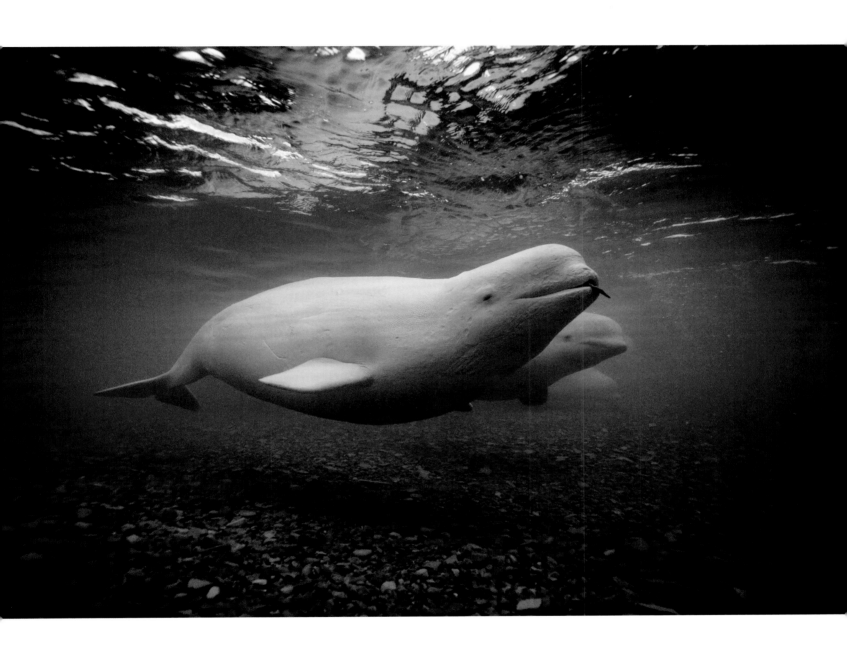

**GAME PLAN**
Similar to the way dolphins play with seaweed, belugas often swim with a small stone in their mouths, eventually dropping it to be picked up by another whale.

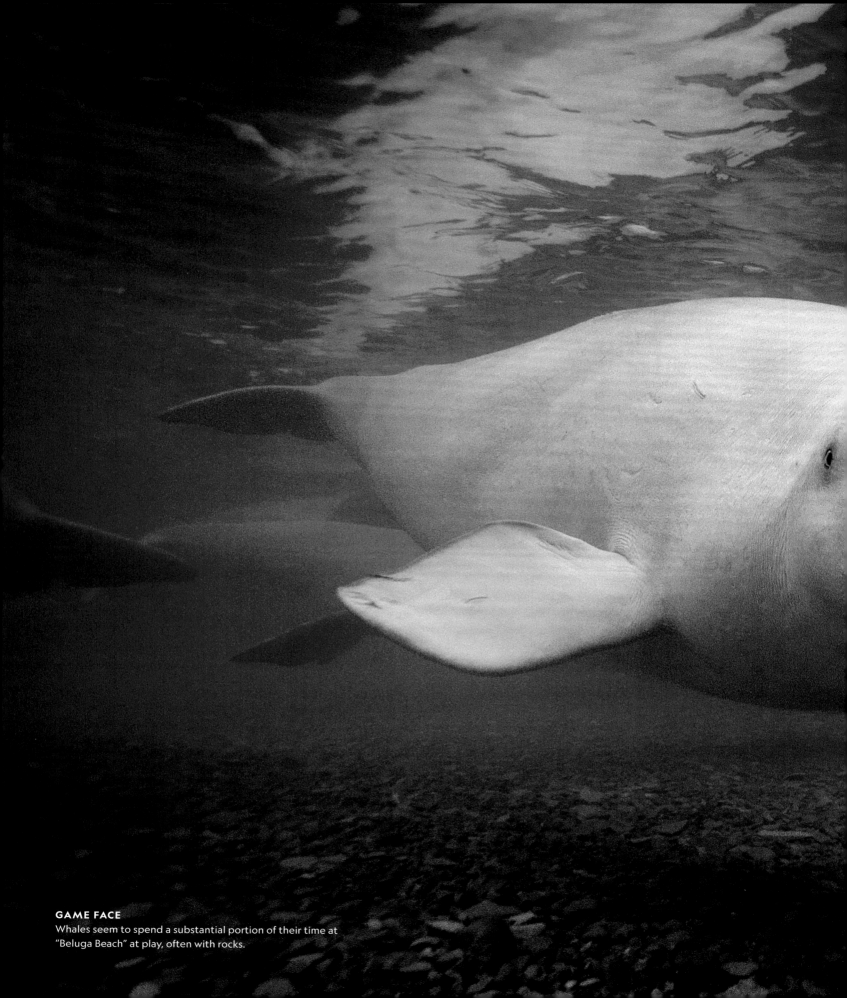

**GAME FACE**
Whales seem to spend a substantial portion of their time at "Beluga Beach" at play, often with rocks.

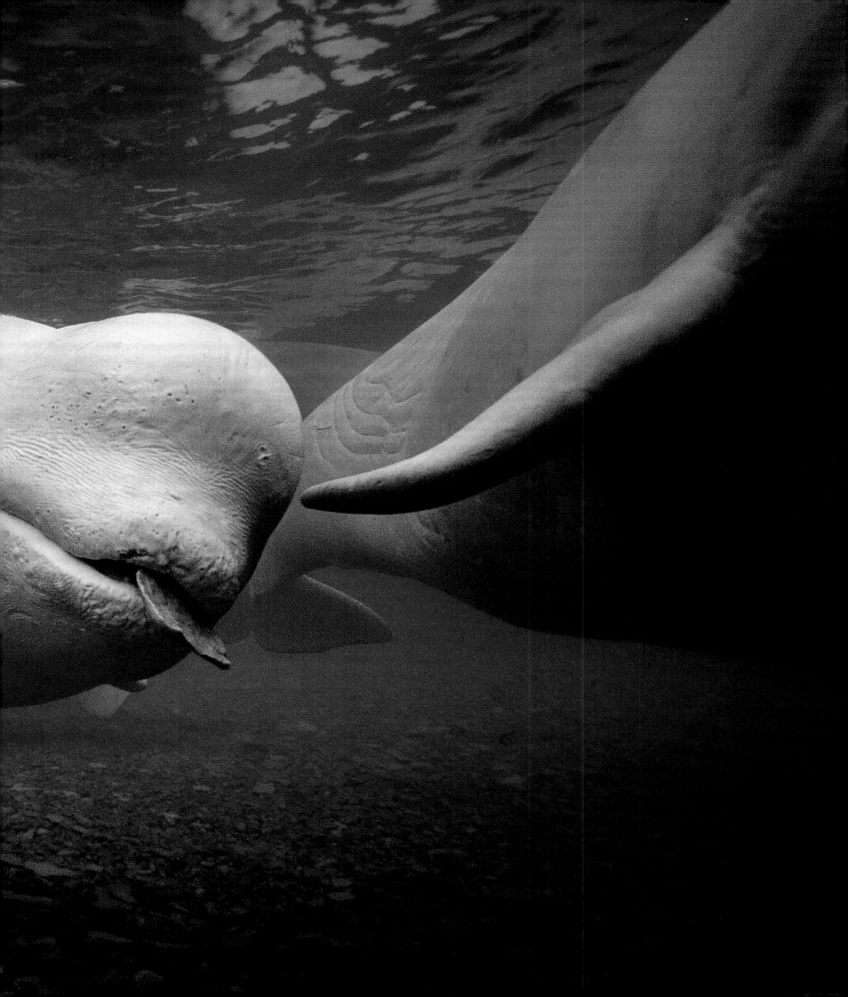

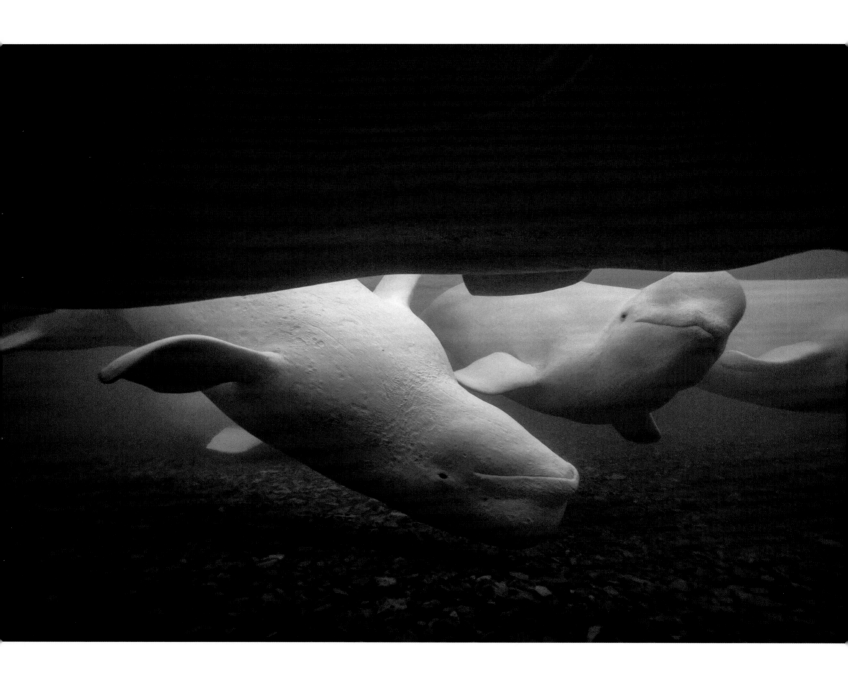

**IN FOCUS**
I feared these belugas might ignore my specially designed, remote underwater housings. Thank goodness, the opposite was true; they were extremely curious and frequently hammed it up for the cameras.

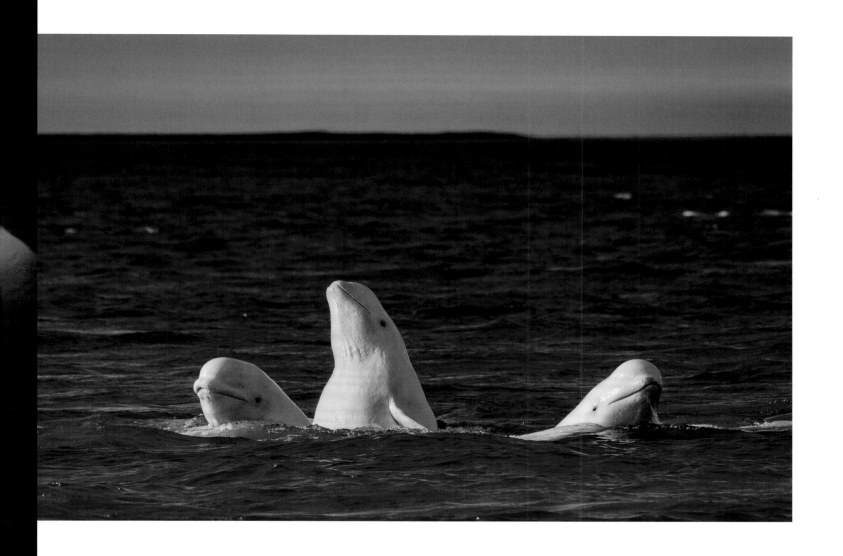

**TRIPLE THREAT**
In the slightly deeper water farther from shore, adult belugas frequently socialize and play. Their winters are spent in complete darkness so in the summer, they seem to love soaking up the sunshine, their heads often above water.

# BEHIND **THE SHOT**

After years of planning, I was finally headed to Somerset Island in the Canadian High Arctic to photograph beluga whales. Their unique culture was of great interest to me, and I had never seen underwater photos from this place. Working with me was Nansen Weber, of the famed family of polar explorers, whose local knowledge was invaluable. He explained that diving with belugas here simply was not possible.

Nansen had experimented with a semi-remote camera years before, with good results. So I built a system I thought might work: one that could be placed passively underwater for extended periods of time. My hope was to capture candid behavior of belugas without human presence.

A primary challenge was the water itself; although it looked clear from the surface, most of the time it was not, because the mixing of sea and river water makes for poor underwater visibility. Scrolling through hundreds of frames following my first attempts, I felt like I had been kicked in the gut. The whales were there, playing over the gravel bottom, but the images I took looked as if I'd been shooting through colorless Jell-O; every picture was unusable. I had finally made it here, the whales were here, and my new cameras worked. But something I had never anticipated seemed poised to torpedo everything.

Refusing to quit, Nansen and I studied the tides and geography of the river and bay. After much trial and error, we found locations with occasional patches of clear water. The results are beyond anything I ever imagined.

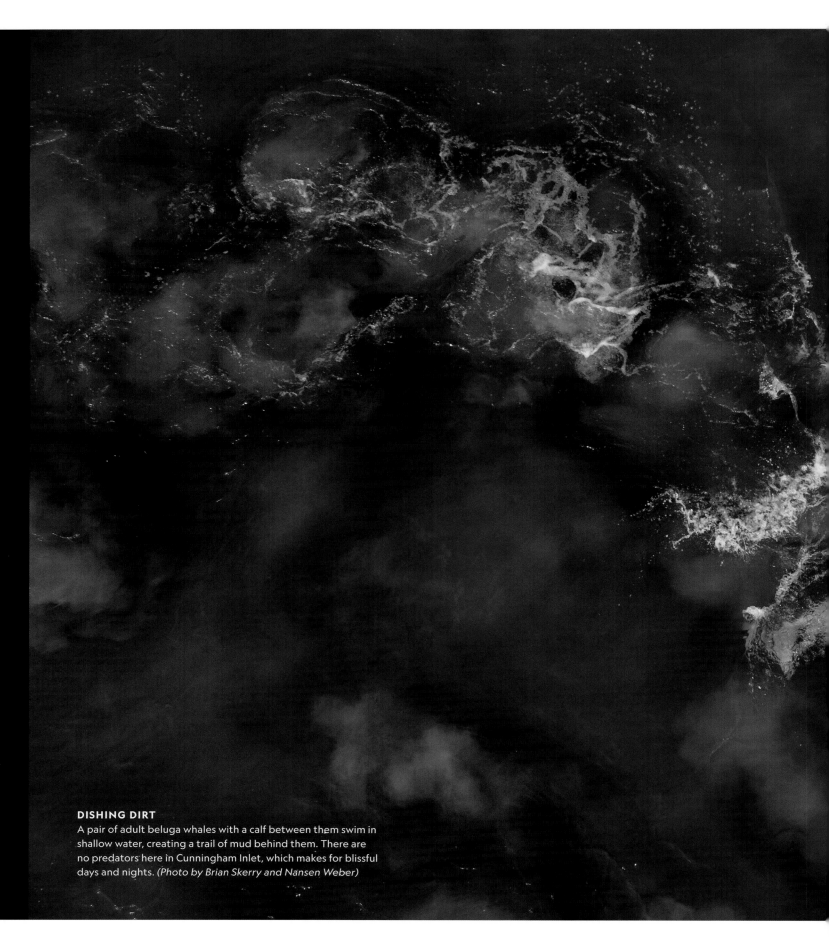

**DISHING DIRT**
A pair of adult beluga whales with a calf between them swim in shallow water, creating a trail of mud behind them. There are no predators here in Cunningham Inlet, which makes for blissful days and nights. *(Photo by Brian Skerry and Nansen Weber)*

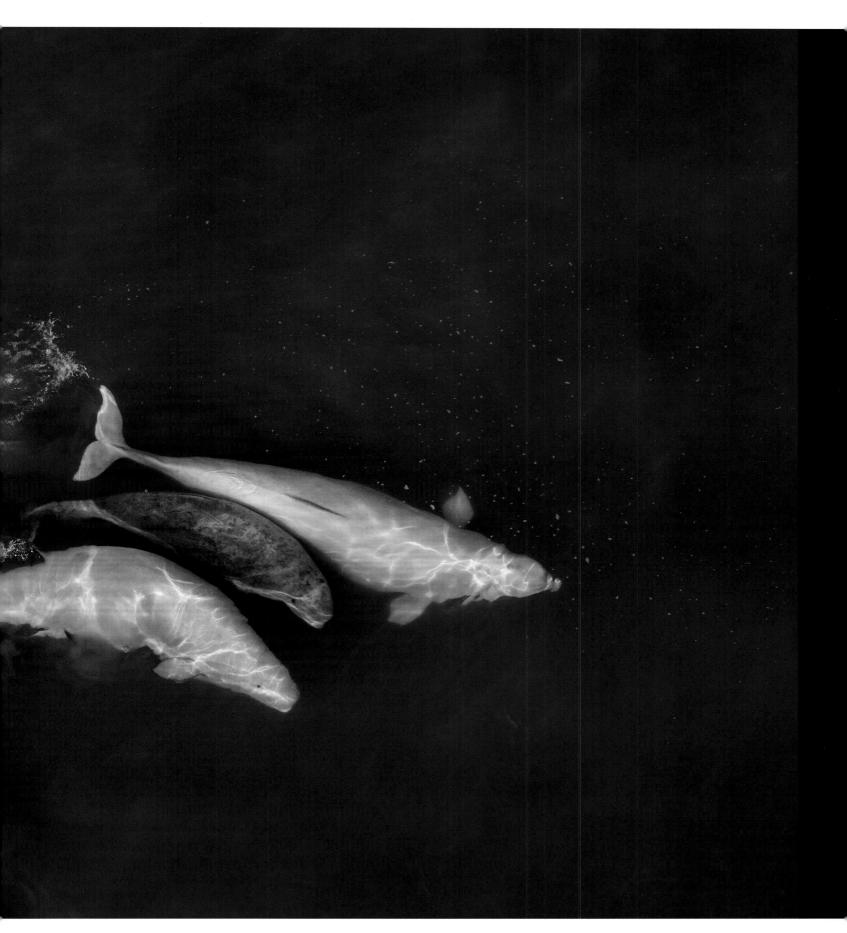

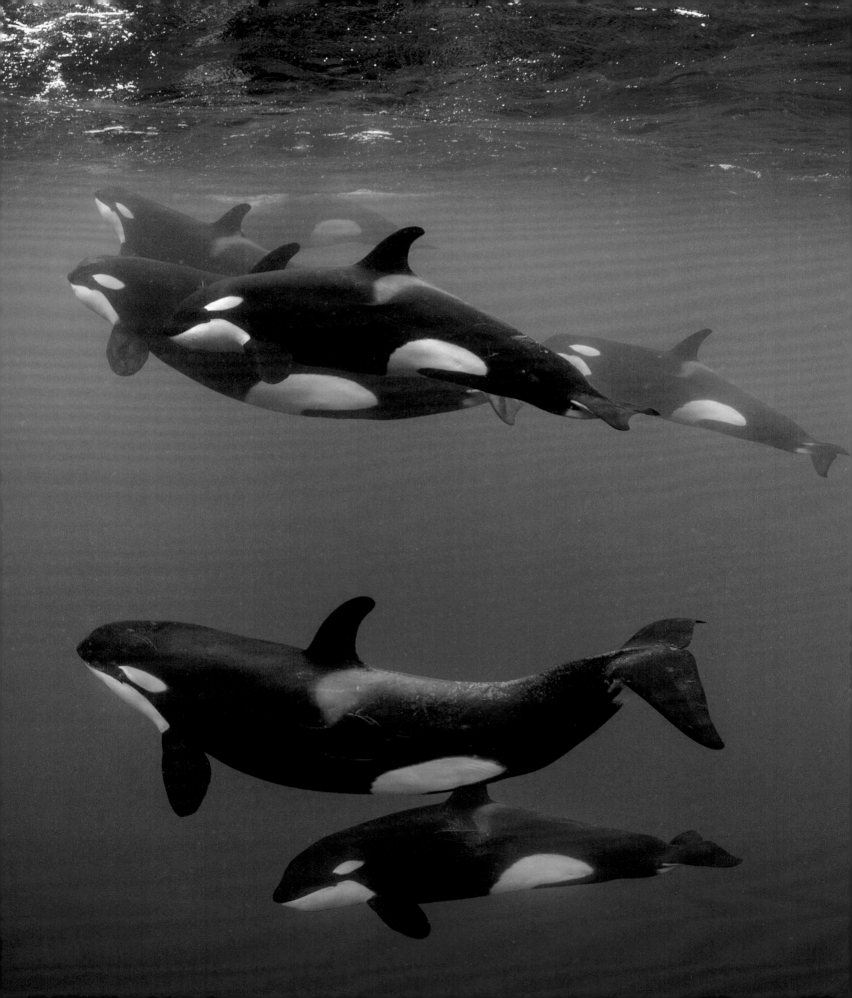

# HUNTERS WITH **A HEART**

When it comes to blood sport, orcas are capable of just about anything. They can kill a shark with a flick of their tail. They eat seabirds and turtles, snatch sea lions from shore, and even bring down other whales.

Working together in small groups, these sleek, calculating animals dream up endlessly clever ways to find food. Their distinctive feeding strategies reveal sophisticated cultures shaped by a level of intelligence and creativity not seen in any other marine mammal.

Found in every ocean in the world, orcas are the largest dolphin species. They live 50 to 80 years in the wild, can weigh six tons, and have teeth up to four inches long. Grouped in pods of up to 40 animals, some families stay in one place for most of their lives, while others are transient, roaming the seas like roving wolf packs. Resident populations tend to eat fish, whereas the nomads go for marine mammals. All orcas use sound and sonar—detecting objects by sending out high-frequency sound waves

**ORCA**
*Orcinus orca*
**AVERAGE SIZE:** 23–32 feet
**AVERAGE WEIGHT:** Up to 6 tons
**LIFE SPAN:** 50–80 years
**IUCN STATUS:** DD

and listening for the echoes—to find prey.

Orcas, also known as killer whales, are some of the world's most powerful predators. But they have a surprising finesse and flexibility in how they go about their work. They have different food preferences depending on where they live. In Argentina, a single family of orcas grabs sea lions right off the beach. In New Zealand, orcas go for stingrays, flipping them over to immobilize them and then ripping out their livers. In Antarctica, a pod of orcas swims together to create a pressure wave to knock a seal off an ice floe; they then attack the animal as it swims away. And in Mexico, orcas hunt gray whale calves as they make their first migration up the Pacific coast to Alaska.

It's not just that orcas target food both tasty and available. It's how they do it—and how those tactics persist for generations. A small group of orcas in the Falkland Islands have come up with a cunning way to feed on elephant seal pups. One older female in the family swims through a narrow channel into a weaning pool

A chance encounter with a pod of orcas in the waters of the eastern Caribbean

where the seal pups play. The whale approaches sideways so her dorsal fin isn't showing and the seals cannot see her. She grabs a pup and drags it offshore, where the rest of her family waits.

For an hour she toys with the pup, who eventually dies, teaching her family how to grab the animal and pull it. It's tortuous for the pup (and for any humans who happen to be watching), but it's vital knowledge for the young orcas. This is how they learn to hunt live prey. As far as we know, the Falkland Islands is the only place in the world where orcas hunt this way. And they've done it for decades.

Even more interesting is that these animals change their behavior when necessary—or when better options come along. Orcas in the Norwegian Arctic have long worked cooperatively by flashing their white underbellies to scare herring into a tight bait ball, whacking it with their tails to pick off the fish. This manner of feeding has gone on for decades. But in recent years, these same orca groups seem to favor takeout. They now loiter near fishing boats that bring in tons of herring; when fish spill out of the net, they are perfectly positioned to grab free lunch.

To be noticed by an orca is both extraordinary and unnerving. Though not the biggest whale species, a 30-foot orca is eight feet thick, and that bulk, along with its speed, puts any diver on notice. Orcas are always moving, always clicking in their unique dialects, always alert. Their dark eyes don't miss a thing. When they come close to check me out, it's as though I'm being scanned by a supercomputer. They seem to know what I'm think-

ing and feeling—right down to what I had for dinner.

In Norway, I swam with orcas who trail fishing boats hoping for a herring snack. Free diving 20 feet down in the green, murky water, I could see the whales below me, circling the net where fish were slipping out. They seemed to regard me as an interesting but harmless presence, as though I were an inefficient sea lion.

But when I came back down an hour later with a scuba tank on, hoping to make better pictures, that vibe shifted in an instant. Suddenly I was a competitor. There I was, just a few feet away from the fish these whales wanted to eat. I focused my camera on a herring that had slipped from the net a few feet in front of me. A whale swam over, and through its eyes, posture, and body language, I had no trouble interpreting the look it gave me: "That's *my* fish, and I'm going to eat it."

Orcas appear to be quick studies in other ways. In just the last several years, they have begun moving into the Arctic as ice melts and new passages open up. And wherever they go, they bring their artful ways with them: They now rival the polar bear—the Arctic's longtime apex predator—and have also been spotted killing narwhal and beluga whales.

Current research shows that these orcas are now venturing farther north than they ever have before. How did they make this decision? Was it curiosity, an accidental discovery, or some other finely tuned sense that told them where to go? How will their presence affect the delicate web of life in the changing Arctic? We don't yet have the answers.

# TO BE NOTICED BY AN ORCA IS BOTH EXTRAORDINARY AND UNNERVING. THOUGH NOT THE BIGGEST WHALE SPECIES, A 30-FOOT ORCA IS EIGHT FEET THICK, AND THAT BULK, ALONG WITH ITS SPEED, PUTS ANY DIVER ON NOTICE. ORCAS ARE ALWAYS MOVING…ALWAYS ALERT. THEIR DARK EYES DON'T MISS A THING.

But being smart and intrepid doesn't protect orcas from the dangers of an industrialized ocean. Like other whales, they become entangled in fishing nets and lines; noise from ships interferes with their ability to communicate, feed, and navigate. Toxins like mercury can get into their tissue, and eventually into mothers' milk. Mortality is tragically high among orca calves because the first drops of milk that mothers feed to their newborns are often so poisonous.

The intense bond between orca mothers and their calves is similar to that of humans. They have the longest gestation period of any cetacean—15 to 18 months—and calves nurse from their mothers for two years. Mothers are deeply protective of their young and show astonishing levels of empathy toward them.

I once saw an orca mother swimming through the frigid waters of the Norwegian Arctic, her dead calf draped over her head. Researchers thought the calf had died from toxins in its mother's milk. A dozen other whales surrounded the mother as she swam. I tried for hours to get close to the family; they didn't want my company.

Like others of her kind, this mother whale was a shrewd hunter with keen instincts. But as I watched her carry the calf for hours that day, clearly engaged in some sort of funeral procession, I thought about how these animals' relationships are nearly as complex as our own. Her reputation as a cold-blooded killer of the high seas seemed inappropriate; now, she was simply a parent mourning the loss of her baby, unwilling to let it go. ■

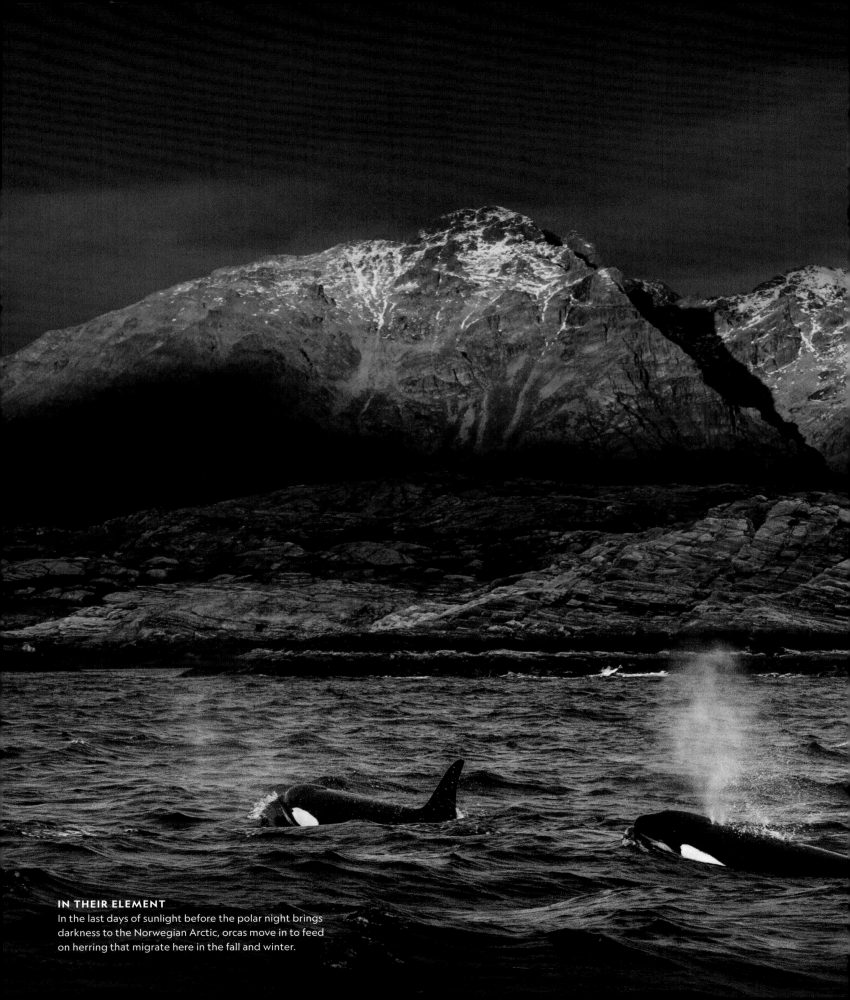

**IN THEIR ELEMENT**
In the last days of sunlight before the polar night brings
darkness to the Norwegian Arctic, orcas move in to feed
on herring that migrate here in the fall and winter.

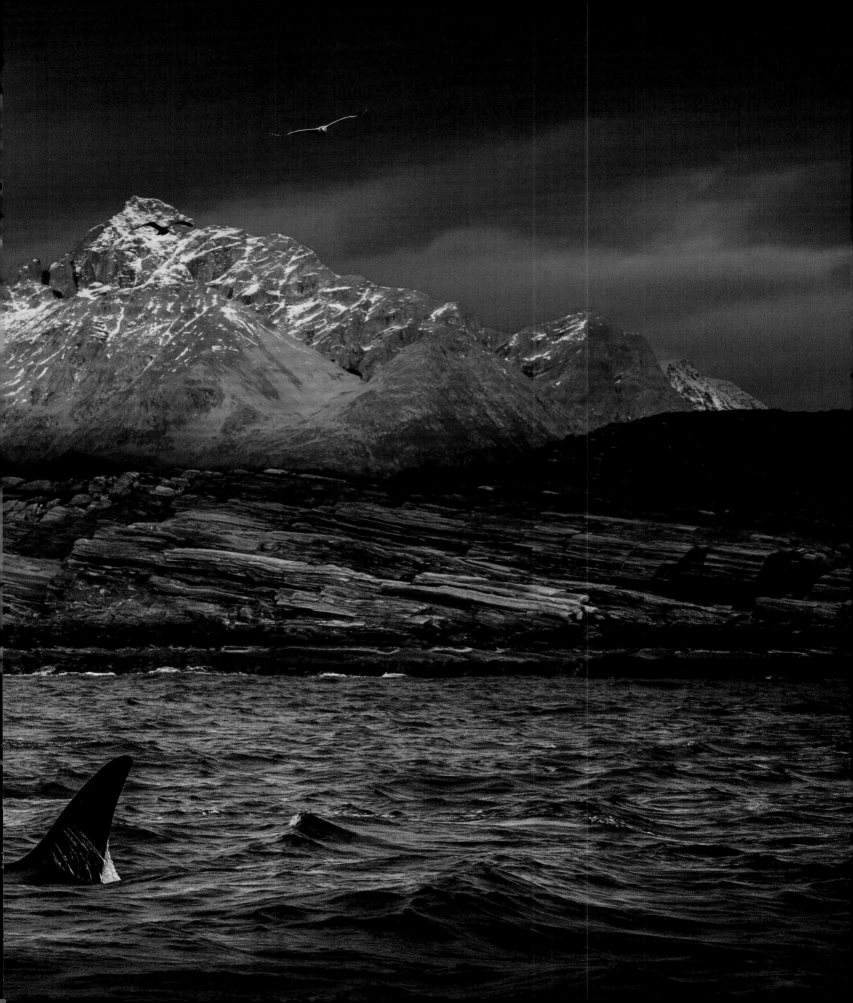

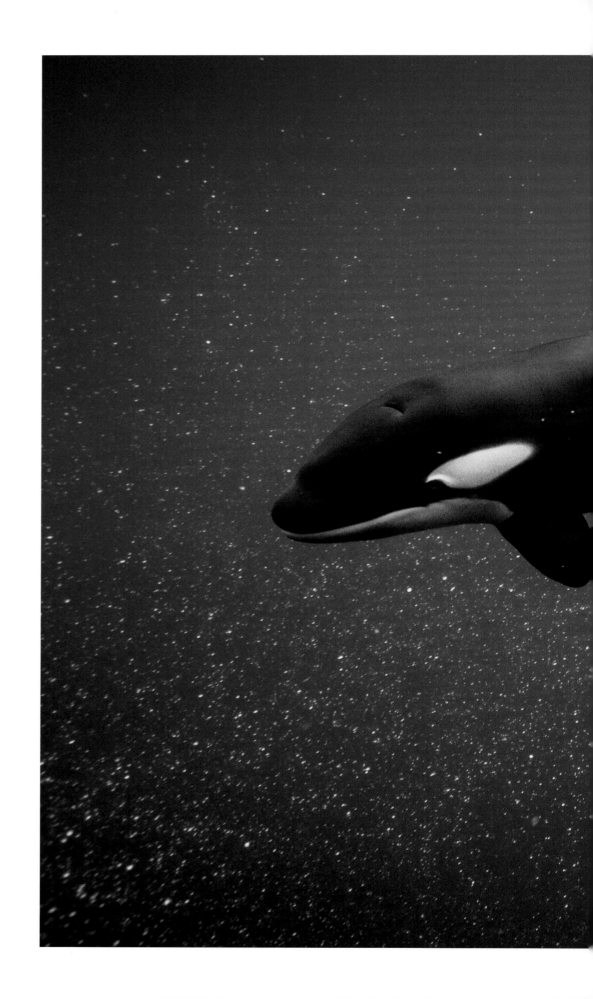

**INTO THE BLUE**
An orca calf swims ahead of two adults through a sea of fish scales in Norway. The scales fill the water column after a whale feeding.

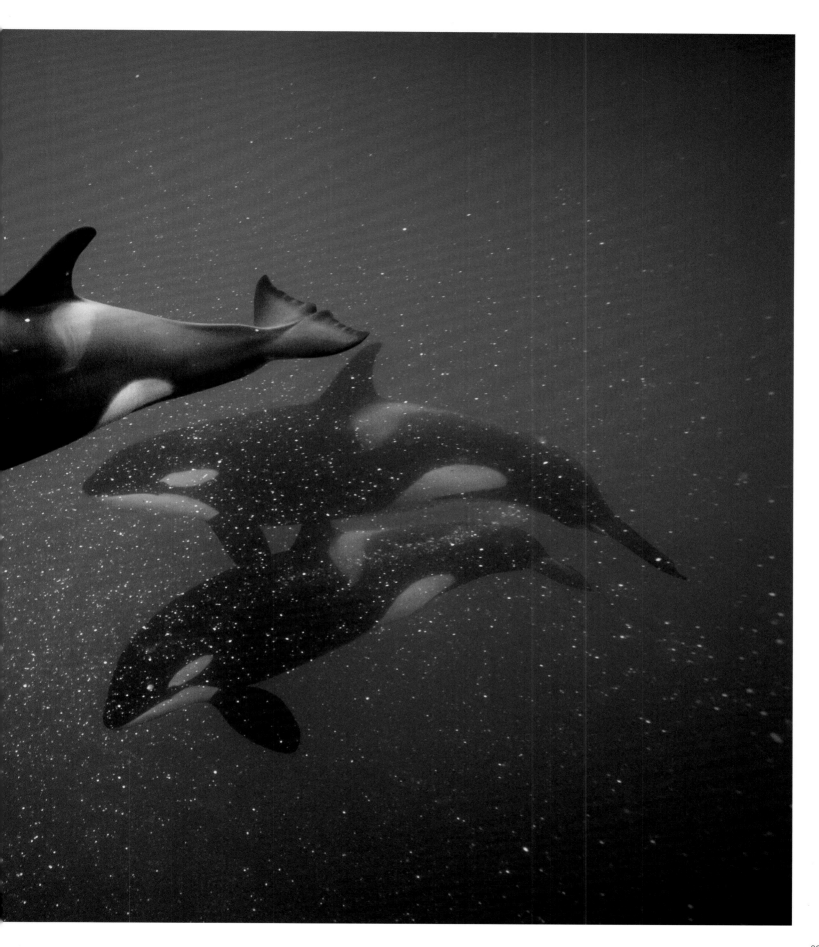

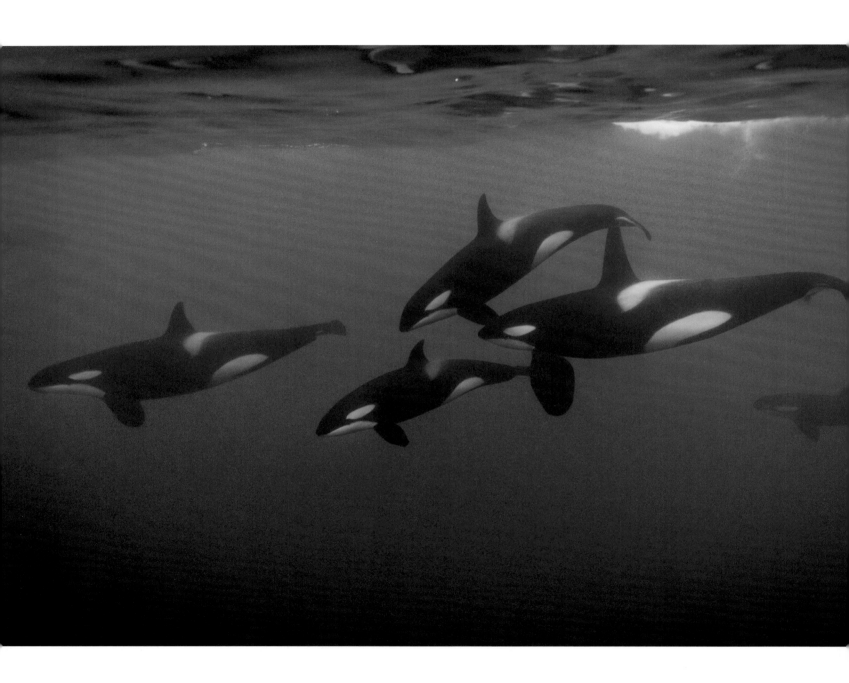

**IN MEMORIAM**
On a cold and dreary November day, I saw a family of orcas swimming through a Norwegian fjord; one of the adults was carrying a dead calf. It was difficult to get close and I did not wish to intrude, but I managed a photo of this somber procession.

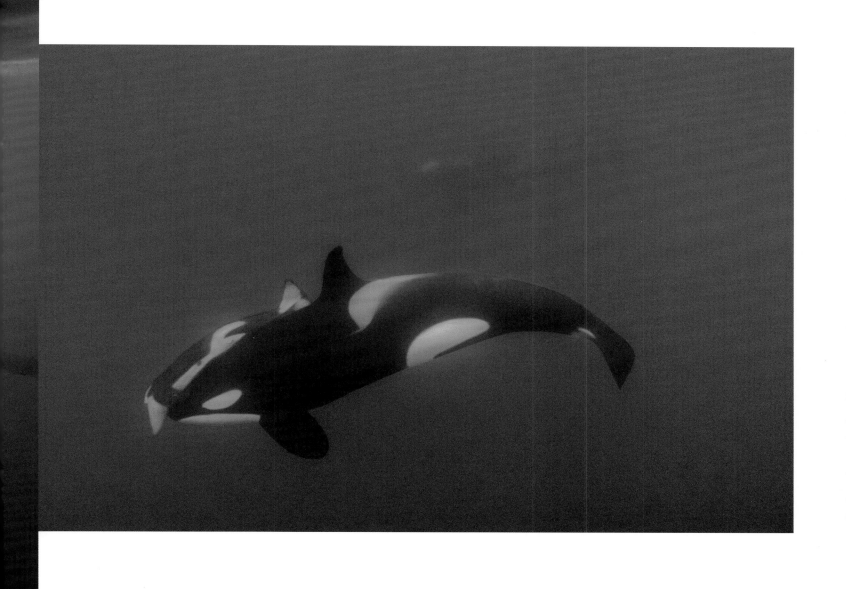

**REST IN PEACE**
The mother with her dead calf. I wished
I could convey my deep condolences.

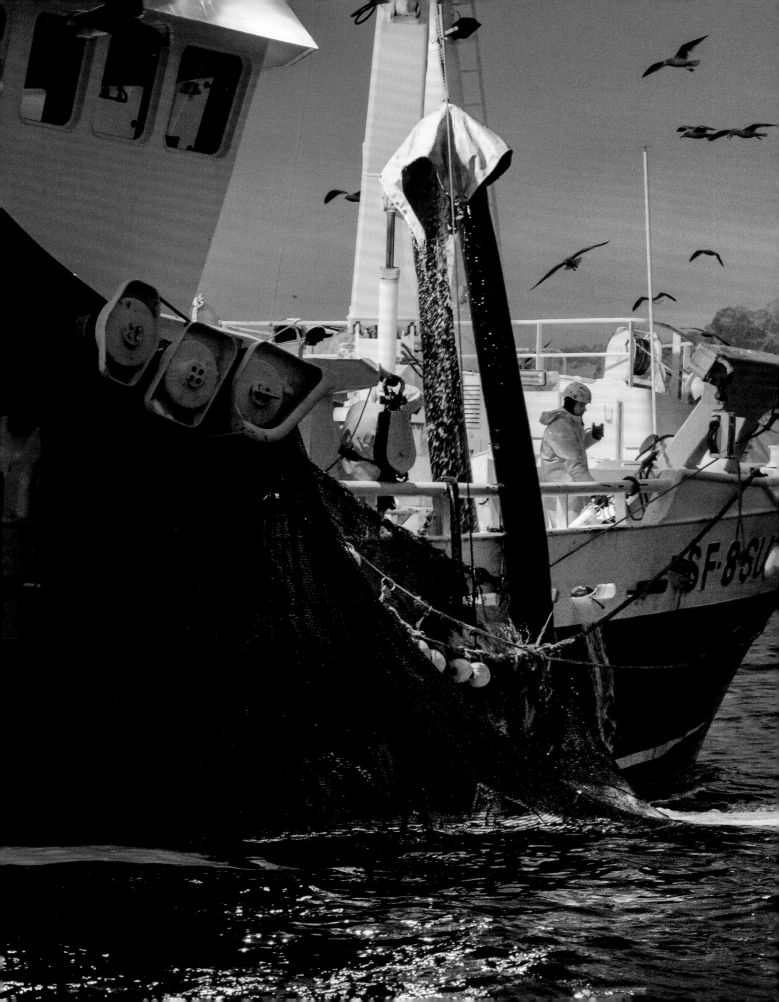

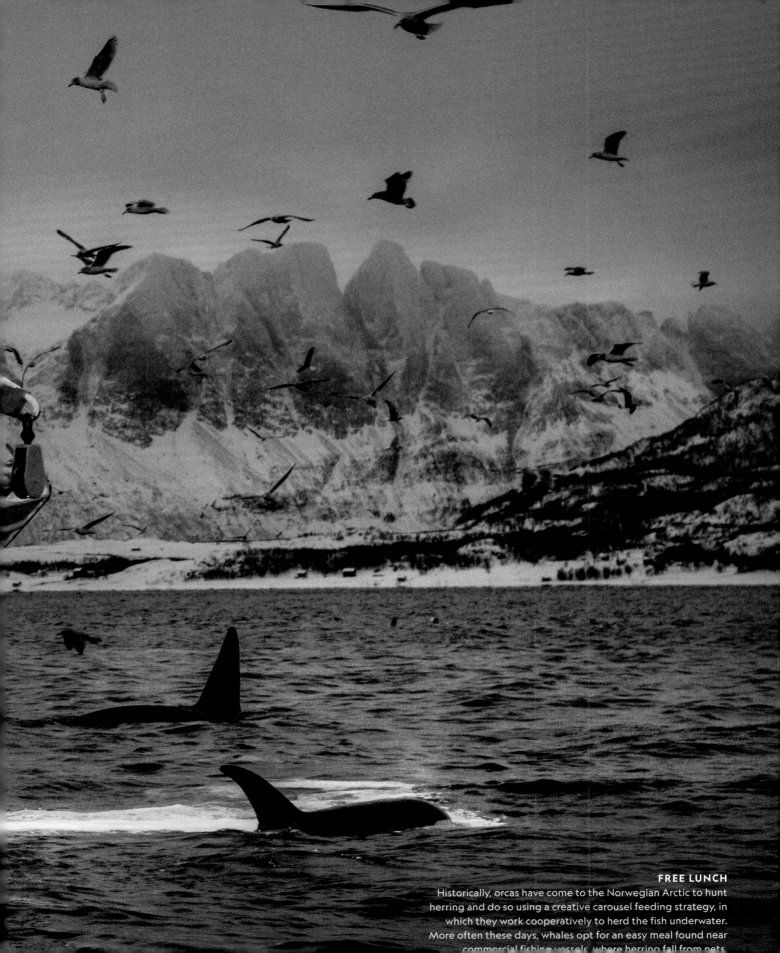

## FREE LUNCH

Historically, orcas have come to the Norwegian Arctic to hunt herring and do so using a creative carousel feeding strategy, in which they work cooperatively to herd the fish underwater. More often these days, whales opt for an easy meal found near commercial fishing vessels, where herring fall from nets.

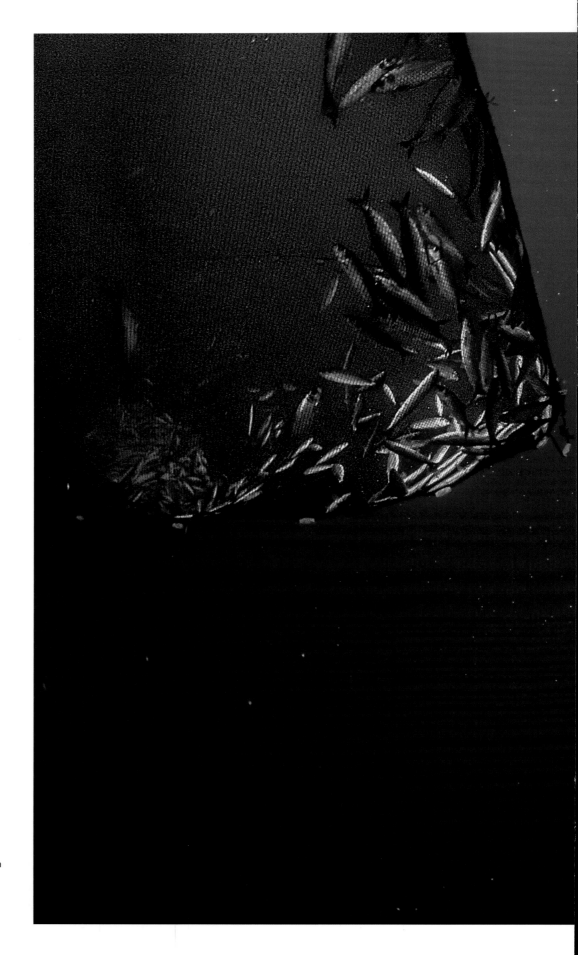

**FAST FOOD**
In the dark and chilly waters of the Norwegian Arctic, an orca moves in to eat a herring that has fallen out of a commercial fishing net. Feeding in this way uses far less energy than the orca's usual method of carousel feeding.

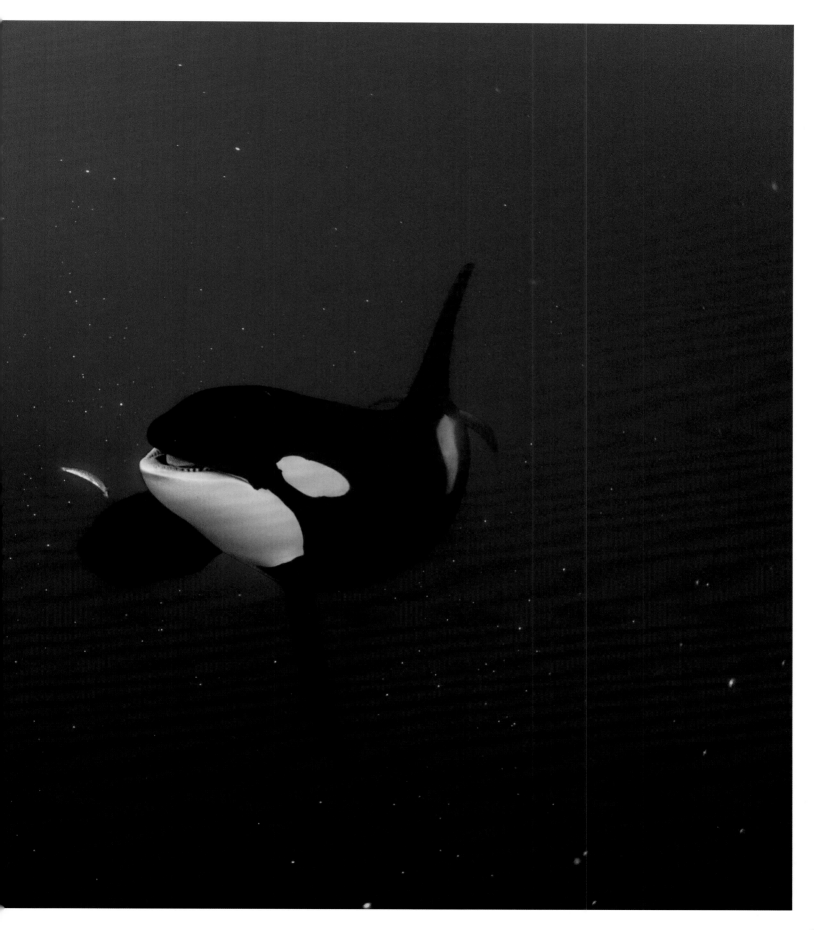

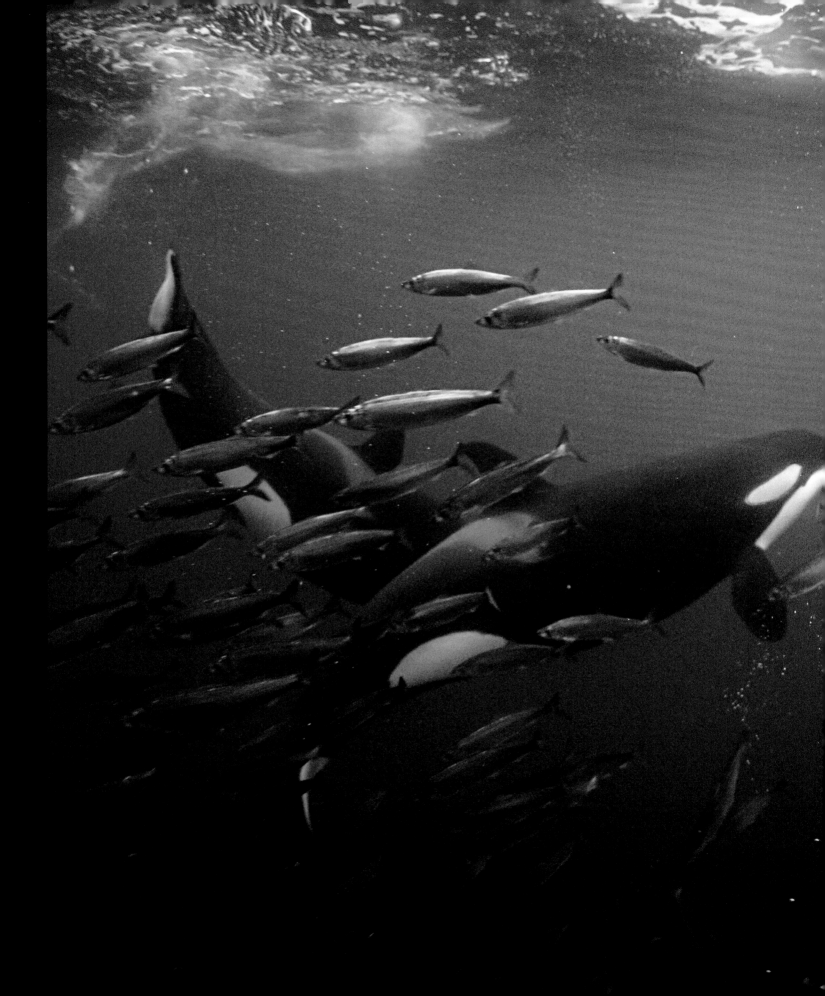

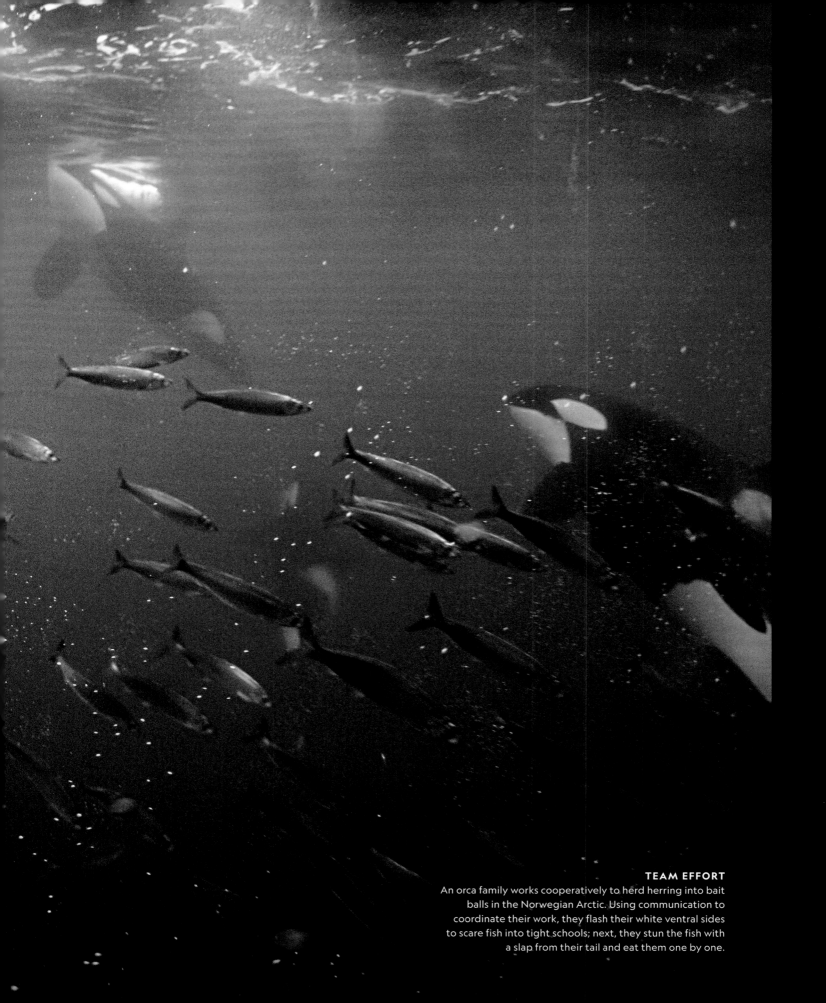

**TEAM EFFORT**

An orca family works cooperatively to herd herring into bait balls in the Norwegian Arctic. Using communication to coordinate their work, they flash their white ventral sides to scare fish into tight schools; next, they stun the fish with a slap from their tail and eat them one by one.

s jet-lagged and a little sleep-deprived, hav-
arrived in New Zealand after months of back-
ack fieldwork. But being at sea searching for
s had me turbocharged and raring to go. I
on a boat with Dr. Ingrid Visser, an orca
archer who has dedicated her life to study-
and protecting this species.

Ve found an orca family offshore and watched
m move toward the coast. Ingrid wanted
eraman Kina Scollay and me to be perfectly
tioned well ahead of the whales. Sliding off
boat, I saw a large, female orca swimming
ard me with a stingray in her mouth. She
ed up at me, then dropped the ray from her
th and watched it drift to the bottom.

swam directly to the ray, thinking the orca
t return. Looking over my shoulder, I saw her
mming toward me. She appeared massive,
ecially in this shallow water. Between us was
dead stingray. The orca hovered there for a
moments, as if to say, "Are you going to eat
? Because if you're not, I'll have it."

he gently moved toward the ray and picked
in her mouth. Lifting her head, she seemed
pause and consider me. Behind her was
her orca. Slowly, she turned to join her family
mber and share the food. Together, they
ppeared into the green sea.

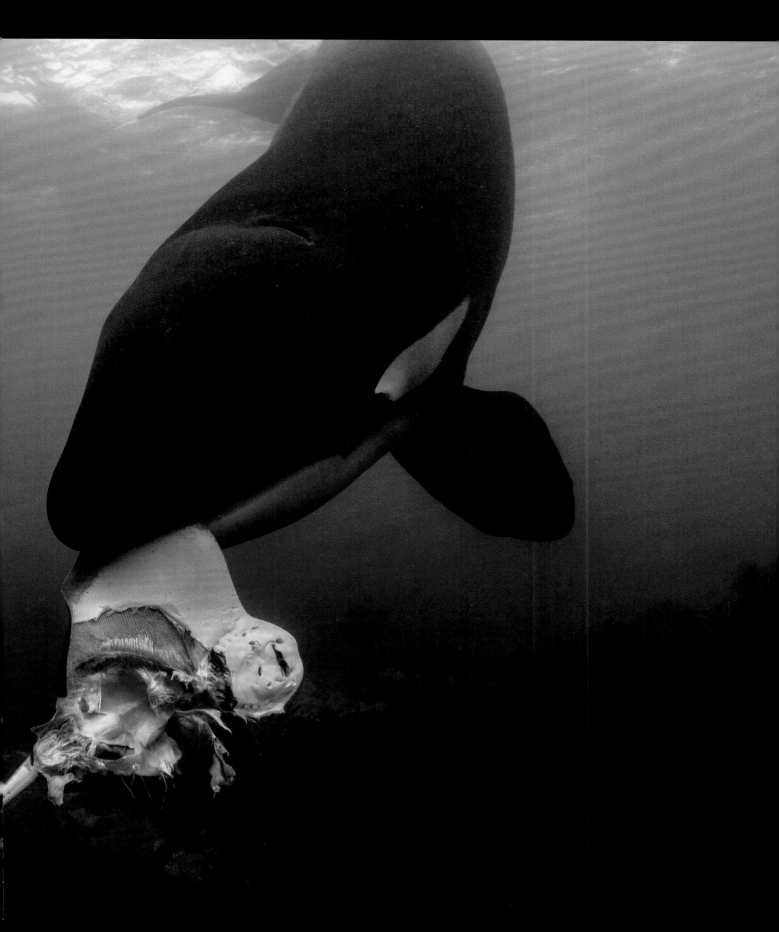

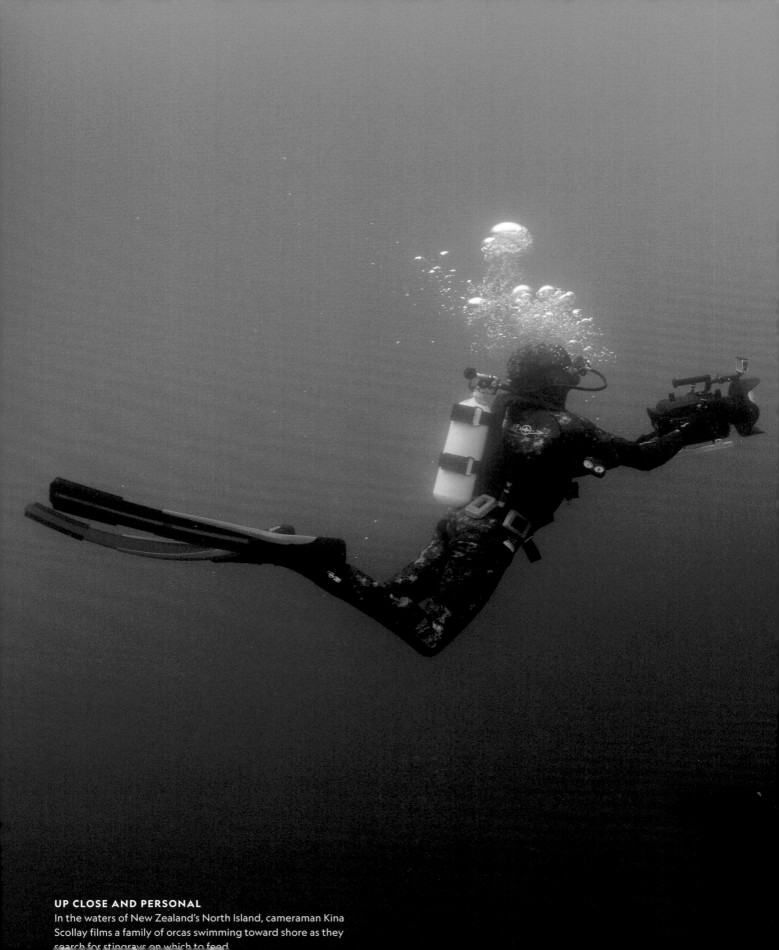

**UP CLOSE AND PERSONAL**
In the waters of New Zealand's North Island, cameraman Kina
Scollay films a family of orcas swimming toward shore as they
search for stingrays on which to feed.

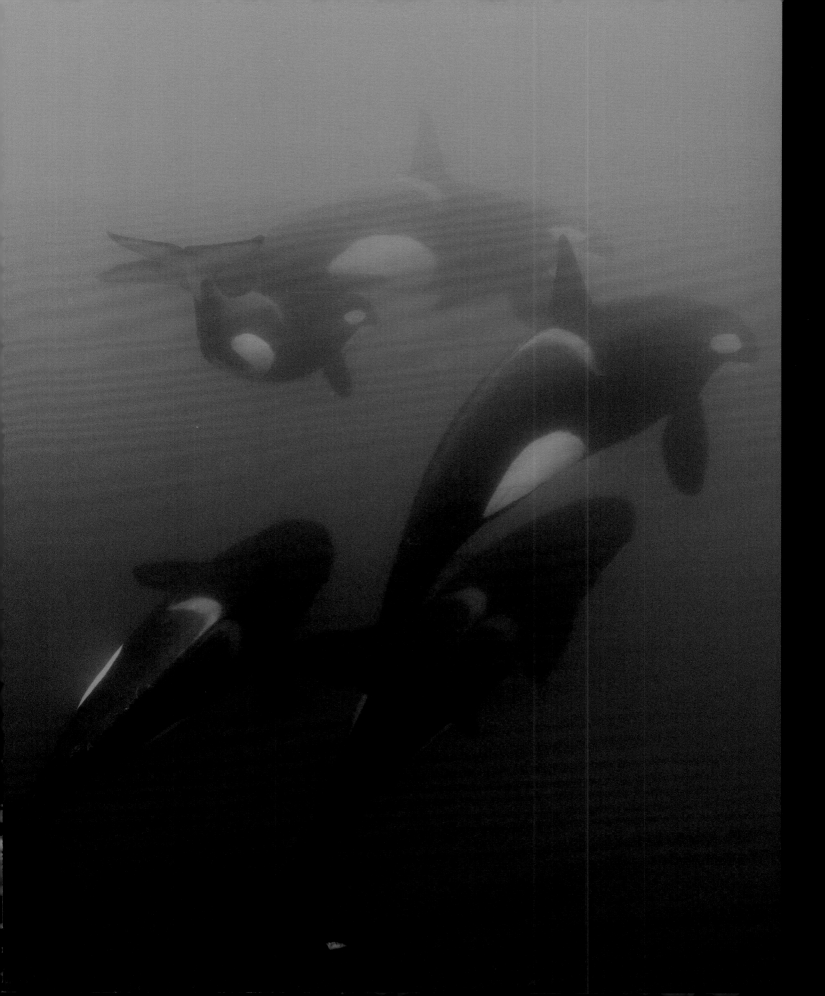

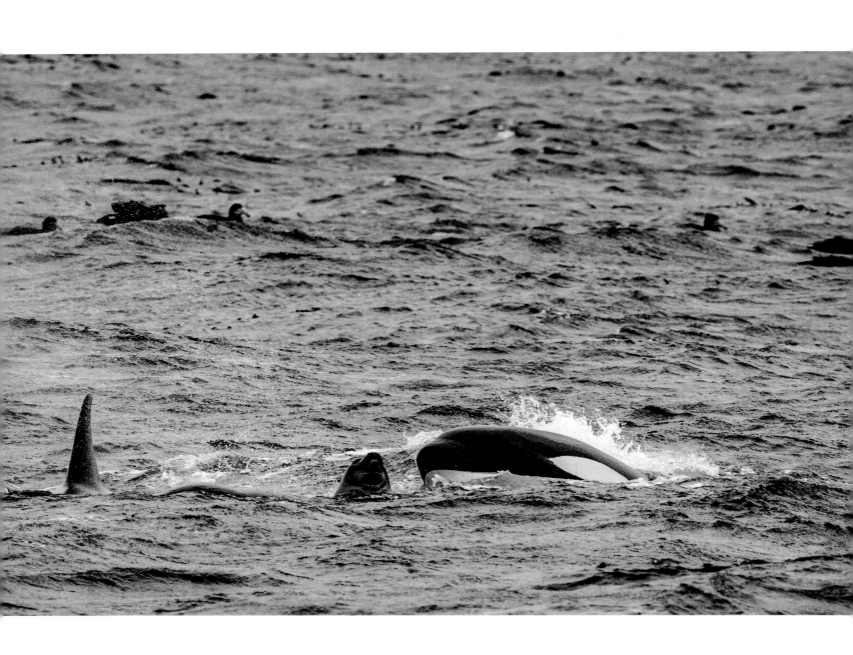

**LEARNING THE ROPES**

In the Falkland Islands, two families of orcas have devised a strategy for feeding on elephant seal pups. The matriarchal female grabs a pup that has entered the water of its protected weanling pool and brings it offshore to teach her family how to hunt.

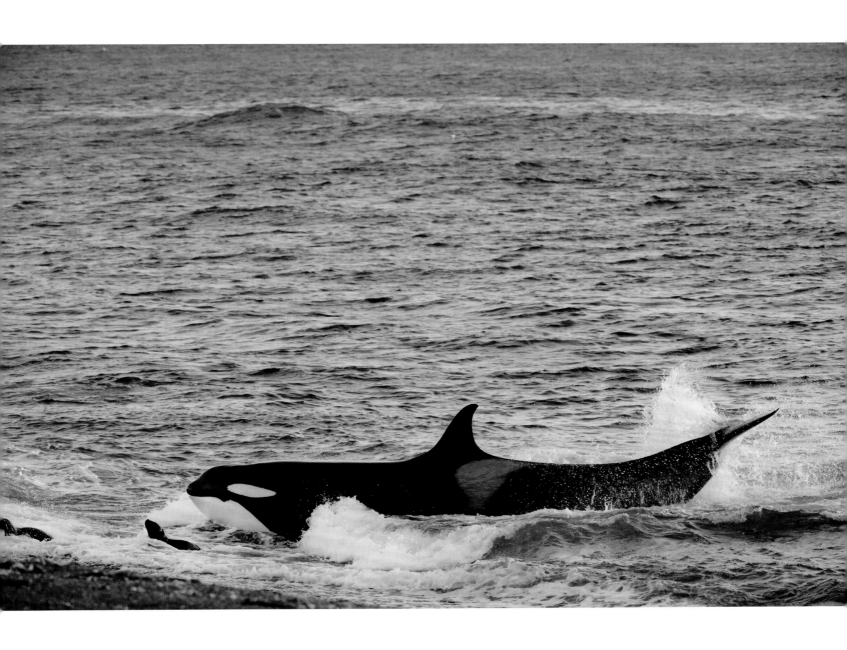

**HUNTING LESSONS**
At Punta Norte on the Valdes Peninsula in Argentina (Patagonia), a small number of orcas have created a unique feeding strategy, attacking southern sea lions on the beach. As with all whale feeding strategies, this is a learned behavior, with mothers teaching their calves the ropes.

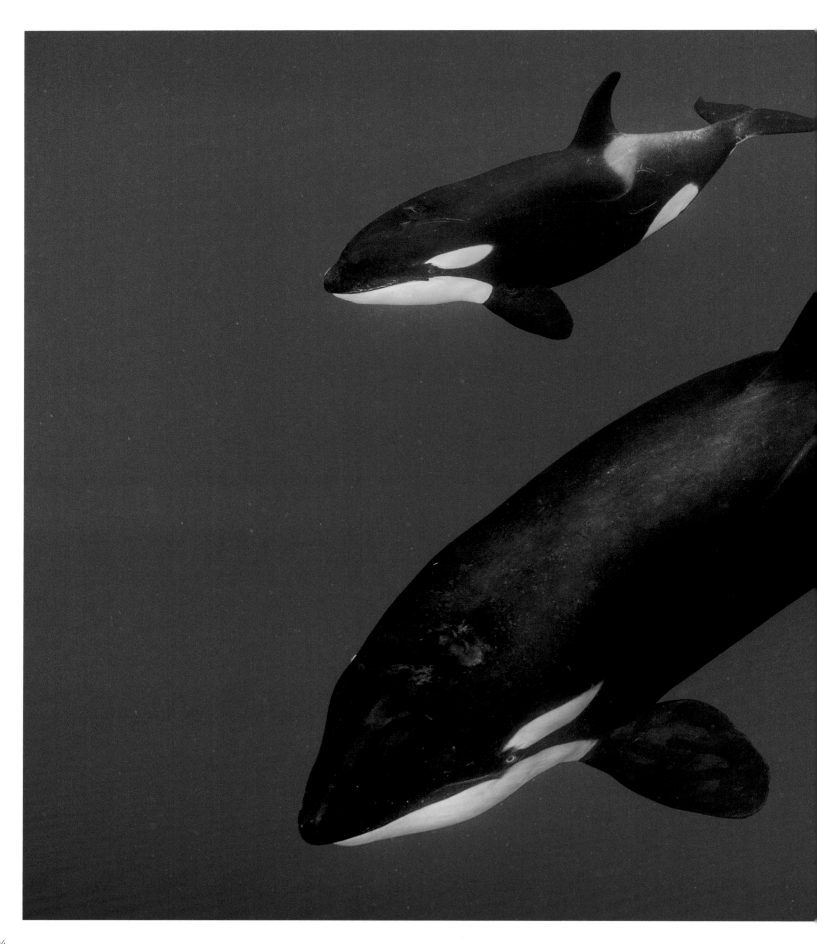

**OCEAN MAGIC**
In the Caribbean, I had an unexpected meeting with a family of orcas; to see them in the clear, blue water was awe inspiring. These are arguably the most intelligent animals in the sea, and in their presence, their endless capabilities are clear.

# SPERM

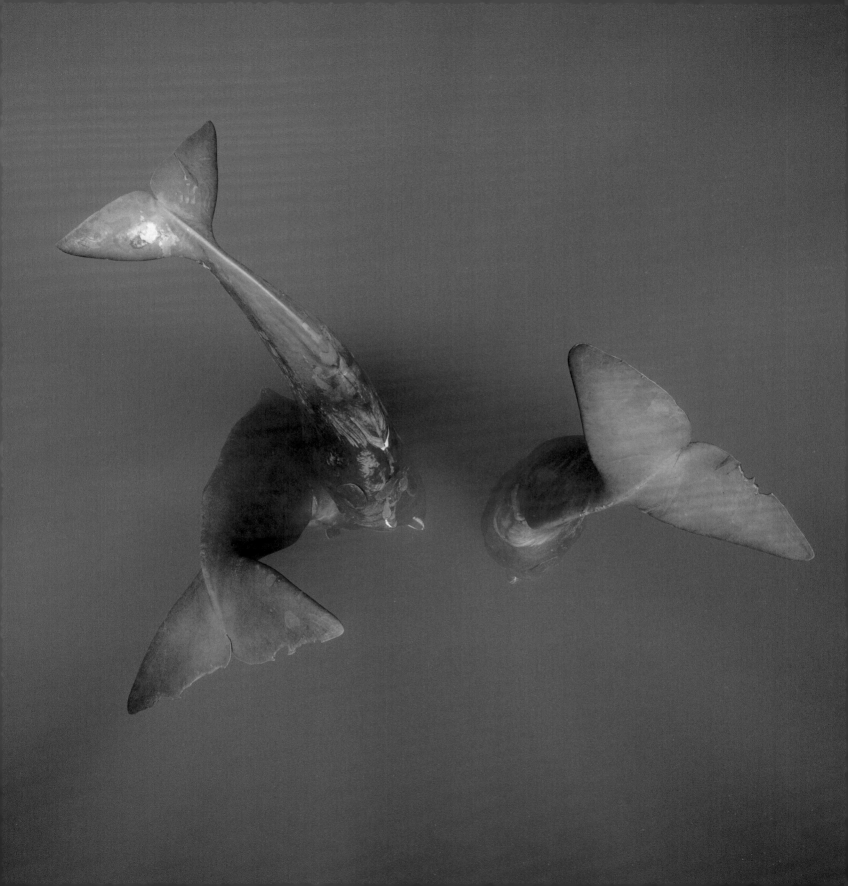

# HIDDEN **DEPTHS**

The newborn's name was Digit. For years, her pod of just three sperm whales had struggled to produce a female calf. Living off the leeward side of the Caribbean island of Dominica, this small group had once been part of a larger family; now its calves were always male and always unlucky, ensnared by fishing gear or struck by boats. Without a young female, the wisdom and unique ways of this pod would vanish. Digit was her family's future.

Mothers and grandmothers have always been the keepers of sperm whale culture. They lead, teach, and nurture, binding families together for decades. And they prepare the next generation to carry on traditions: Although all sperm whales feed, swim, babysit, defend, socialize, and communicate, how they achieve these tasks varies from clan to clan. But the females are always the conduits.

In her first few years, young Digit thrived. She grew strong on her mother's milk and learned the ways of the sea, beginning to raise her tail to dive deep and hunt for squid.

**SPERM WHALE**

*Physeter macrocephalus*

**AVERAGE SIZE:** 49–59 feet
**AVERAGE WEIGHT:** 35–45 tons
**LIFE SPAN:** Up to 60 years
**IUCN STATUS:** VU

But then, a crisis: When Digit was around four years old, she swam into a long fishing line attached to a large, heavy buoy. For three years, she dragged the contraption behind her, unable to dive or feed. A local diver tried to help by cutting the line, but only succeeded in cinching the whale's tail. A story that began with so much hope darkened into tragedy. The sperm whale population of the eastern Caribbean is declining by 4 percent a year, and the scientists who study them watched the unfolding drama with despair.

Distress soon gave way to amazement. The extended family came back to rejoin their relatives. Reunited, they closed ranks around the injured young animal; anytime a boat came near, the whales formed a circle around Digit, protecting her. The young whale was well beyond her nursing days, yet once the other whales returned, she began to make nursing dives alongside her mother, presumably to feed. Between those dives, the other females kept her company.

And then—nobody quite knows how—the fishing line

Three sperm whales socialize in the waters off Dominica in the eastern Caribbean Sea.

disappeared from Digit's tail. Scarred where the rope had once been, she now swam freely with her family and with evident joy. How did Digit break free? Was it nudging and nibbling from so many attentive relatives that loosened the knot? Or did they intentionally bite off the rope? Only the whales know.

Growing up in Massachusetts, I didn't have to look far to see sperm whales portrayed as monsters of the deep. Along the coast of New England—in New Bedford, Fall River, or on Nantucket—I've seen paintings of sperm whales smashing into the hulls of whaling ships, their jaws agape, hurling sailors into the sea. Herman Melville's harrowing tale, *Moby-Dick,* is perhaps the most famous of all.

Maybe a sperm whale is violent when it has a harpoon in its side. But my encounters with them have been anything but savage. These whales are gentle, curious, and intelligent. They like to investigate if something or someone unfamiliar ventures into their waters. Sometimes they play hide-and-seek with research boats, circling the vessels and rolling on their sides to have a look at the scientists on board. Their expressiveness is not so different from ours.

Sperm whales are the largest toothed whale species on the planet. They grow up to 59 feet long and weigh between 35 and 45 tons. They eat a ton of food every day, diving down some 3,000 feet below the ocean's surface to hunt squid. And they have the largest brains of any animal known to science—living or extinct.

Those giant brains power an astonishing dexterity with communication. When two sperm whales meet, they do what we do: introduce themselves. Using a pattern of clicks known as a coda, they greet each other in dialect, as if to say, "I'm from Dominica" or "I'm from the Galápagos Islands." That coda—which young whales spend years perfecting—is their passport and their sense of belonging. If the exchange reveals they hail from two different ocean neighborhoods, the whales swim on. They are genetically identical and could easily pair off. But like the Irish or Italians of 19th-century New York City, they have their clans and prefer to stick with their own kind.

Scientists are just beginning to understand how sperm whales communicate. Using artificial intelligence and acoustic sensors, a team of biologists, military cryptologists, and other researchers is hard at work trying to decipher sperm whales' language—and talk back to them.

The possibilities are tantalizing. These whales populate oceans around the world; they've been swimming and surviving for longer than humans have walked upright. What might we learn from them? What could they tell us about the mysteries of the deep ocean, its seamounts and canyons, its prey? What do they know about the changing planet, or the shifting fortunes of the ocean? Two hundred years ago, we hunted sperm whales and lit our lamps with their oil. Today, we spend tens of millions of dollars trying to learn their language.

But we don't have to know the precise contours of the whales' communication to appreciate the complexity of their lives. They spend much of their time in the dark, cold depths foraging for food, a dozen whales in a family unit spread across acres and acres of water. Aunts

WHEN TWO SPERM WHALES MEET, THEY DO WHAT WE DO: INTRODUCE THEMSELVES. USING A PATTERN OF CLICKS KNOWN AS A CODA, THEY GREET EACH OTHER IN DIALECT, AS IF TO SAY, "I'M FROM DOMINICA" OR "I'M FROM THE GALÁPAGOS ISLANDS." THAT CODA IS THEIR PASSPORT AND THEIR SENSE OF BELONGING.

or grandmothers babysit calves while their mothers hunt below.

Every day there comes a moment when the foraging stops. All the whales in a pod—three, four, up to a dozen—assemble in shallower water and socialize. Their aqua ballet can last for hours. They rub one another, rake their teeth across tails and backs, float, and talk—always talking, a *click-click-click* of whale chatter.

What's remarkable to me is that these animals are otherwise not tactile. They don't rest on the bottom of the ocean, or on a beach; there are no rocks to rub on. They encounter nothing 3,000 feet down but three-dimensional darkness. And yet when they gather, they greet one another with tenderness and touch.

The year after Digit was free, a mother in her family had a calf. It was another female. I swam with her one day for nearly two hours as she frolicked in the sargassum weed, biting it the way a baby chews on a toy. She was unafraid of me, rolling with her mouth open and standing on her head so her tail went straight up the water column. This calf was just a playful toddler following her curiosity.

If this whale reaches maturity, she will hold the secrets to survival in these waters. She'll need it: Her ocean is changing, her species' future uncertain. But on this day, with her mother nearby but not paying her much mind, the calf seemed carefree.

Scientists studying sperm whales of the eastern Caribbean give each animal a name, and for this new calf, I suggested one that felt right. The researchers liked it, too. We agreed to call her Hope. ■

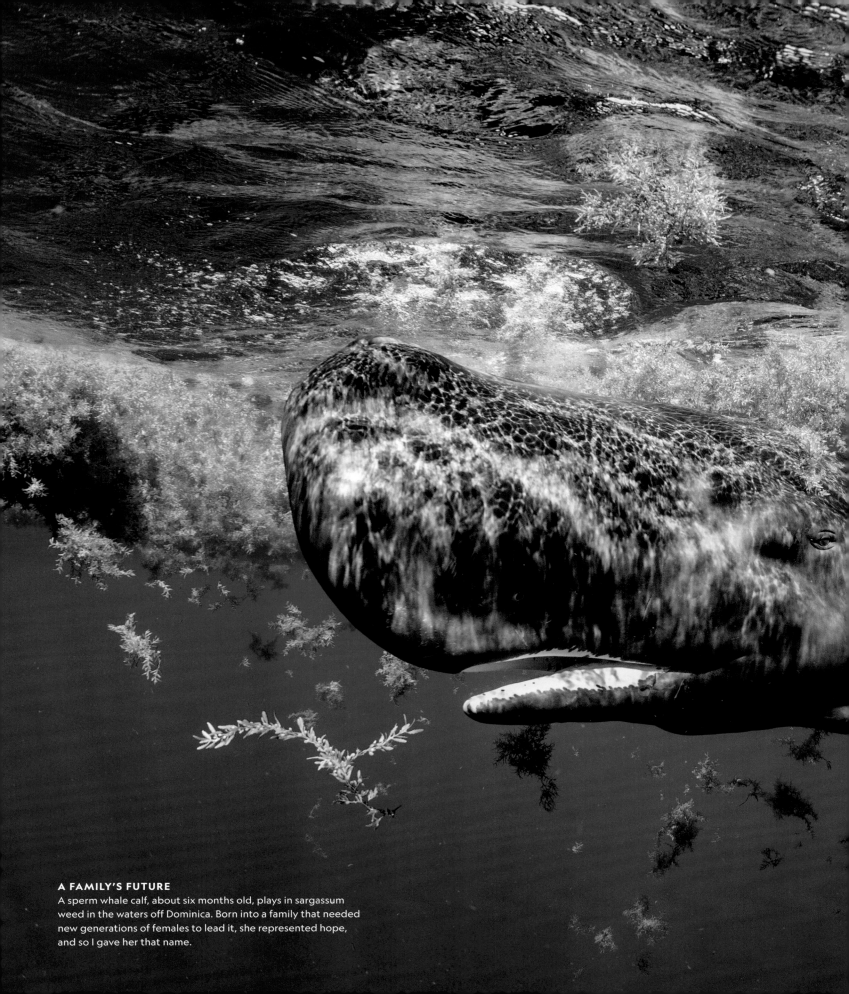

**A FAMILY'S FUTURE**
A sperm whale calf, about six months old, plays in sargassum
weed in the waters off Dominica. Born into a family that needed
new generations of females to lead it, she represented hope,
and so I gave her that name.

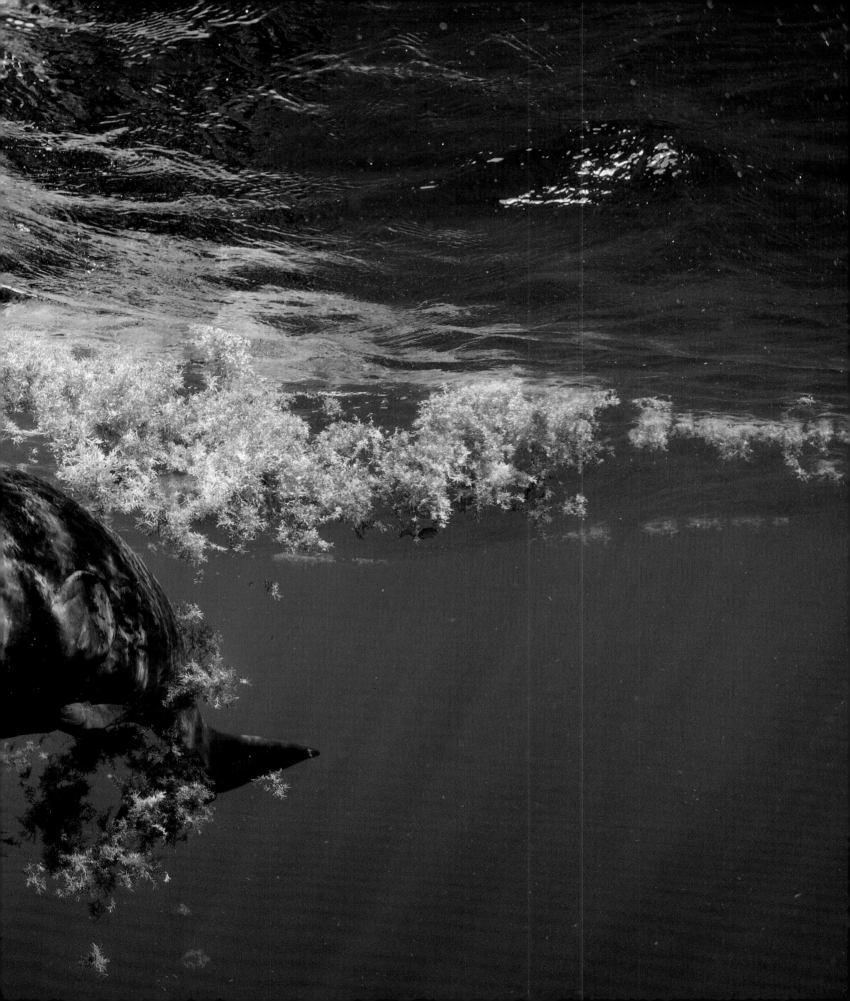

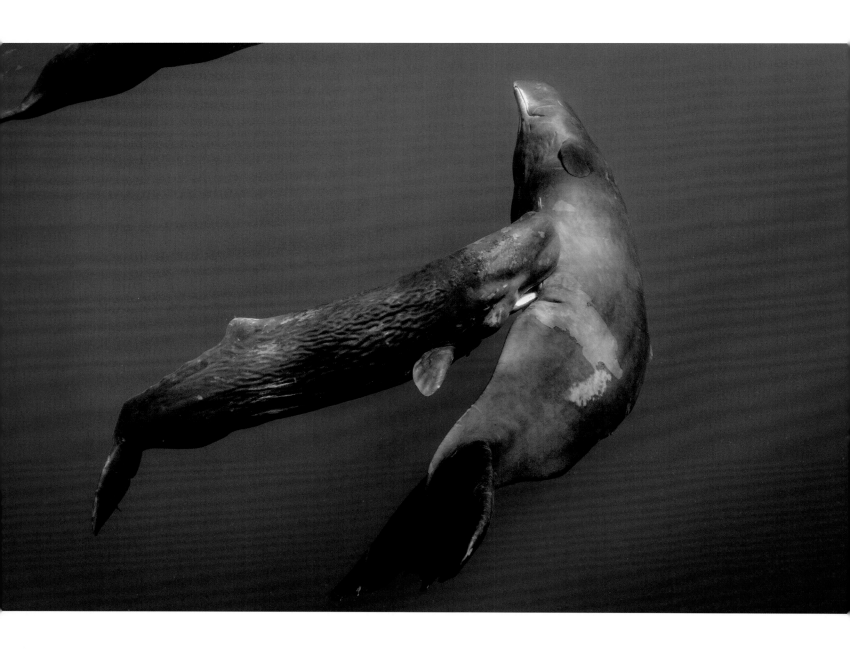

**TENDER MOMENTS**

Hope, the calf we discovered in 2019, nurses. After making this picture, I showed it to sperm whale scientist Shane Gero. "There's an old saying in the whale biology world: Someday we'll know everything about whales, except how a sperm whale calf nurses," he remarked. "But now we know!"

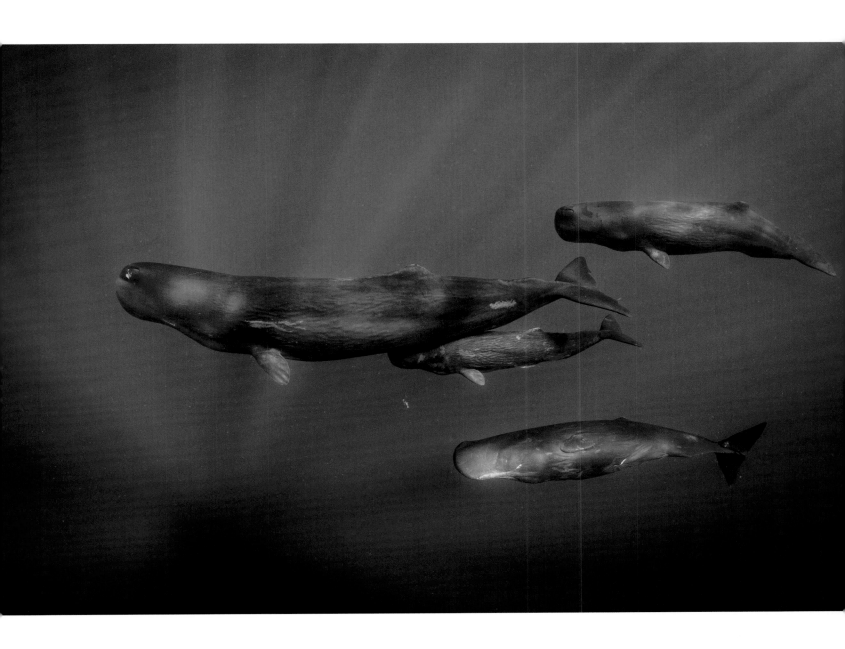

**MATRILINEAL LEADERSHIP**
A sperm whale family swims together off Dominica.
These units are led by older, wiser females who make
decisions for the group.

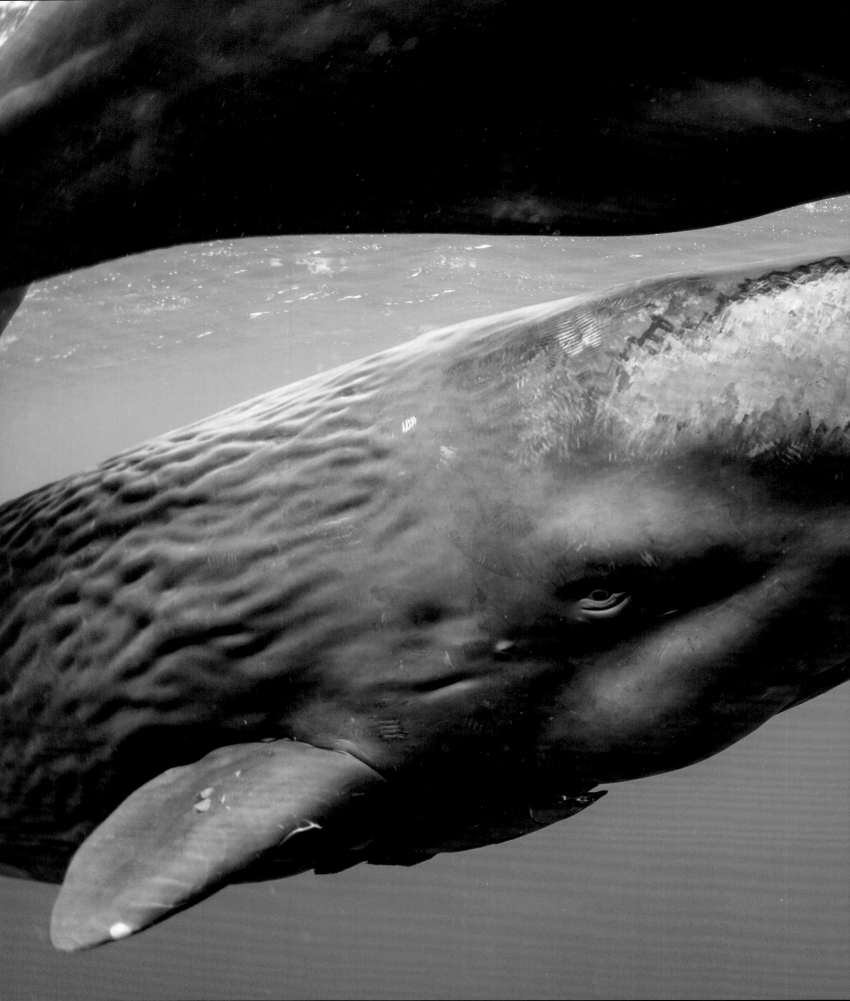

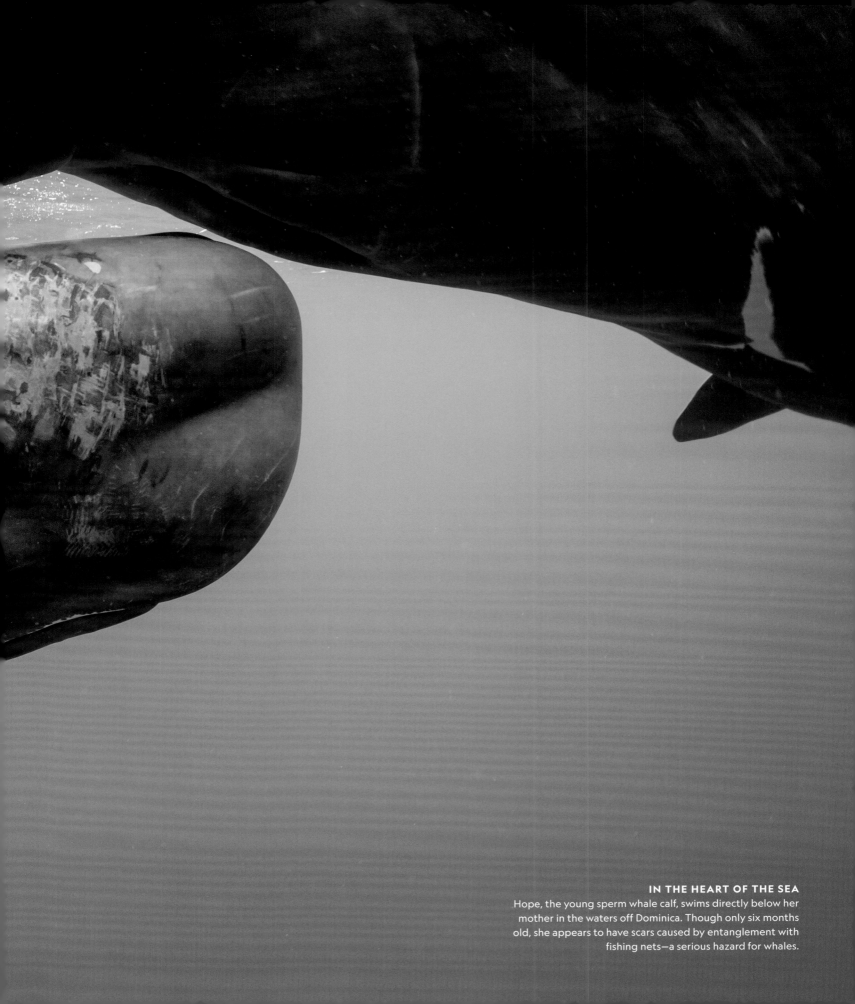

**IN THE HEART OF THE SEA**
Hope, the young sperm whale calf, swims directly below her
mother in the waters off Dominica. Though only six months
old, she appears to have scars caused by entanglement with
fishing nets—a serious hazard for whales.

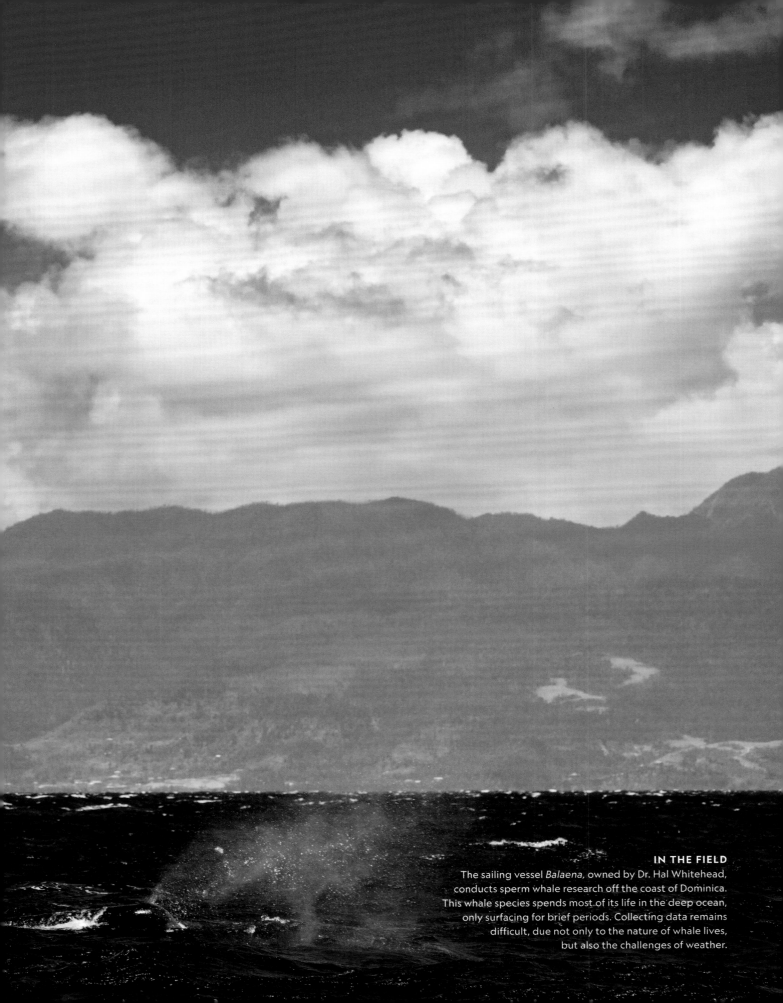

### IN THE FIELD

The sailing vessel *Balaena,* owned by Dr. Hal Whitehead,
conducts sperm whale research off the coast of Dominica.
This whale species spends most of its life in the deep ocean,
only surfacing for brief periods. Collecting data remains
difficult, due not only to the nature of whale lives,
but also the challenges of weather.

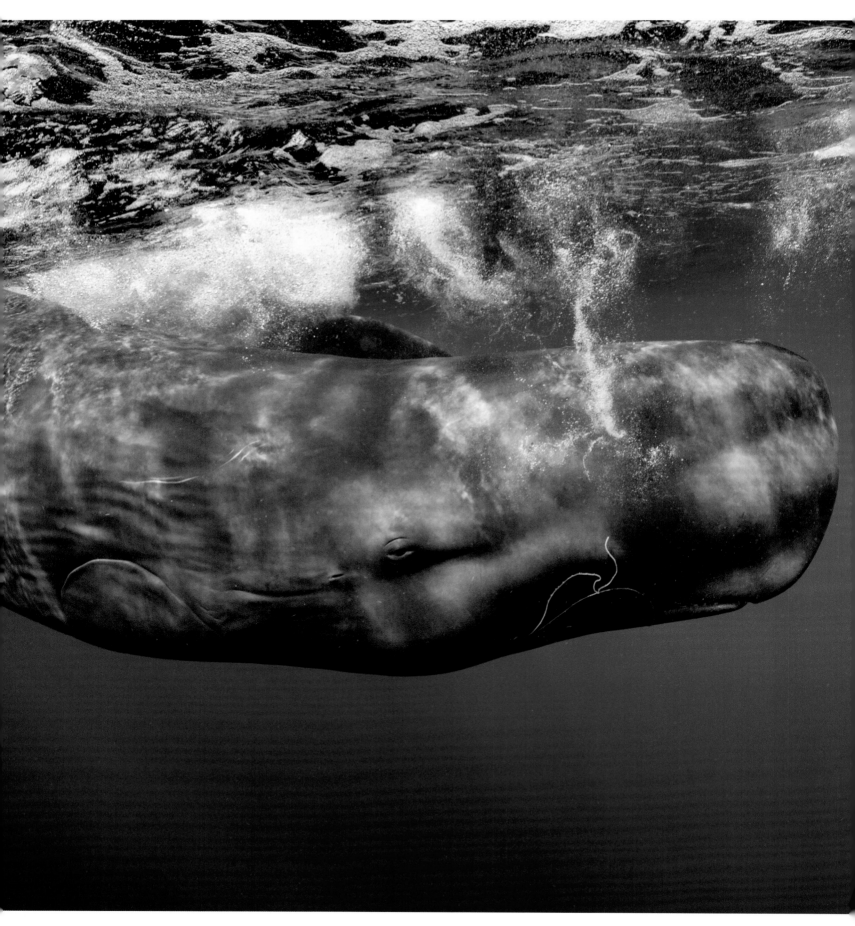

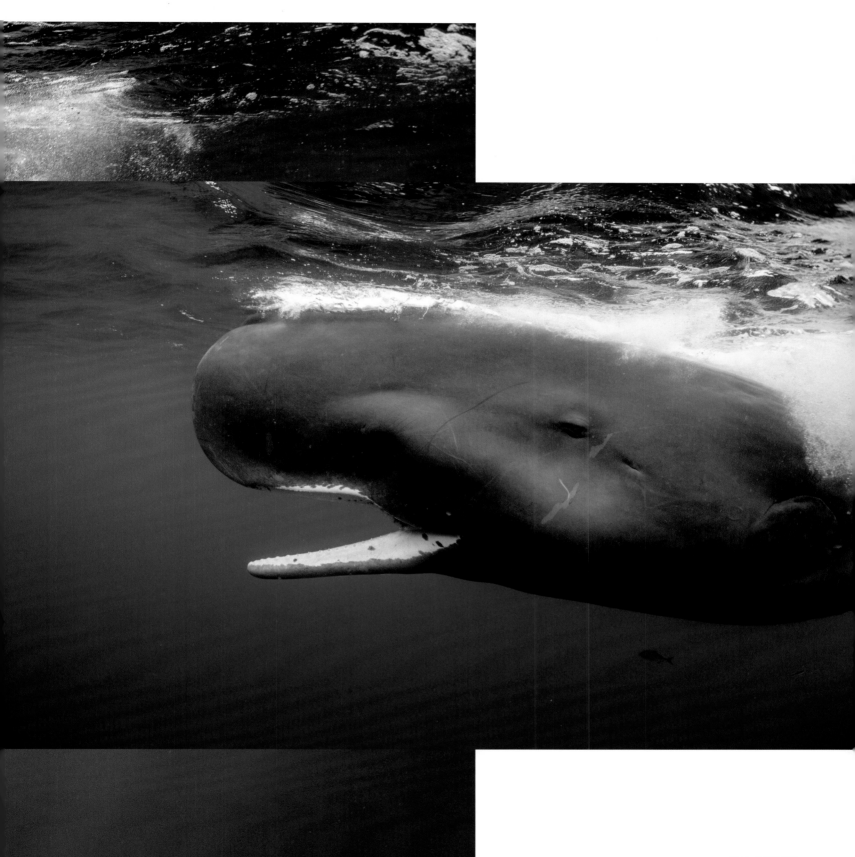

**SEA SCENES**
With squid tentacles streaming from her mouth, a sperm
whale (left) rests just below the surface. A different
whale (right) swims with her mouth open.

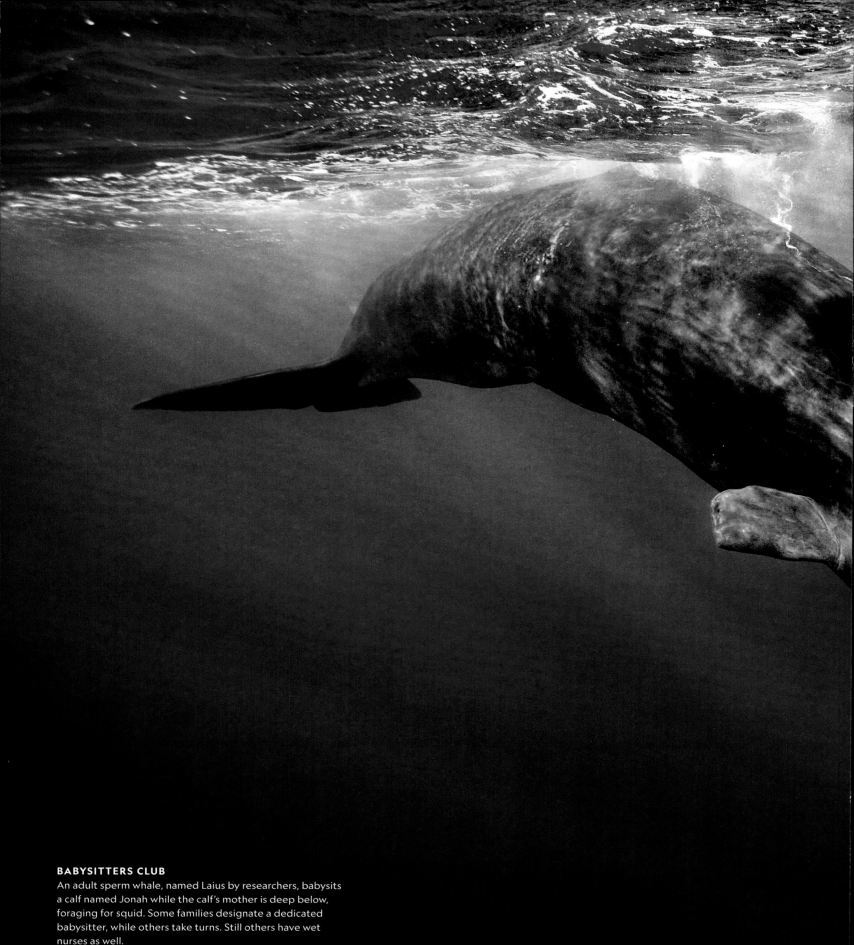

**BABYSITTERS CLUB**
An adult sperm whale, named Laius by researchers, babysits a calf named Jonah while the calf's mother is deep below, foraging for squid. Some families designate a dedicated babysitter, while others take turns. Still others have wet nurses as well.

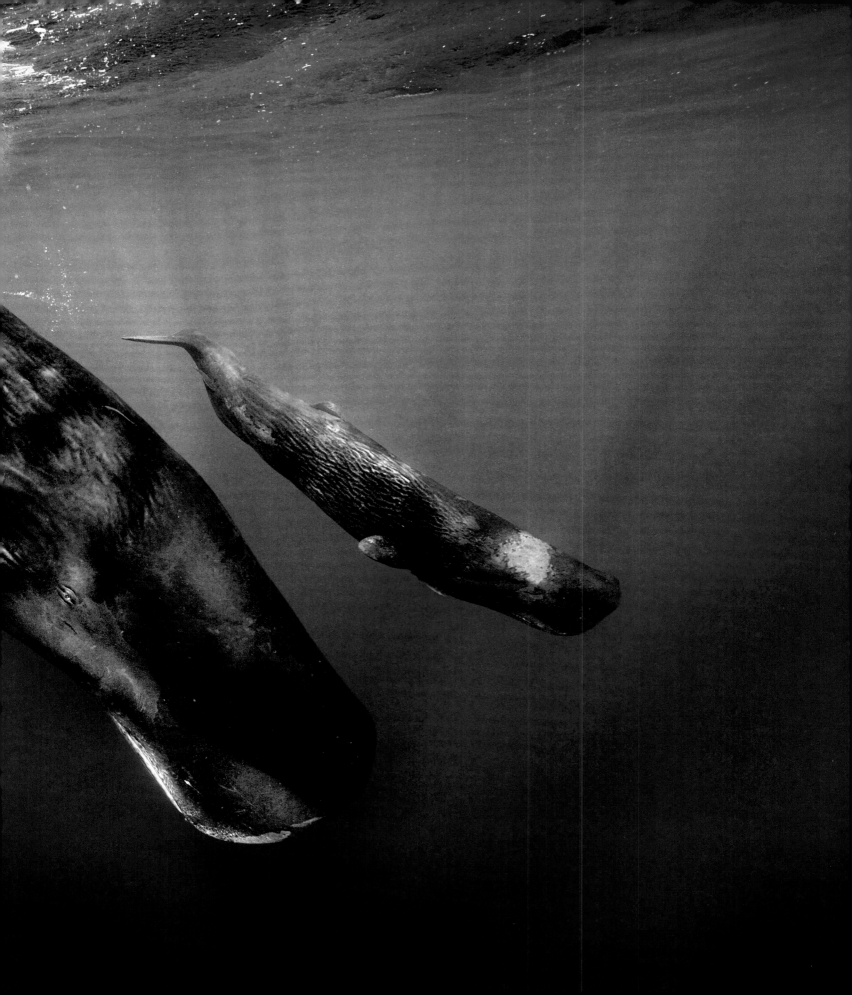

**SPA WORLD**

An adult female sperm whale plays among sargassum weed off Dominica. In the time we spent with this family unit, we saw only this whale and her calves engaging in this behavior. One theory is that she discovered that the weed acts like a loofah on her skin.

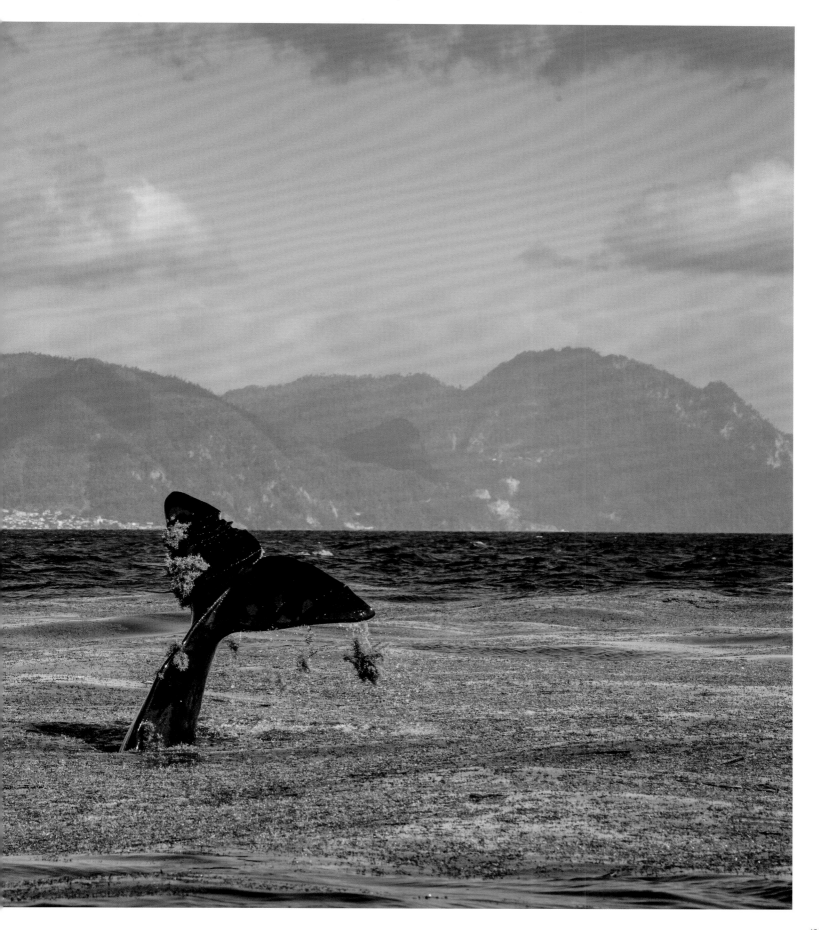

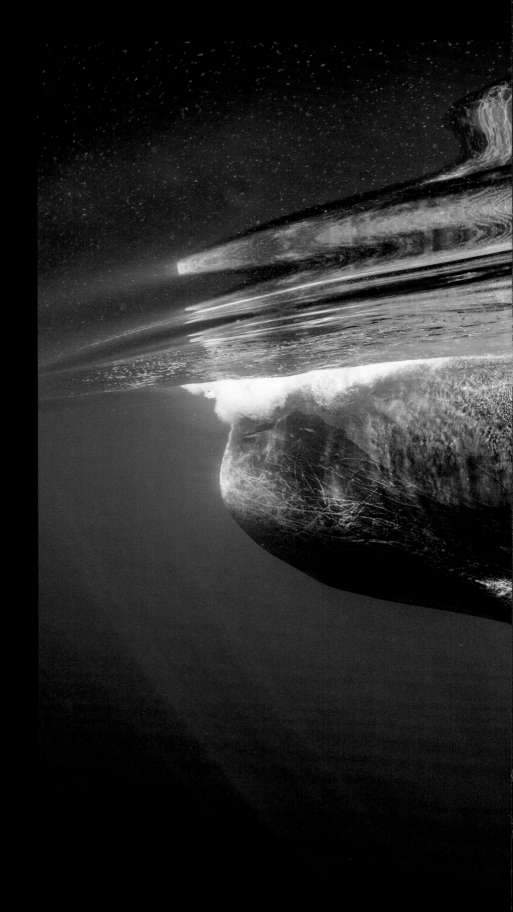

# BEHIND THE SHOT

In Sri Lanka, everything underwater seems bigger: the sea feels more vast, and sperm whale families are at least three times larger than in other places I've photographed them. Encountering an adult male in these waters is rare, because most families are composed of females and juvenile males. But I once met a whale here that was the stuff of legends.

Underwater one day, I heard the distinctive sound of a sperm whale "clanging." This is the noise males produce to announce their presence and to attract a mate. The clang was clear and loud, and though I believed the whale was close, I couldn't see him.

As the days progressed, we journeyed farther afield than our usual grounds—and there I met Zeus (the name I bestowed upon him). My first glimpse underwater took my breath away. He was massive—at least 45 feet in length—with a giant, powerful tail, swimming up toward the surface.

Zeus turned and approached me; from a distance, all I could see was a wall of white. As he drew near, the front of his head emerged: flat, scarred, and nearly pure white. He turned slightly and passed within a few meters; we made eye contact. From that gaze I sensed strength and power and maybe even slight annoyance that I had intruded. But I also sensed wisdom and acceptance. His body was covered in scars, and he possessed an aura unlike any whale I've ever encountered.

From time to time, I imagine Zeus in the great depths, musing about the stories he could tell.

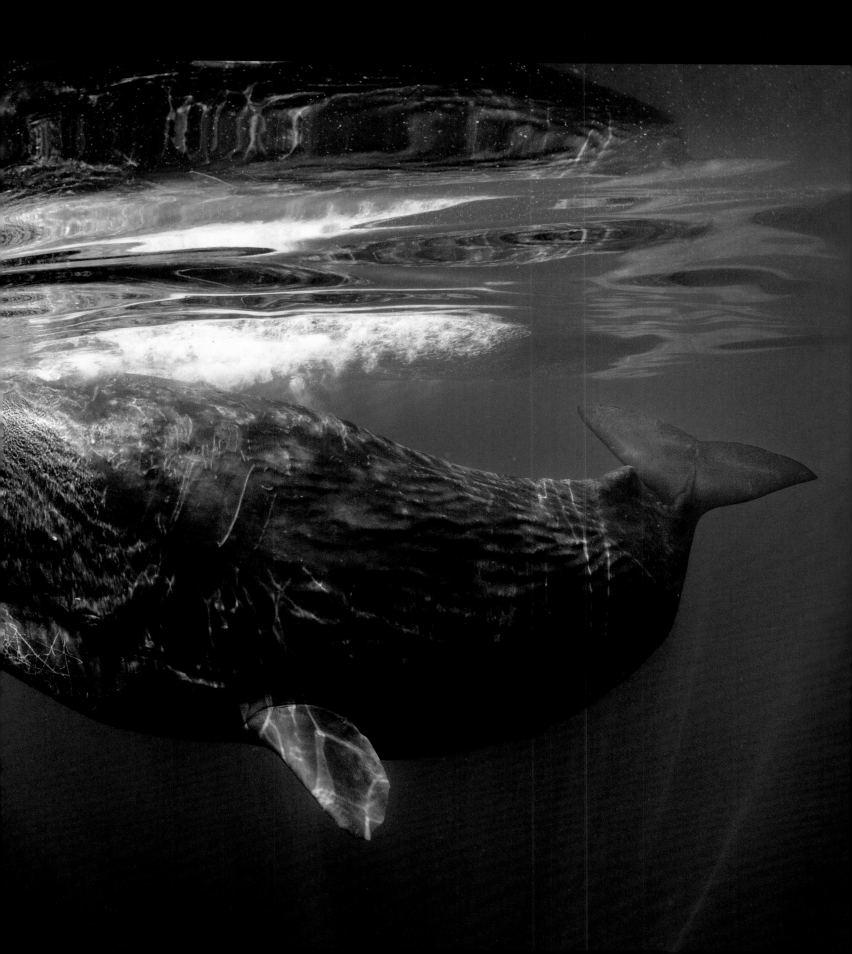

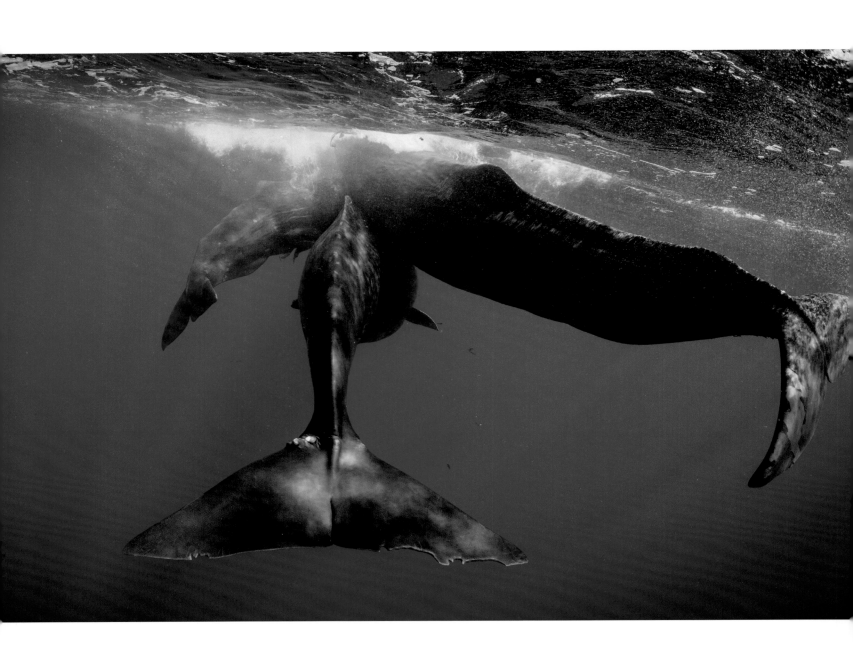

**FREE AT LAST**
A sperm whale named Digit, once entangled in fishing nets, socializes with her family. Scar tissue on her tail is evidence of the net that almost ended her life.

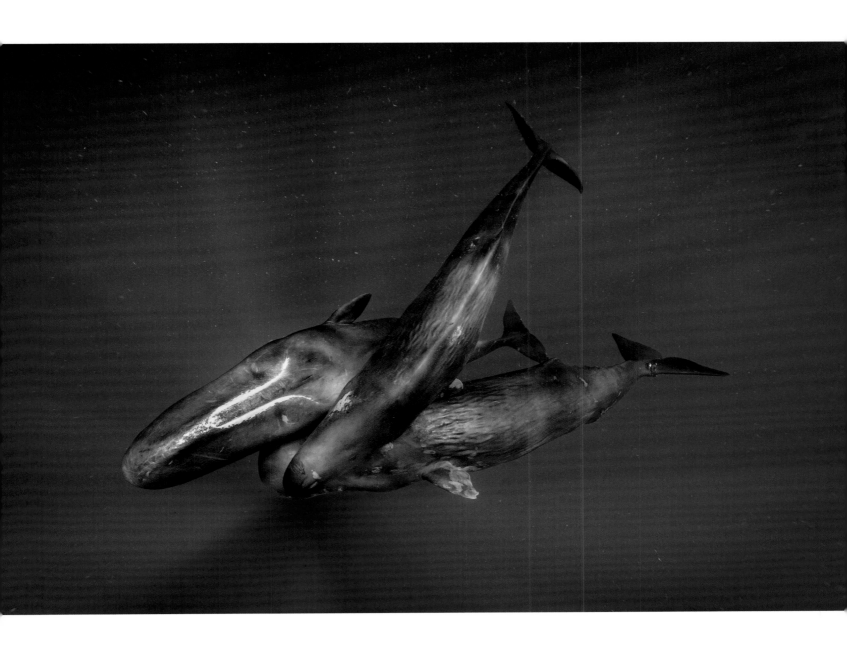

**RAPTURE IN THE DEEP**
As Digit cavorts with members of her family, the sea fills with their codas, or special dialect. Witnessing the joy these animals derive from one another's company is a privilege. I muse on what they're saying; my guess is that they're expressing love.

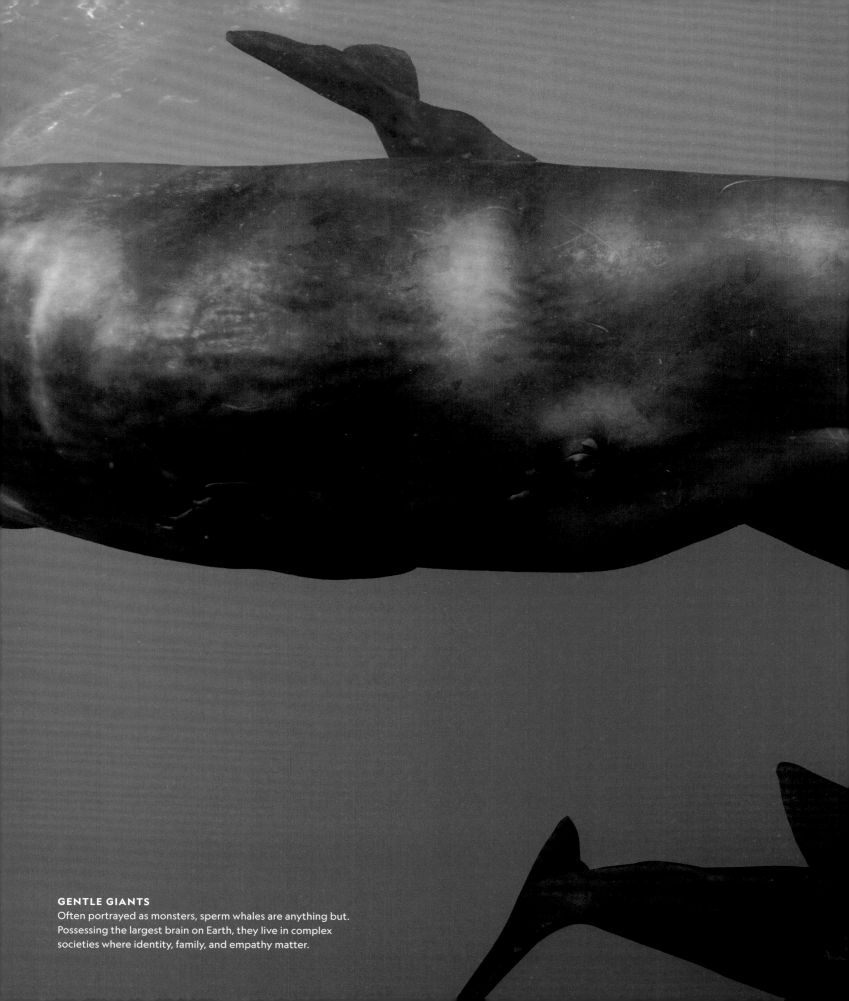

**GENTLE GIANTS**
Often portrayed as monsters, sperm whales are anything but.
Possessing the largest brain on Earth, they live in complex
societies where identity, family, and empathy matter.

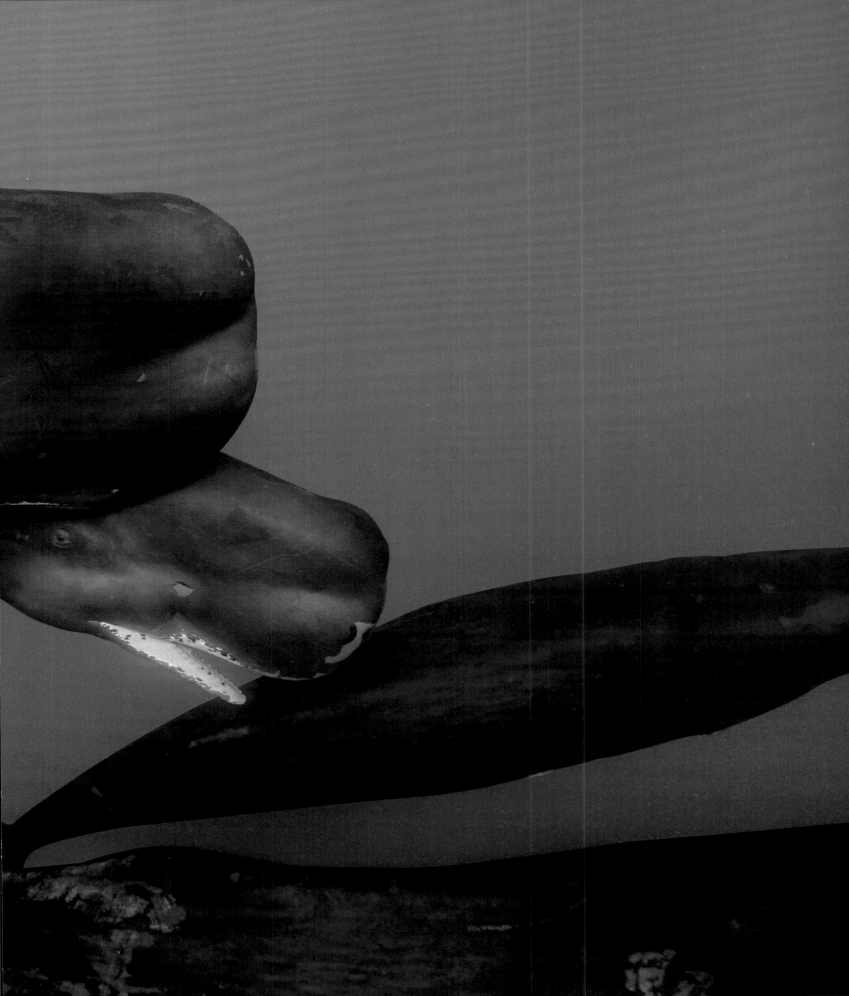

HUMP

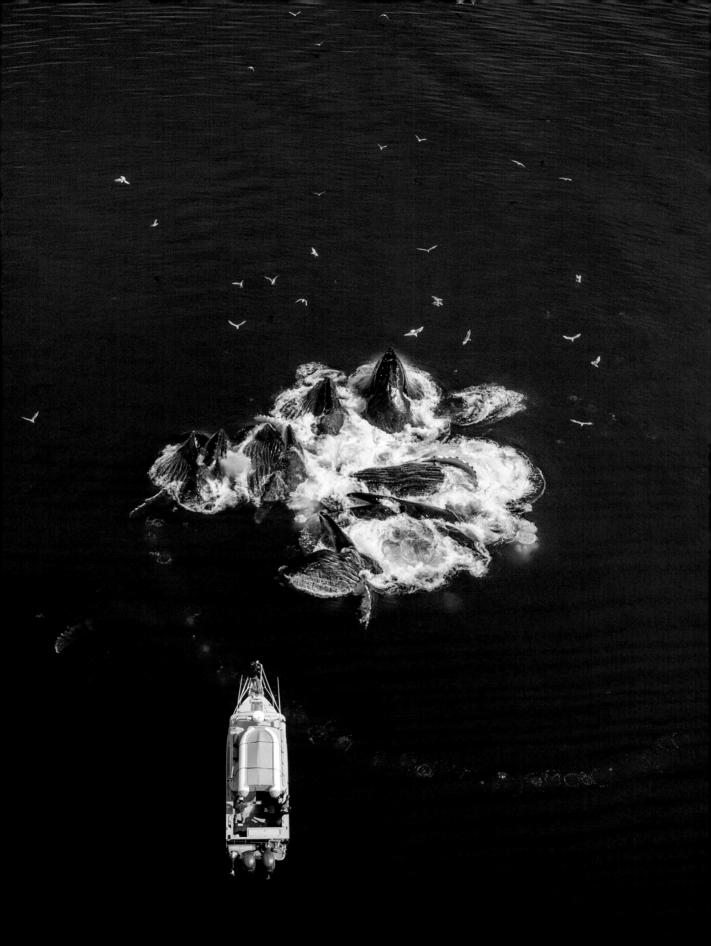

# SONGS OF **THE SEA**

Not until the modern era did humans figure out how to communicate across thousands of miles of ocean. But humpback whales, through their magical songs, have likely been at it for ages.

And even more surprising, it seems they conduct what we might think of as singing contests. Every year, after testing out a variety of tunes—sequences of moans, howls, cries, and other noises—male humpbacks in the Pacific settle on a winning song. Eventually, that melody will travel across the entire Pacific Basin. Group by group, singing to attract mates or challenge rivals, the whales spread the song from Australia to French Polynesia, some 4,000 miles away.

The hit singles sound quite different from one year to the next: some like a crying baby, others like a creaking door, still others like a bad case of the hiccups. When the whales sing, they tend to invert their bodies so they look as though they're standing on their heads in the water column, floating and motionless. Some researchers hypothesize that male singers use the topography of the seafloor to amplify the sound of their songs.

**HUMPBACK WHALE**

*Megaptera novaeangliae*

**AVERAGE SIZE:** 48–62.5 feet
**AVERAGE WEIGHT:** 40 tons
**LIFE SPAN:** Up to 80 years
**IUCN STATUS:** LC

Although scientists have studied these undulating humpback songs for decades, they have only scratched the surface of what the melodies might mean. To my untrained ear, the songs are haunting and complex; the whales' distinctive music takes me back to a primordial time.

Humpbacks are one of our most familiar whale species. Their Latin name, *Megaptera novaeangliae,* means "big wing of New England"—a nod to their large pectoral fins. Numerous and apparently thriving, they live in every ocean, and we can see them easily on whale-watching excursions.

These whales' communications travel at four times the speed of sound. Yet humpbacks' songs are just one way they amaze us with their culture.

Consider the way some humpbacks in Alaska find their food. They use a technique known as bubble netting, and each creature has a specific job. Although scientists have found that individuals can feed quite successfully on their

---

Aerial view of humpback whales bubble-net feeding in Alaskan waters alongside the research vessel of the Alaska Whale Foundation (*Photo by Brian Skerry and Steve De Neef*)

own, the whales often choose to do it in a group. Members of different families frequently work together—not necessarily because it's more efficient, but because they want to.

The process begins when one animal sounds the alarm, letting others know it's time to eat. The call is a haunting, primal scream; I've heard it vibrating and resonating up through the hull of a boat. This signal alerts all the humpbacks that it's time to go to work. (It probably also startles the fish.)

Another whale will blow a bubble net around the fish by swimming downward in a spiral below a spot rich with food, creating a curtain of bubbles as it exhales. The bubbles confine the fish in a small area. Other whales swim around the edges, flashing their white underbellies, scaring the fish. Then the whales will charge up the middle of the tight ball of fish, mouths agape, and feast.

Some of those same Alaska humpbacks have developed a surprising new tactic to find food. Fishermen, in an attempt to boost local salmon populations, have built salmon hatcheries. They collect salmon eggs from spawning areas in rivers and streams, carefully raise them in the hatchery, and release the young fish into a bay.

The humpbacks are wise to the plan. They now gather outside the gates of salmon hatcheries every spring, just before fishermen release the fish. What's amazing about this new behavior is that the fishermen don't even know exactly when they're going to release the fry, because the conditions—water temperature and salinity—have to be just right. The date varies every year. And yet the whales show up like clockwork.

I saw it for myself one afternoon. Standing on a dock in an enclosed bay, I sipped my coffee and watched bald eagles as pens made out of nets holding young fish stretched out in front of me. All of a sudden a giant humpback whale spouted next to me. This female whale had negotiated a narrow channel to the enclosed area with the pens and was now swimming in less than 10 feet of water.

Humpbacks don't have sonar, and yet this animal longer than a city bus was deftly maneuvering her huge body around an underwater industrial obstacle course. The dock, submerged pylons, hoses, old tires, and machinery—the whale could have knocked into or become tangled in any one of them. But she didn't.

When the fishermen released the baby fish a few days later, that same humpback returned. I saw her blowing a single little bubble net under the pen and feeding on the young salmon. The fishermen shook their heads. They just can't beat these whales.

Humpbacks make long migrations every year from the warmer waters where they mate and give birth to their feeding grounds near the poles. During the journey, humpback mothers, traveling with their calves, swim close together. They often touch one another with their flippers. It's a tender show of affection, and just one example of their close relationship.

Calves whisper to their mothers when swimming in places where predators, such as orcas, might otherwise hear them. And mothers help their little ones learn how to become strong swimmers to make their long migrations:

ALTHOUGH SCIENTISTS HAVE STUDIED THESE UNDULATING HUMPBACK SONGS FOR DECADES, THEY HAVE ONLY SCRATCHED THE SURFACE OF WHAT THE MELODIES MIGHT MEAN. TO MY UNTRAINED EAR, THE SONGS ARE HAUNTING AND COMPLEX; THE WHALES' DISTINCTIVE MUSIC TAKES ME BACK TO A PRIMORDIAL TIME.

Scientists have seen mothers and calves swim from the open ocean to the shore and back again, over and over, in what appear to be swimming lessons.

Humpbacks' speed comes from their large tails, or flukes, which power them through the water. But it takes more than endurance and strength to migrate from the South Pacific to Antarctica. They also appear to be superb navigators.

Researchers using satellite technology to study humpbacks in the South Atlantic and South Pacific have found that migrating whales—who feed in colder waters, then travel to warmer waters to calve and mate—chart startlingly precise paths across vast stretches of ocean. Storms and powerful currents are no match for the animals. As they swim across thousands of miles, they never deviate more than five degrees from their migratory paths. About half the whales in the study strayed less than one degree.

How they swim so straight through some of the world's most tempestuous oceans is a tantalizing mystery scientists are eager to solve. Humpbacks, like birds and other creatures that also make long-distance migrations, seem to rely in part on Earth's magnetism to guide them. They also use the sun's position, and maybe even the moon and stars.

But what of their music? Could humpbacks' haunting melodies drift through a giant sea to provide acoustic signals to fellow travelers far away? Science is gradually revealing more details and unlocking some of the whales' secrets. For now, we can only wonder ■

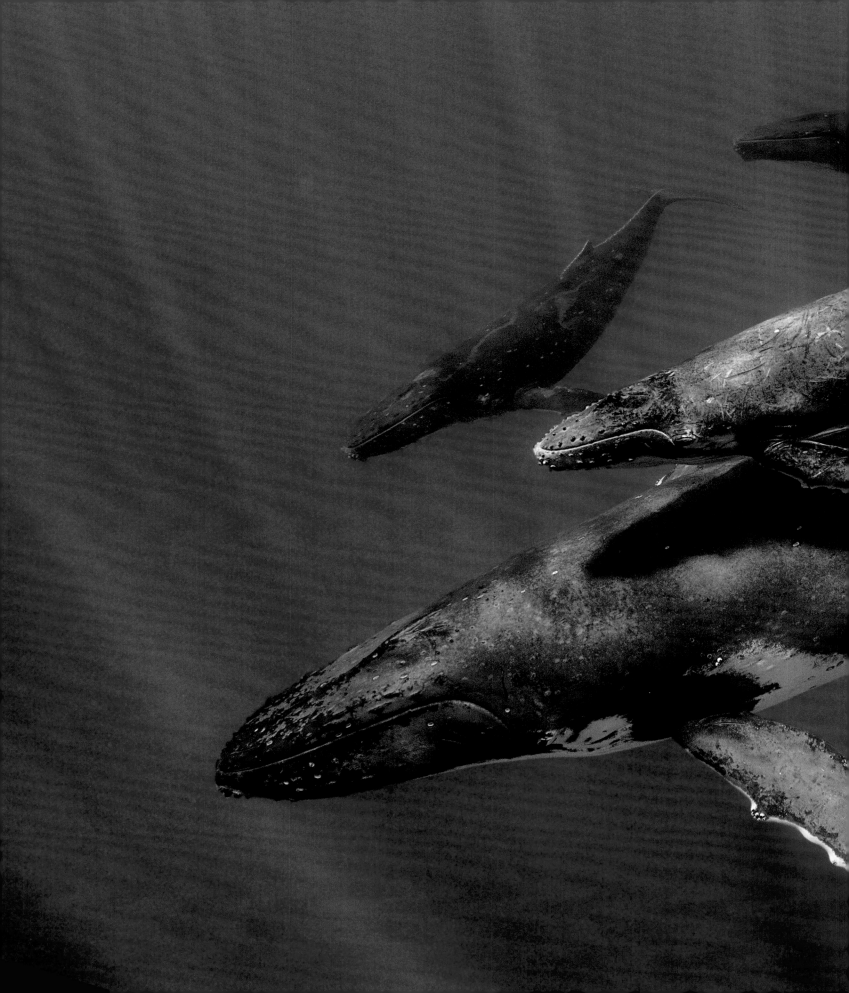

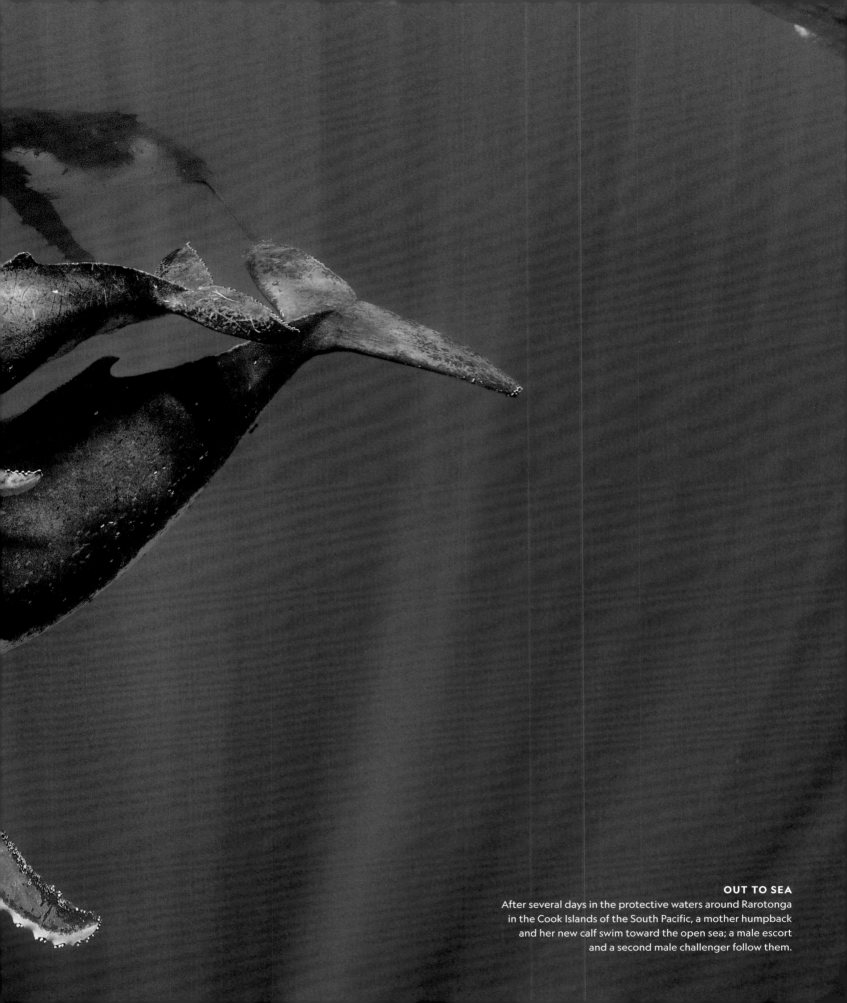

**OUT TO SEA**
After several days in the protective waters around Rarotonga in the Cook Islands of the South Pacific, a mother humpback and her new calf swim toward the open sea; a male escort and a second male challenger follow them.

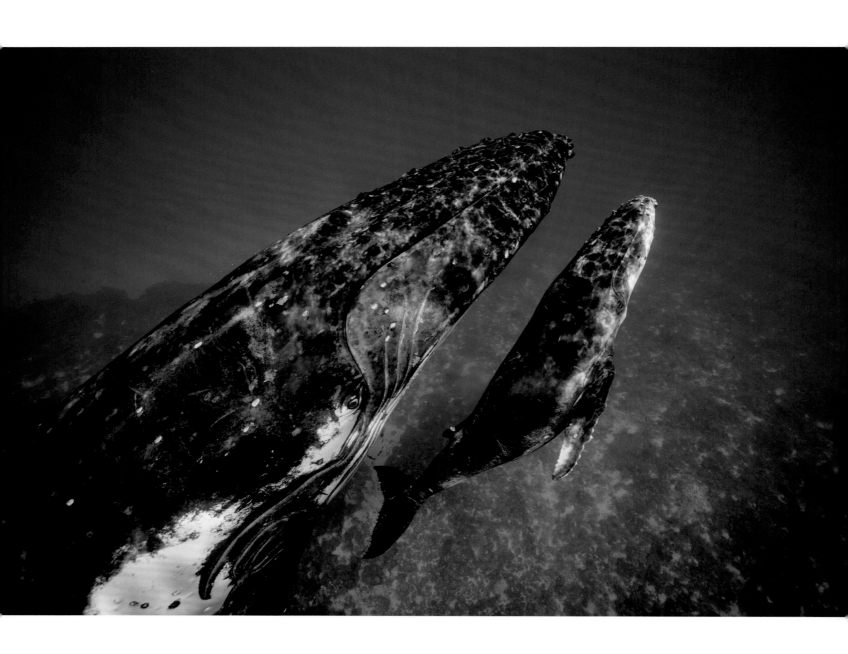

**A MOTHER'S LOVE**
A mother humpback and her calf rise to the surface over coral reefs in the waters of Tonga in the South Pacific. Most mothers are especially protective of their calves in the first few weeks but can become more relaxed over time.

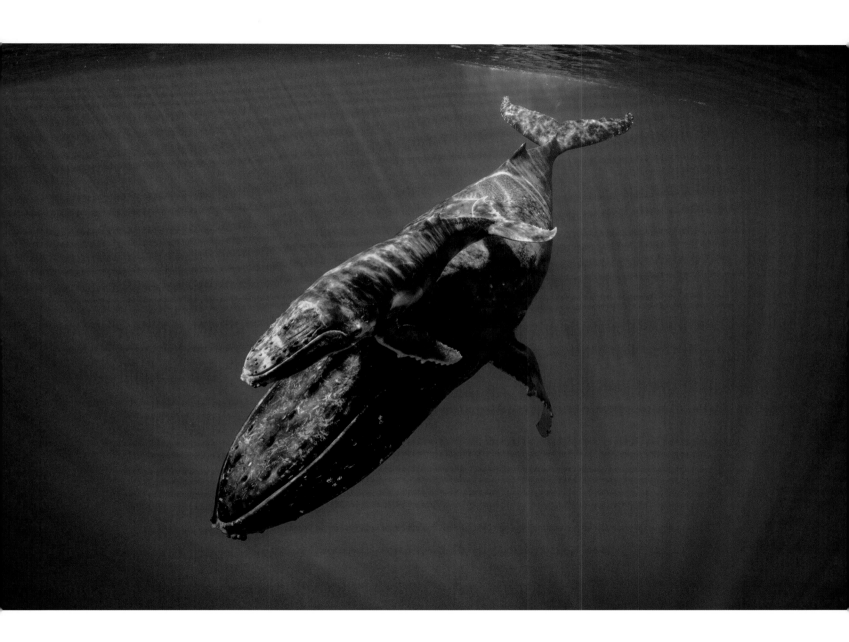

**PIGGYBACK RIDE**
Like the space shuttle being carried by a 747, a humpback
whale calf rides atop his mother's back in the waters of Tonga.
When swimming in places with predators around, humpback
mothers are known to quietly whisper to their calves.

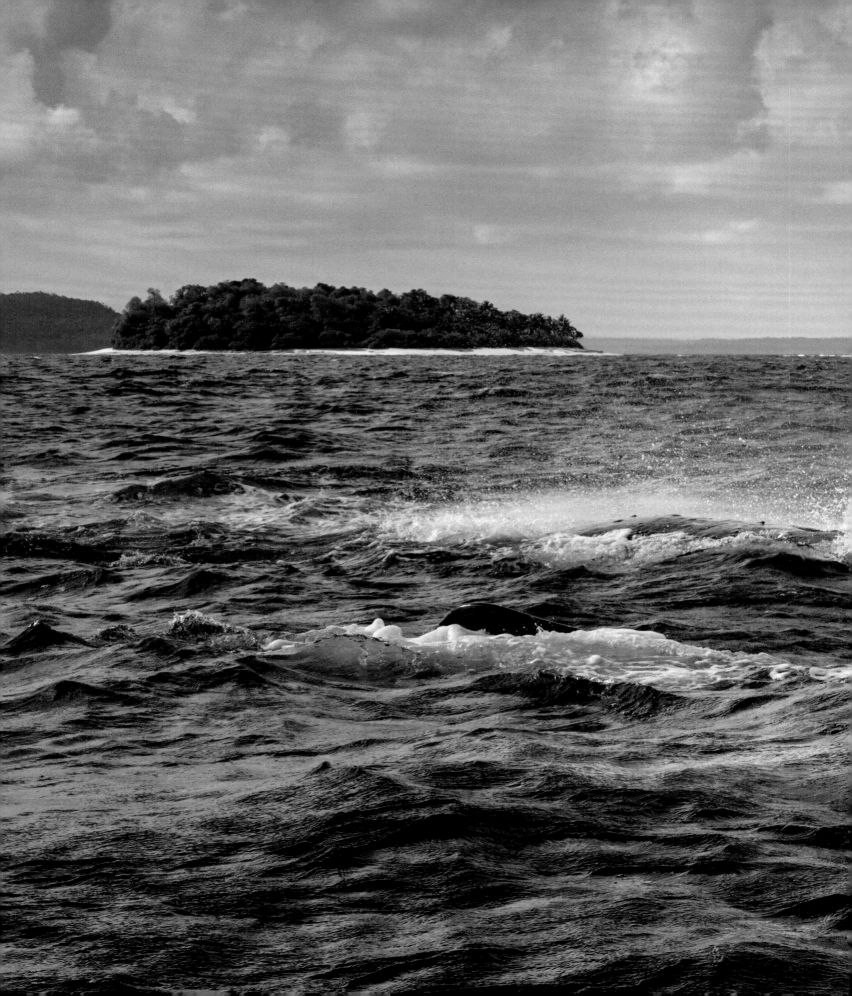

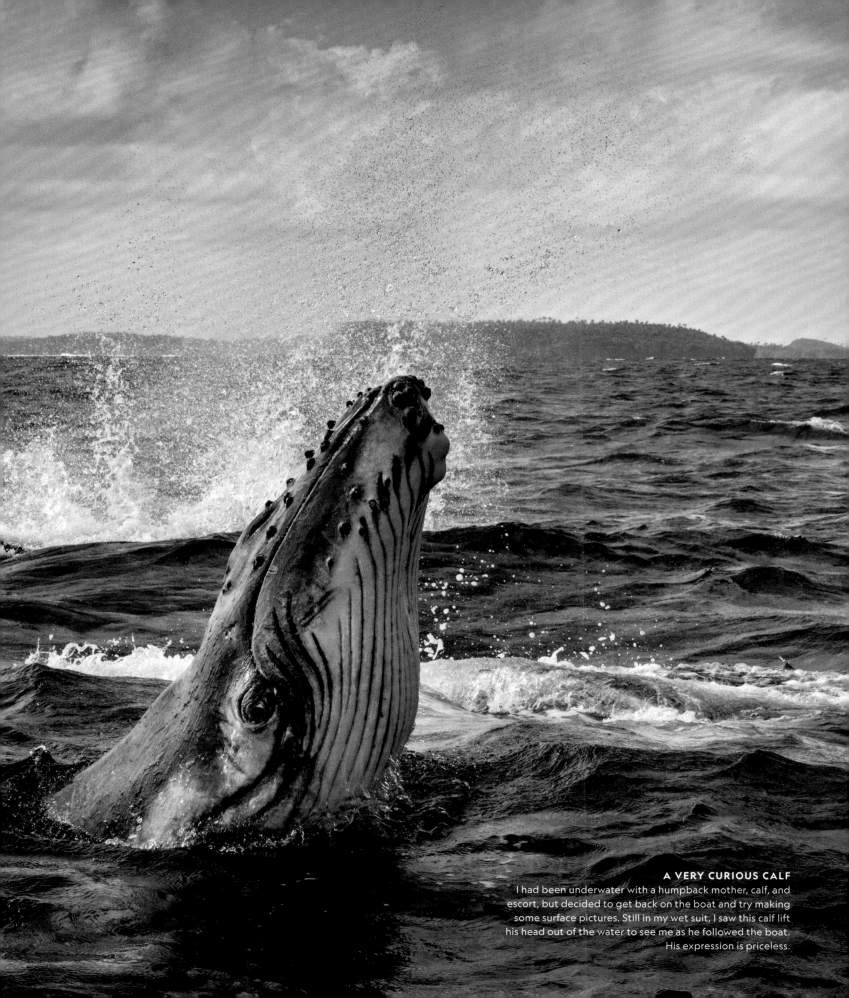

### A VERY CURIOUS CALF
I had been underwater with a humpback mother, calf, and escort, but decided to get back on the boat and try making some surface pictures. Still in my wet suit, I saw this calf lift his head out of the water to see me as he followed the boat. His expression is priceless.

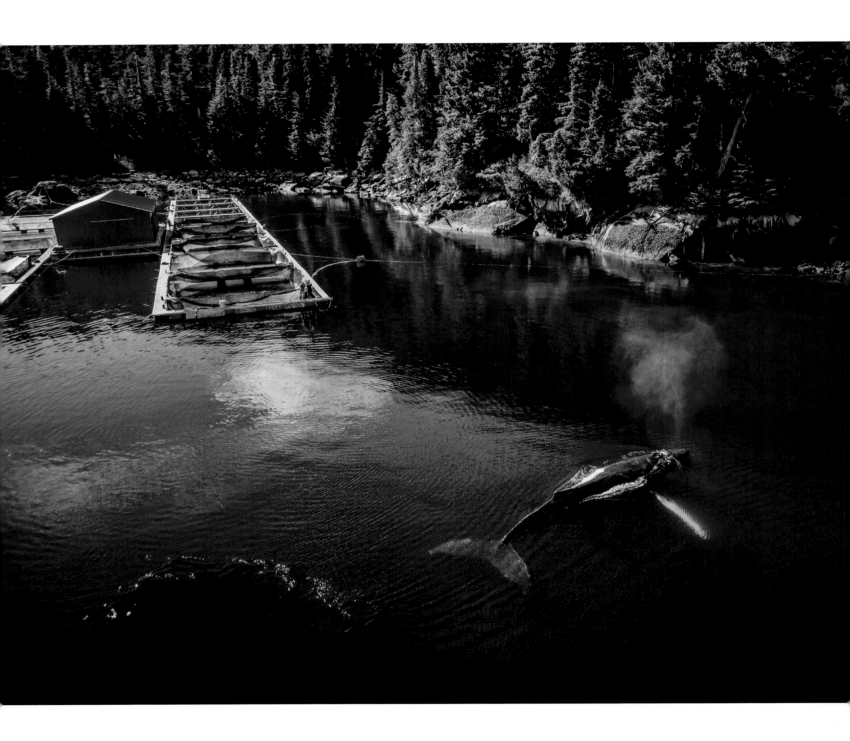

**OLD FAITHFUL**
At the precise time a salmon hatchery releases its baby salmon, a humpback whale appears in the protected cove in Alaska. Whales deftly navigate the minefield of lines, nets, and other structures to feed on the mass of young fish.
(Photo by Brian Skerry and Mark Romanov)

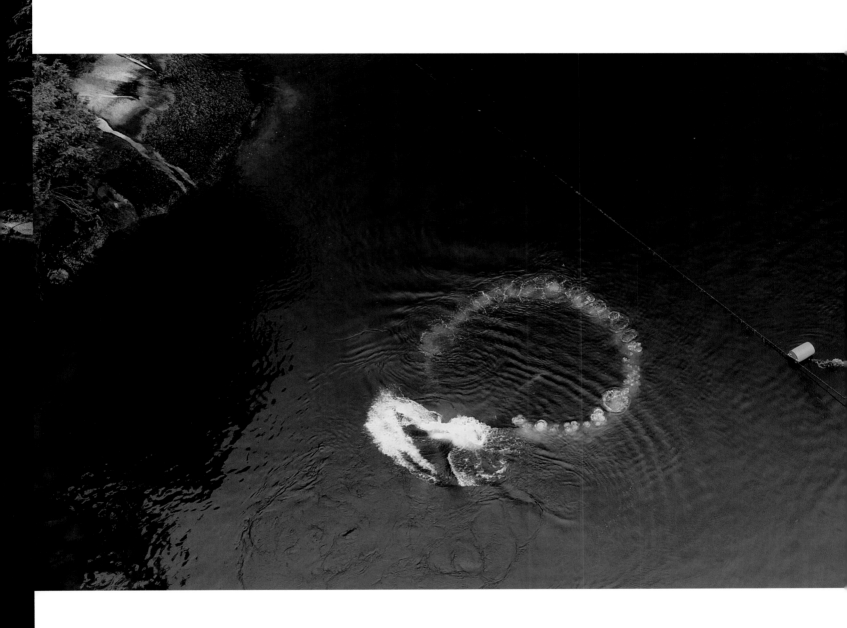

**LUNCHTIME!**
Working alone, the humpback produces a bubble net below the fish, forcing the baby salmon into a tight school. Then, the whale rises up to feed. *(Photo by Brian Skerry and Dan Evans)*

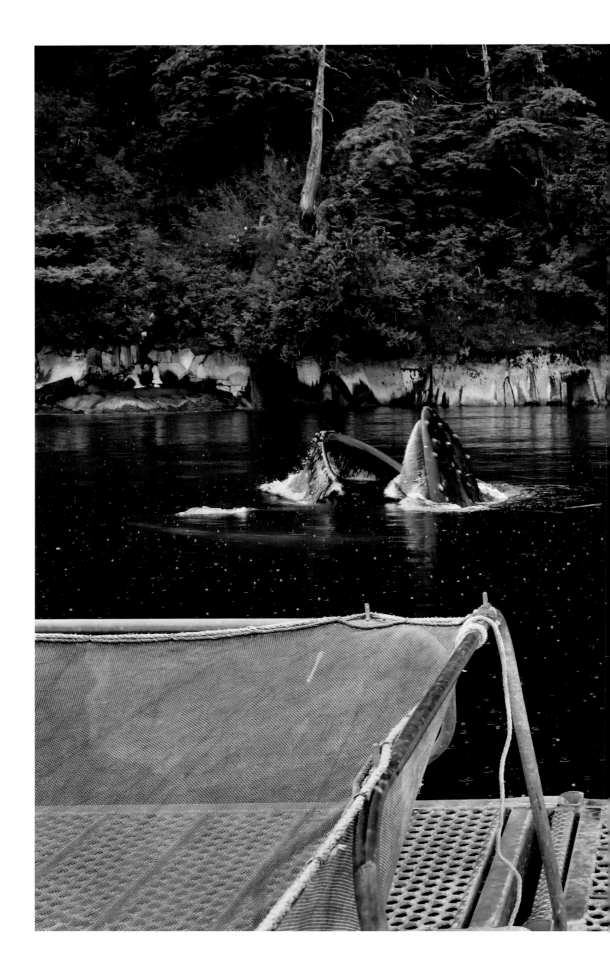

**FOILED AGAIN**
A worker at the Hidden Falls Hatchery in Alaska stares crestfallen at a humpback whale feeding on baby salmon just released on a rainy day. The hatchery raises the fish from eggs gathered in nearby rivers to increase the number of baby fish— and the number of adults that fishermen can catch. The whales, however, have changed the equation.

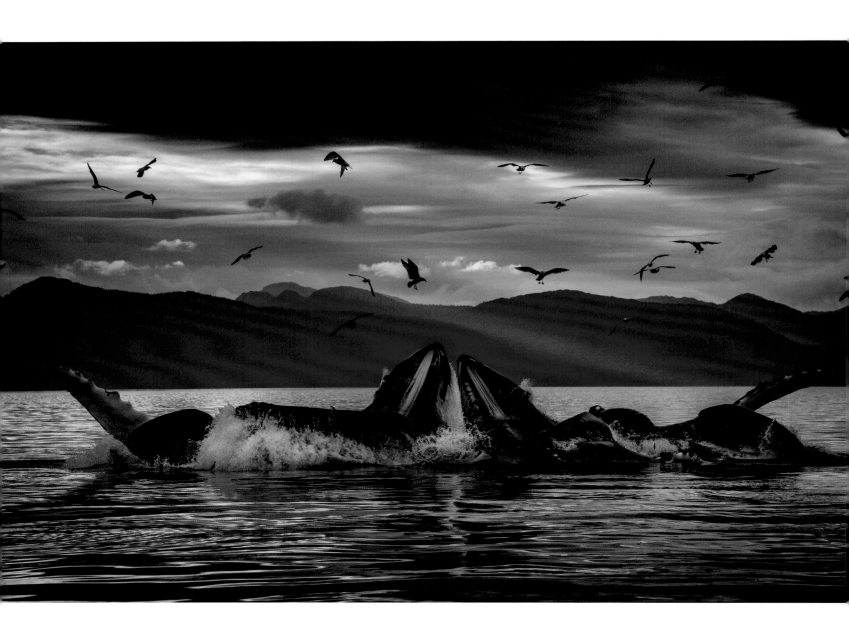

## DINNER WITH FRIENDS

As the last rays of sun wane across the mountain landscape, a group of humpbacks break the surface in a climax of bubble-net feeding in Alaska's Chatham Strait. The whales engaged in this communal culture come together each year to feed: old friends reuniting each summer.

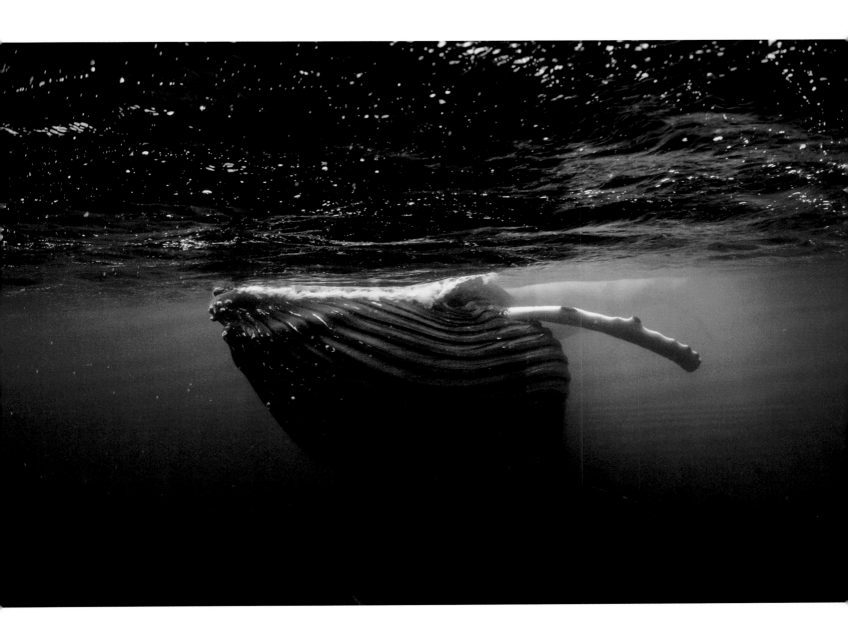

**BOO!**
In the dimly lit waters of the Norwegian Arctic, a humpback whale fills its mouth with herring, its throat pleats fully expanded. This whale surprised me, appearing a few feet away with an open mouth. Being around feeding whales in water with low visibility can sometimes be a dicey business!

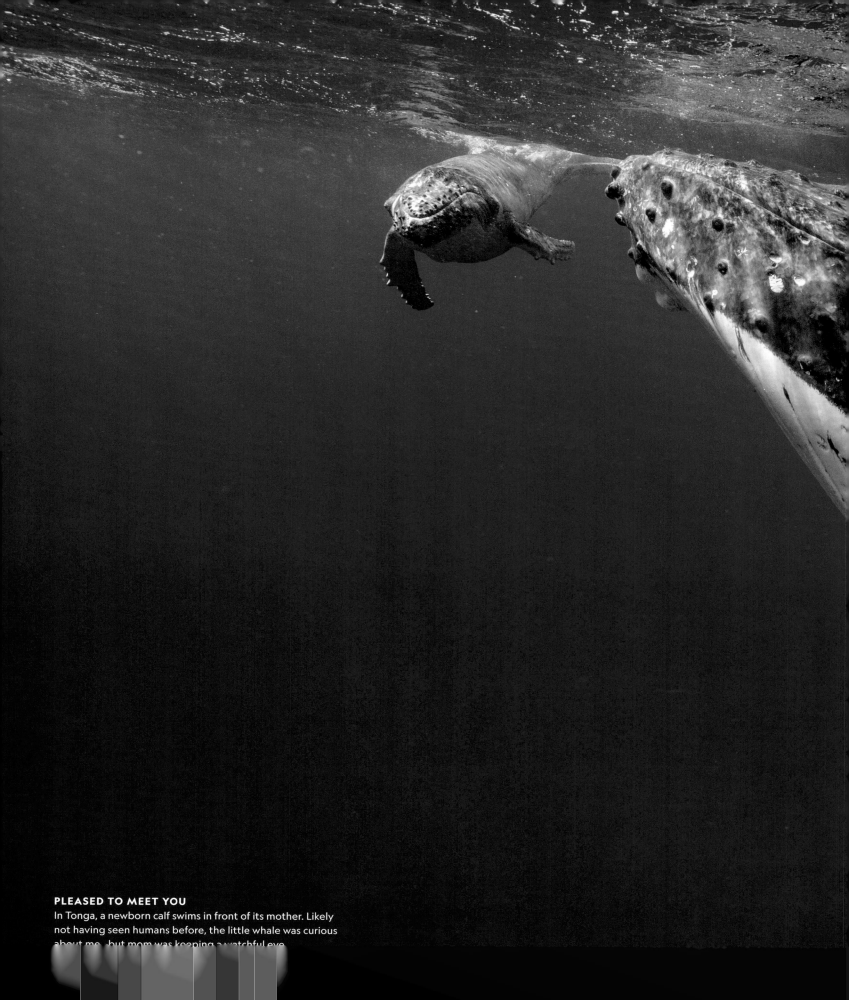

**PLEASED TO MEET YOU**
In Tonga, a newborn calf swims in front of its mother. Likely
not having seen humans before, the little whale was curious
about me, but mom was keeping a watchful eye.

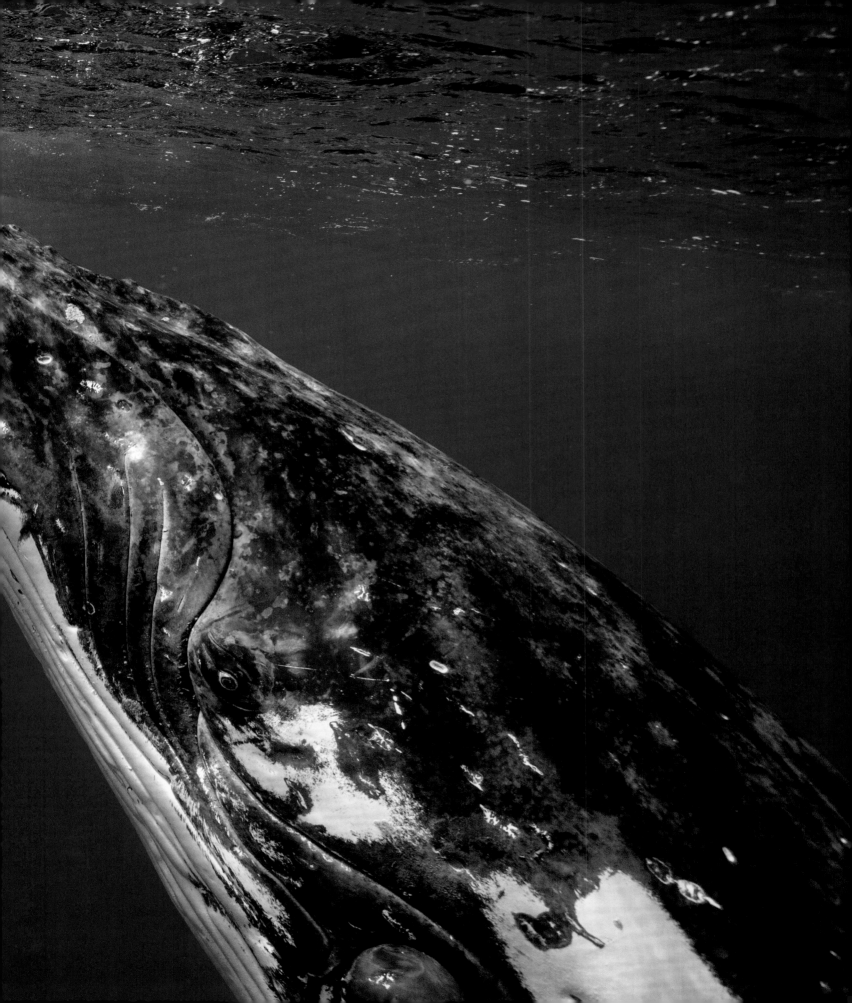

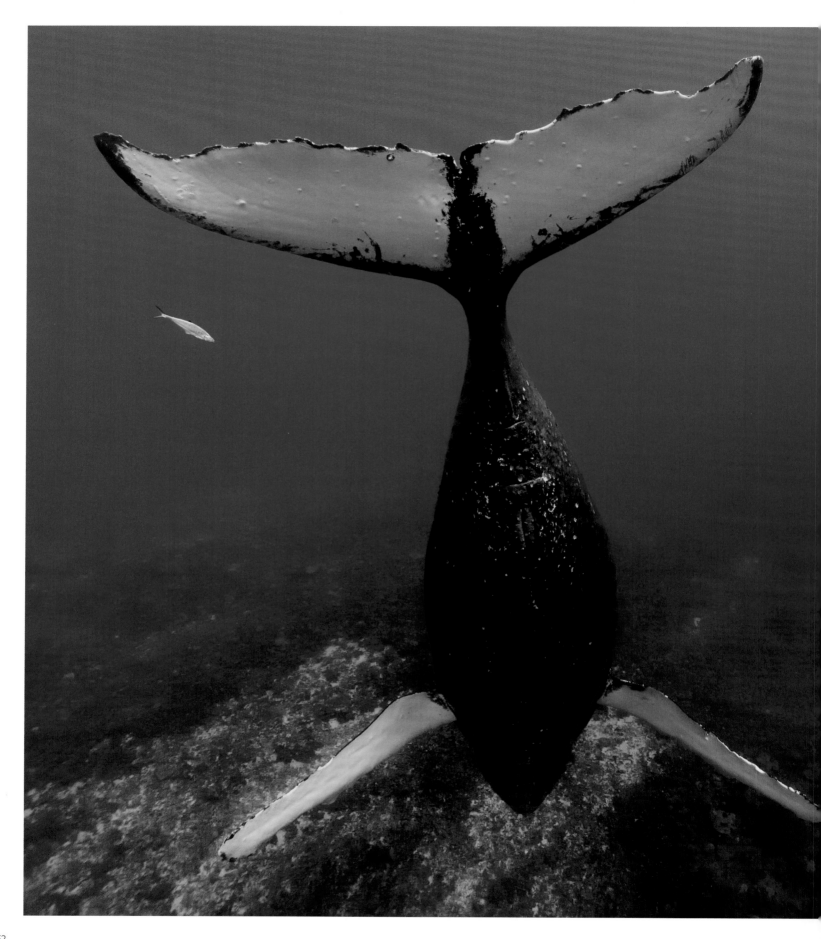

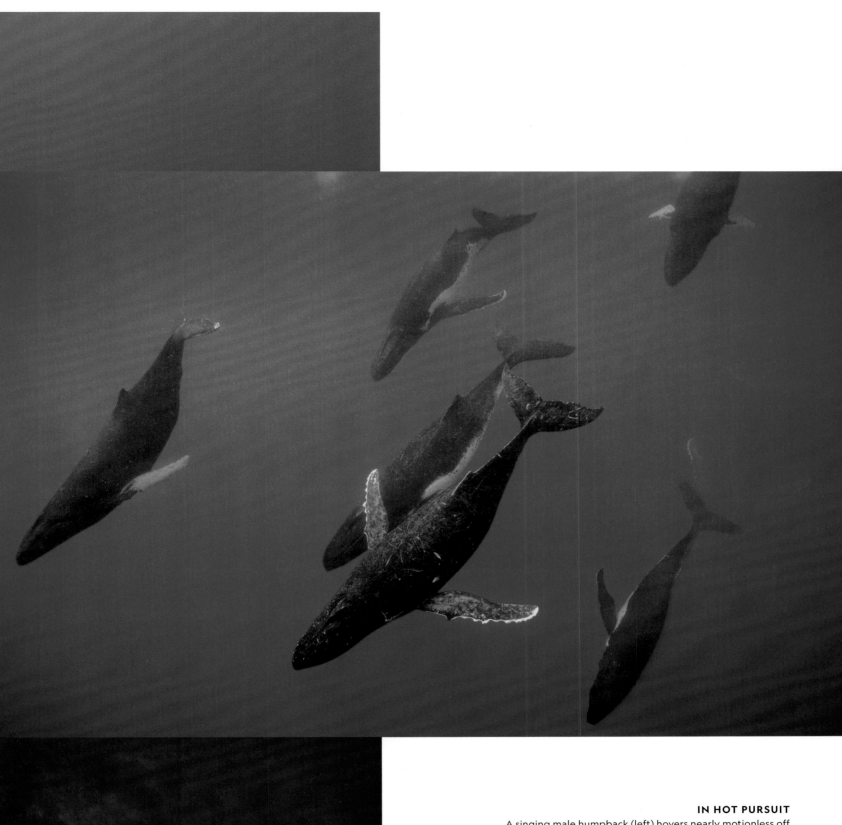

**IN HOT PURSUIT**
A singing male humpback (left) hovers nearly motionless off the Cook Islands. A squadron of male humpbacks in Tonga (right) pursue a female in what is sometimes called a heat run or active group. This is essentially a battle between males for the right to accompany a female—but whether the female has an interest in the winner is another matter.

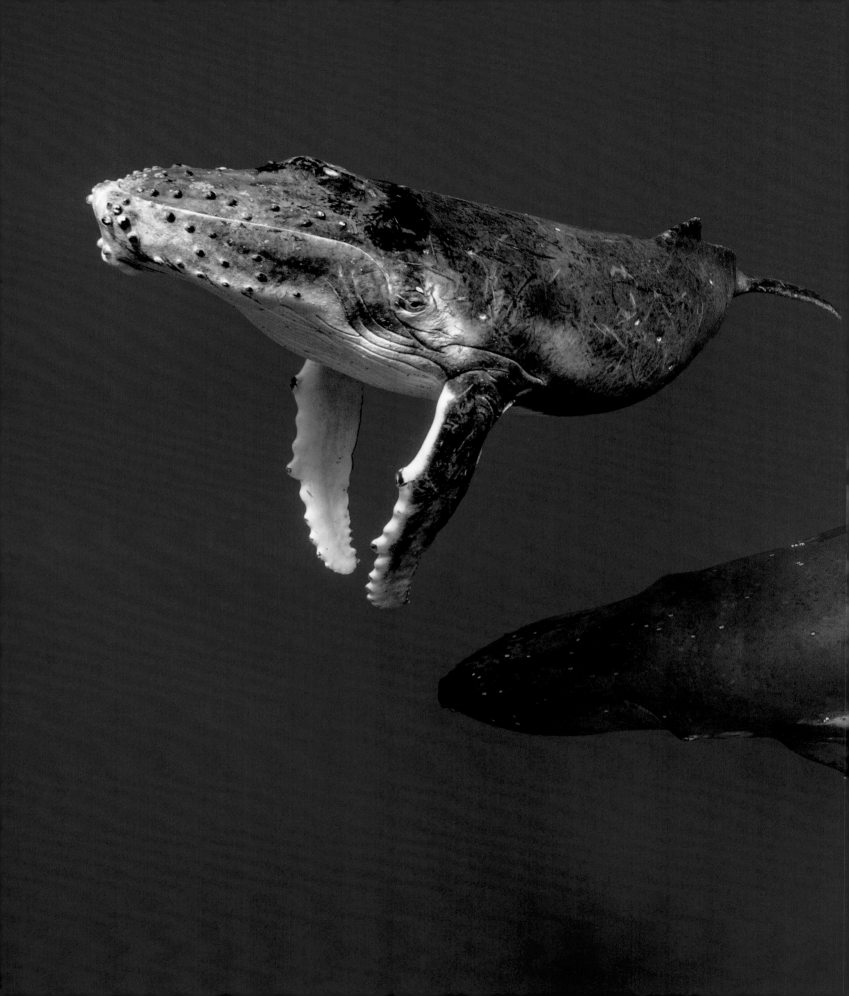

# BEHIND **THE SHOT**

One morning in a cove off the coast of a sm
island in Tonga, in the South Pacific, I saw a lit
blow on the surface. A humpback calf had co
up to take a breath; its mother, I thought, v
down below, probably sleeping. I slipped quie
into the water and began to swim toward the

I could just barely see the calf; the mother v
perhaps 50 feet below the surface. But the clo
I got, the clearer her form became. She was I
a spacecraft, completely motionless. As she
suspended in the monochromatic blue of t
water, her smaller vessel orbited around her.

After nursing, this giant baby crept up towa
its mother's head. Nuzzling its mother's face,
calf settled in beneath her body for a nap w
its nose sticking out.

But the little one had to take a breath at so
point. Up it floated. As the young whale nea
the surface, I could see its head more clea
illuminated by the sun. Then, its eye.

The calf looked at me, curious but hesitan
that moment I felt like apologizing to this anir
for all the harm humans have inflicted on wha
I tried to slow my heart rate so the young wh
wouldn't sense any aggression from the f
human it had probably ever seen. We watch
each other. Then it raced back down to its moth
who still lay sleeping in the dark blue sea.

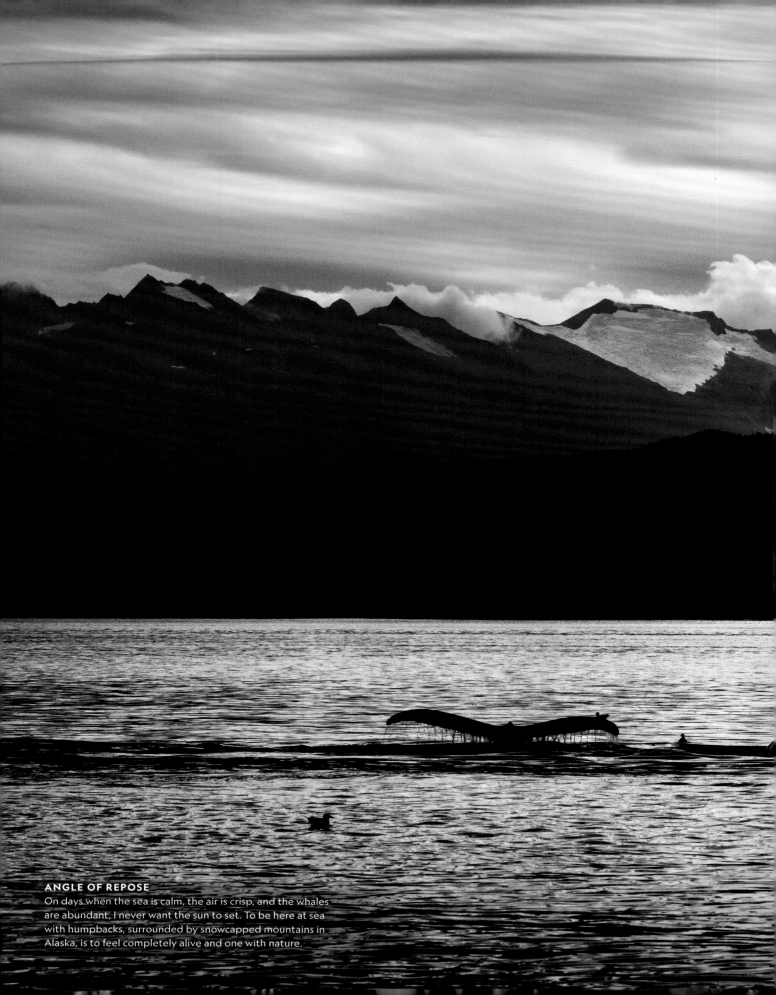

**ANGLE OF REPOSE**

On days when the sea is calm, the air is crisp, and the whales are abundant, I never want the sun to set. To be here at sea with humpbacks, surrounded by snowcapped mountains in Alaska, is to feel completely alive and one with nature.

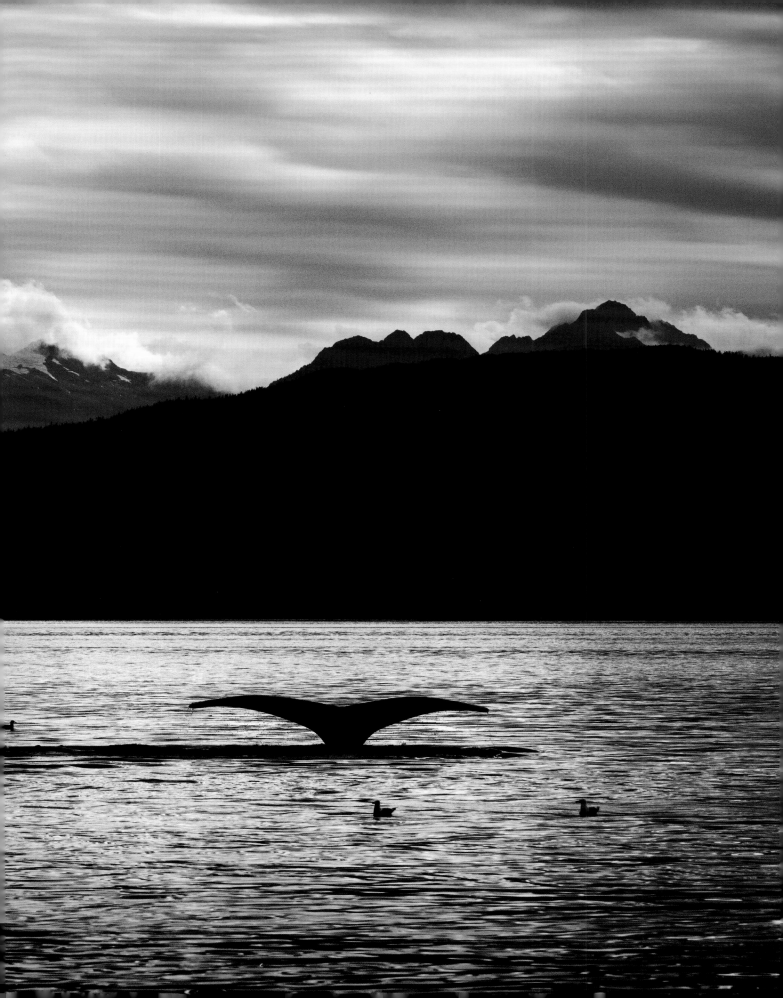

DOLP

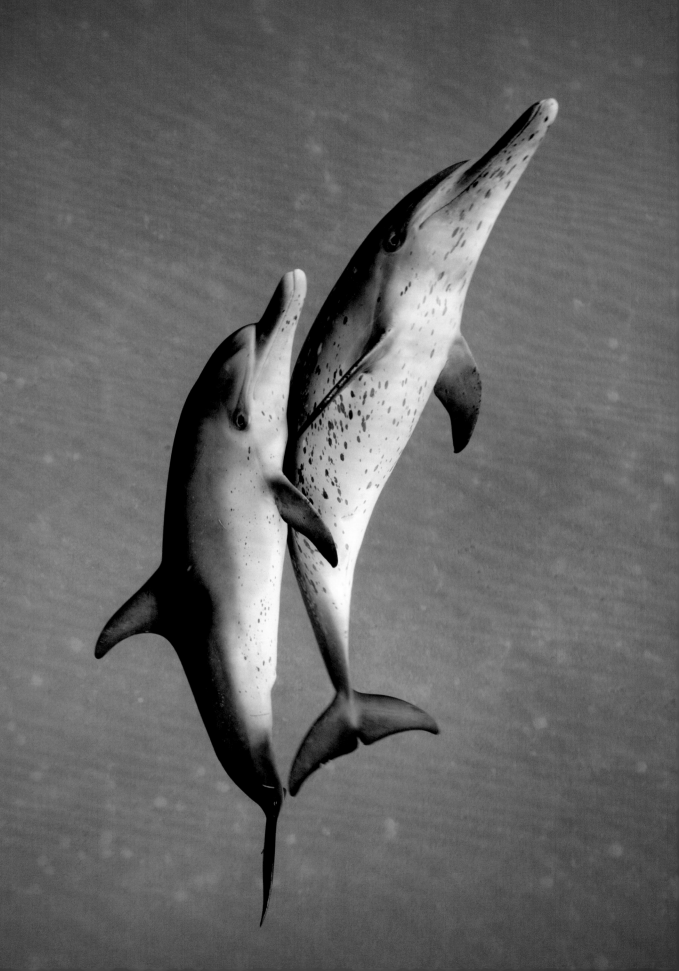

# GUARDIANS OF **THE DEEP**

W e've all heard the stories: A stranded swimmer or shipwrecked sailor is adrift at sea, believing the end is near, when a graceful animal with a curved mouth glides over. Then another, and another. Dolphins have come to the rescue.

Tales of dolphins helping people—some the stuff of legend, but many grounded in fact—have captivated our imaginations since ancient times. One of the first great seafaring people, the ancient Greeks, put dolphins on their coins, pottery, and in their frescoes. Homer wrote about the creatures; Herodotus told of a poet captured by pirates who jumped into the sea and was carried to shore by dolphins.

We don't know why dolphins appear to help humans. Like all cetaceans, much of what they do is a mystery. But something about their smarts and charisma make them some of the most magnetic of all marine mammals.

There are 36 dolphin species, and all belong to the whale family. They live in every ocean, with a few species in rivers and streams. Dolphins are highly social, living in

**DOLPHINS**
*Odontoceti*
**AVERAGE SIZE:** 3.5–23 feet
**AVERAGE WEIGHT:** Up to 6 tons
**SPECIES:** 36
**IUCN STATUS:** Varies

pods of a dozen or more animals, and need an almost humanlike level of social stimulation to thrive. They communicate in squeaks, whistles, and clicks.

Whether I'm with spotted dolphins in the Bahamas, spinner dolphins in Hawaii, or dusky dolphins in the Golfo Nuevo, I marvel at a common theme: Dolphins always seem like they're having a blast.

This cannot really be the case, of course. We know these animals have sophisticated lives. They can be threatening; sometimes they hurt or kill other dolphins. They've been known to mob much larger whales. (One scientist summed it up this way after watching a half-dozen Pacific white-sided dolphins swarm a humpback, apparently just for the fun of it: "Dolphins can be mystical *and* complete jerks—both things are true.") And dolphins confront many of the same dangers as other marine mammals—particularly ship strikes and entanglement with fishing gear.

Yet every time I see them, they're always swimming, leaping, and biting each other. They like to play games

A pair of spotted dolphins rise up over a sandy seafloor in the Bahamas.

with seaweed, passing it back and forth, before racing off somewhere. They've always got someplace to go.

How do we know dolphins are smart? For starters, after humans, they have the largest brain-to-body ratio of any living being. They show self-awareness and recognize themselves in mirrors at an even earlier age than humans do. Half their brain stays awake during sleep so the creatures can breathe. They love to play games. And they can solve complex problems—like how to catch, kill, and consume a writhing octopus.

Few animals know how to use tools, but dolphins can. They've been known to affix marine sponges to their noses for protection while looking for food in rough sand. And in Australia, scientists have documented bottlenose dolphins chasing fish into empty seashells, ferrying the shells to the surface, and then using their rostrums to shake the shells and empty the fish into their mouths.

What's most striking about this technique, known as "shelling" or "conching," is that it isn't something dolphins learn from their nuclear family; they pick it up from other unrelated animals in their social circles. It's a sophisticated way of learning, usually seen only in orangutans, chimpanzees, and humans.

Dolphins use finely tuned sonar to see the world acoustically and locate their prey. Like some other cetaceans, their feeding strategies vary widely and exemplify their unique cultures. Bottlenose dolphins in Florida, for instance, create a ring of mud in shallow water, encircling fish—typically mullet. The fish will not swim through the ring, but do leap over the top. The dolphins position themselves outside the ring and feed on the jumping fish.

In the Bahamas, this same species of dolphin will swim along the sandy seafloor using sonar to scan for prey. Then they'll make a sudden turn and dig their rostrum into the sand to grab a meal. One study found that dolphins who use this method of crater feeding show an even stronger right-side bias than humans. Dolphins nearly always turn the same direction just before digging into the sand.

One of the most revealing aspects of dolphins' lives is the way they communicate. Researchers have spent decades trying to understand whether the sounds and structures of dolphins' vocalizations might form the basis of a language.

Scientists are careful not to characterize marine mammals' behavior in human terms. This is especially true for highly expressive dolphins. But sometimes dolphins make sounds that suggest they are conveying complicated emotional information to one another. A few years ago, researchers working in southern China encountered a Indo-Pacific humpback dolphin carrying a dead calf, trailed by other dolphins. The animals whistled in longer, more complex calls than the researchers were accustomed to hearing. The pitch of the whistles was different; there were many more inflection points. The scientists speculated that the dolphins were grieving.

Although we haven't yet figured out exactly what dolphins say to one another, we do know they're capable of these sorts of complex communications. In addition to their whistles and clicks, which they make—and hear—on

# FEW ANIMALS KNOW HOW TO USE TOOLS, BUT DOLPHINS CAN. THEY'VE BEEN KNOWN TO AFFIX MARINE SPONGES TO THEIR NOSES FOR PROTECTION WHILE LOOKING FOR FOOD IN ROUGH SAND. AND IN AUSTRALIA, SCIENTISTS HAVE DOCUMENTED BOTTLENOSE DOLPHINS CHASING FISH INTO EMPTY SEASHELLS.

a frequency 10 times higher than that of humans, they also use postures to express themselves. With the help of machine learning, researchers are trying to parse the animals' sounds, crack the code of dolphin-speak, and maybe even establish two-way communications.

Dolphins also exhibit an uncanny sixth sense, which I experienced firsthand a number of years ago. After wrapping up some work with spinner dolphins in Hawaii, I invited a special guest on the boat: a teenager named Skye who'd been battling cancer. Through the Make-a-Wish Foundation, she came to Hawaii to spend a day with me. My goal was to get Skye in the water with dolphins.

It hadn't been an easy stretch of work. The animals had been elusive, and my photos were hard-won; I wasn't completely confident they'd show up at all. I set out on the boat with Skye and her mother. We spotted some dolphins, and Skye got in the water. Within minutes, the dolphins swam over.

Around and around they spun, circling her as she snorkeled. For hours, they fell into a beautiful ballet with this girl who'd been through so much. Her mother watched from the boat in tears. As the sun set that evening, we were salty and a little sunburned. The dolphins had worked their magic on Skye and her mother. A catharsis had occurred.

Maybe luck was on our side that day. Or maybe those dolphins, through some powerful intuition, sensed Skye's presence and her vulnerability. She wasn't stranded or shipwrecked. But the dolphins rescued her all the same. ■

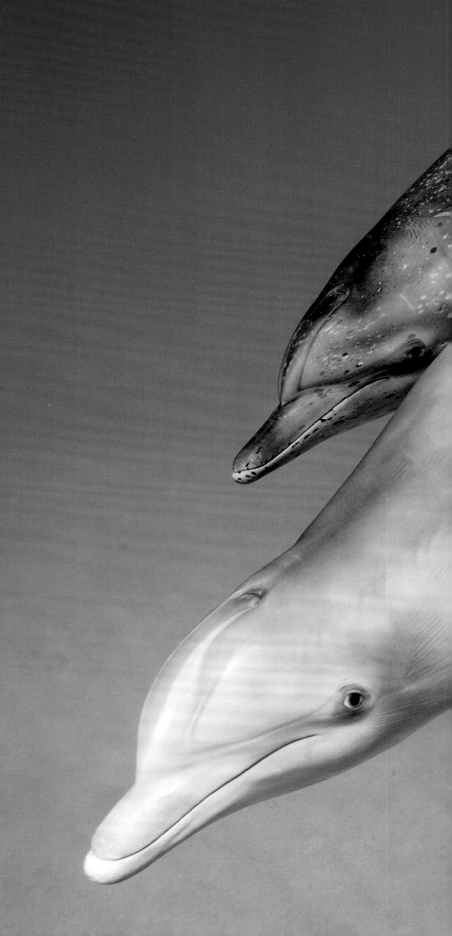

**WHAT ARE THEY THINKING?**
A bottlenose dolphin swims among spotted dolphins in the Bahamas. With the largest brains relative to body size after humans, dolphins possess high cognitive ability. Yet they are voluntary breathers, keep half their brains awake while sleeping, and see acoustically as well as with their eyes.

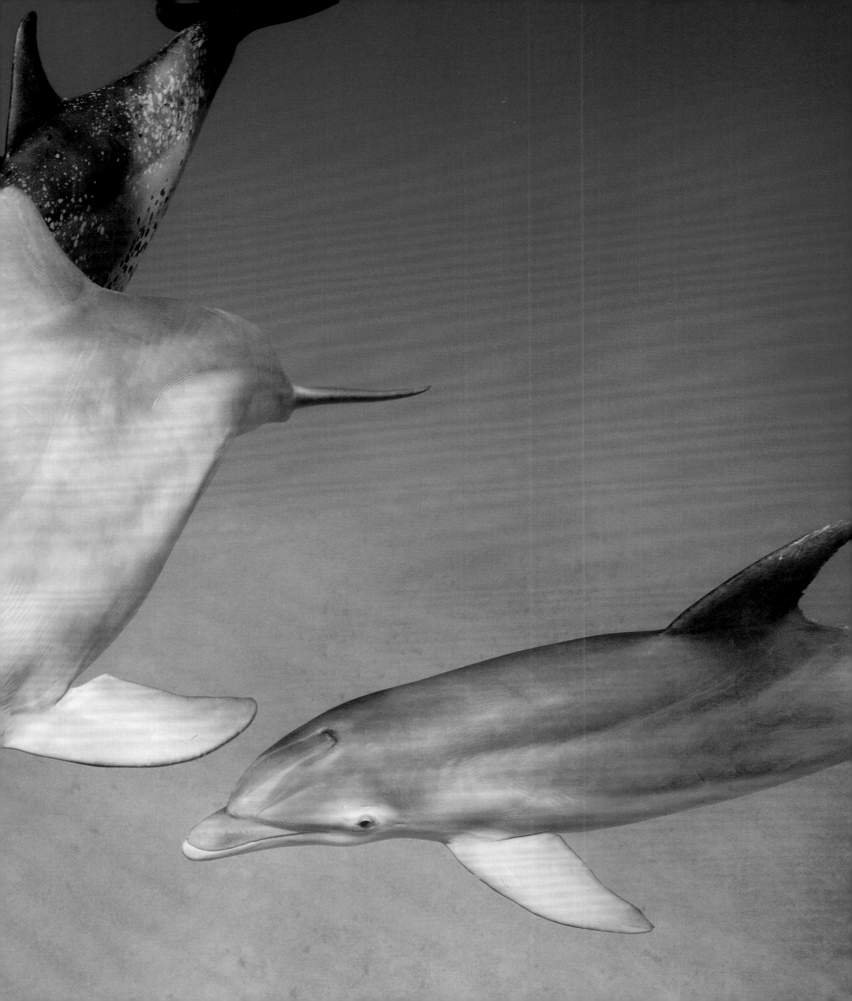

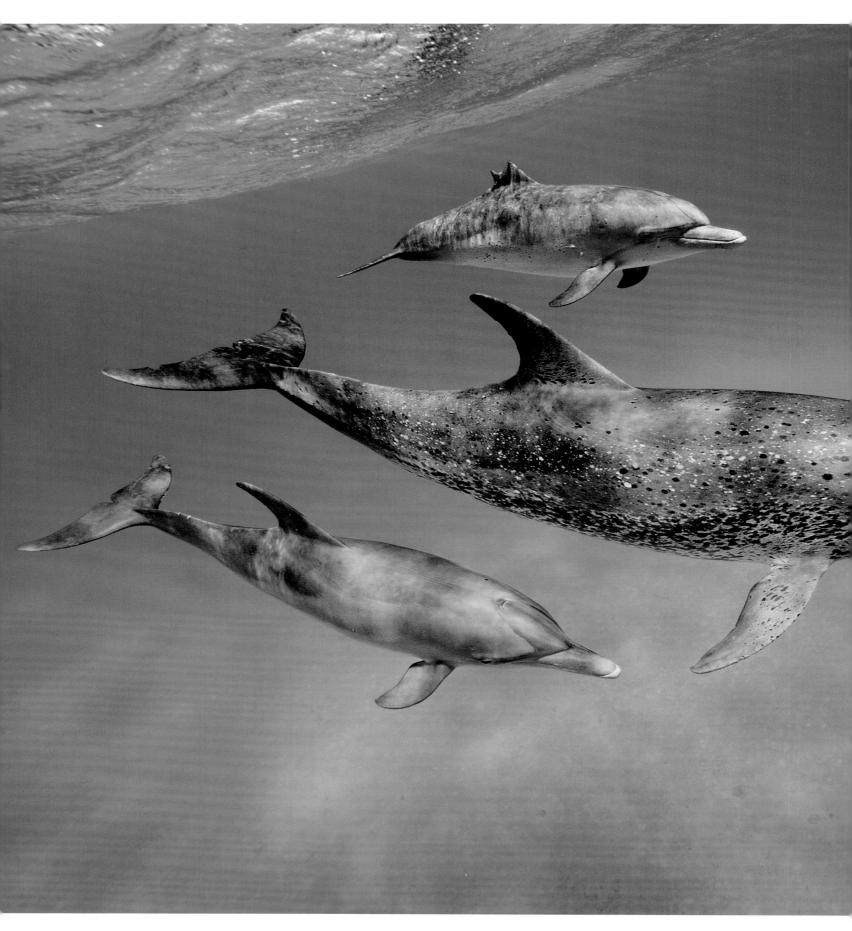

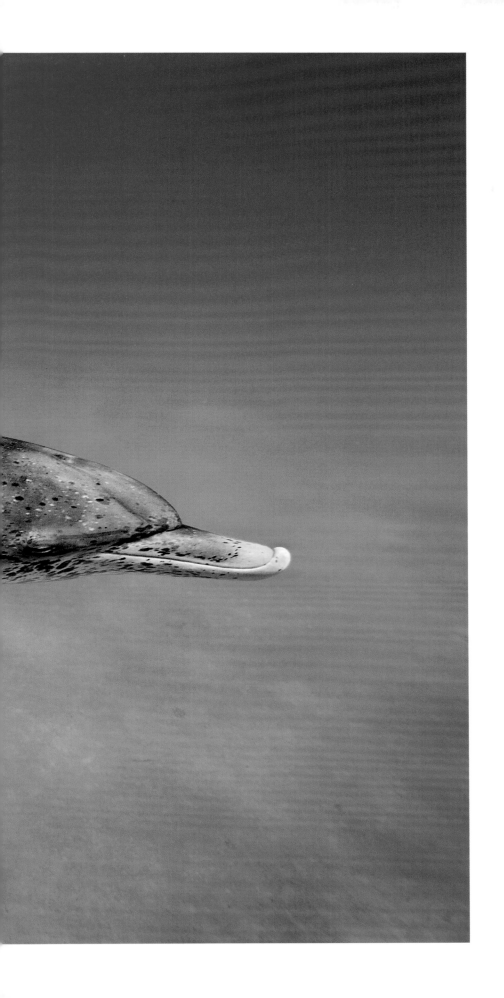

**BENEATH THE WAVES**
A trio of spotted dolphins glides just below the surface in the Bahamas. The animal in the background lost a piece of its dorsal fin to a shark bite.

167

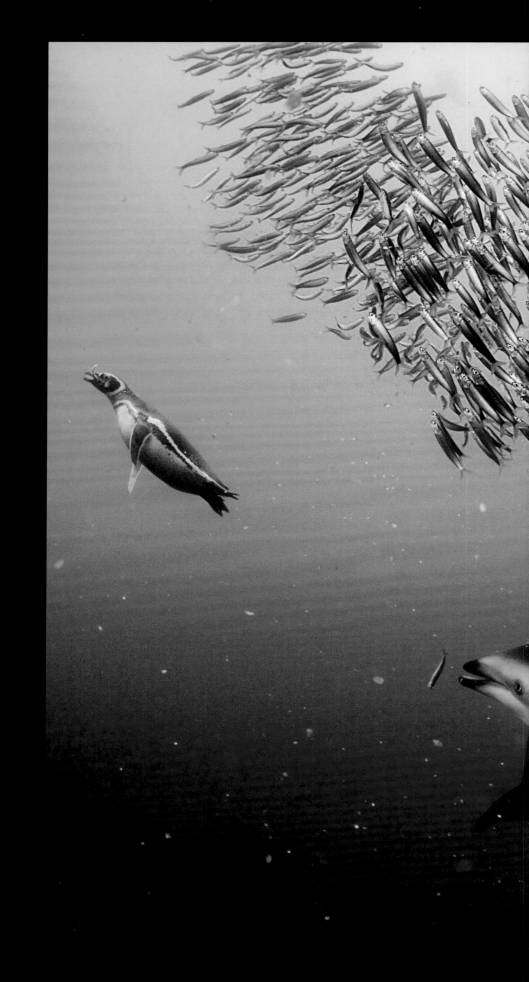

# BEHIND **THE SHOT**

The greatest skill a wildlife photographer can possess is patience. But after three weeks in Patagonia, my patience was severely tested.

I had come to Argentina in hopes of photographing dusky dolphins feeding on anchovies. The duskies herd small fish into bait balls using communication underwater; it's a unique strategy that speaks to the dolphins' intelligence and culture.

But it was a cold, rainy March in Valdes Peninsula, and in three weeks I was only able to go out to sea a handful of times. I swam with dolphins, but never glimpsed the elusive behavior I sought.

My last day in Patagonia dawned like all the rest. I made dozens of "jumps," but nothing materialized. I sat on the transom in all my gear, the inevitability of defeat closing in around me. My assistant, Luis Lamar, suggested I change my pony bottle. I demurred; we only had 15 minutes of sunlight left. But Lu persisted, so I agreed.

A moment later I was at a depth of 30 feet, awestruck. In front of me was what remained of a bait ball of anchovies, along with at least six dusky dolphins, penguins, shearwater birds, and sea lions. In the dimly lit sea, I spun around shooting like a madman. Time no longer existed, and I was in another place, struggling to frame a shot in the chaos.

On the long ride back, I scrolled through the images on my camera's display, then stopped and smiled at Lu. I had my picture.

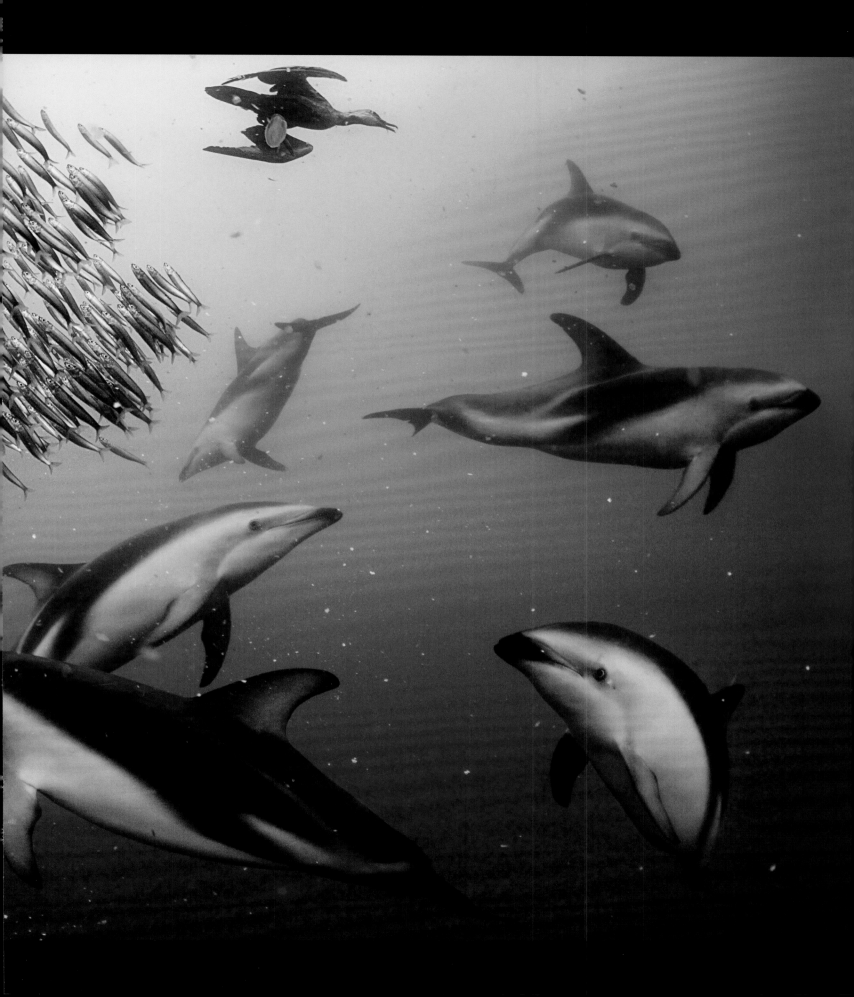

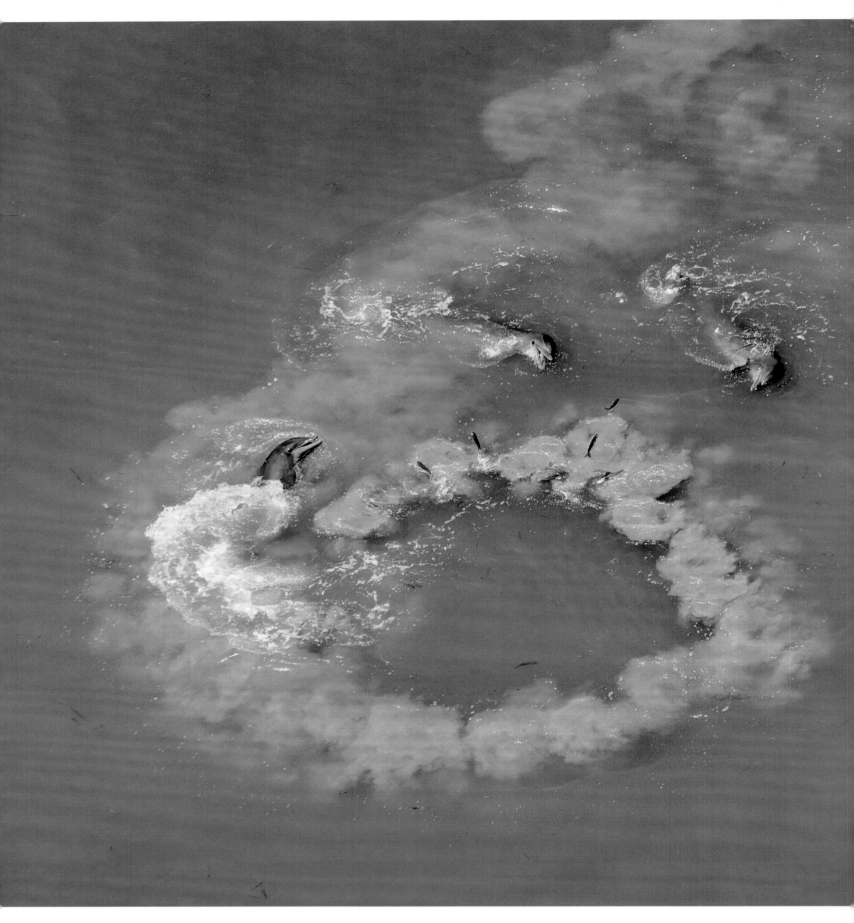

### CREATIVE DINING
Three bottlenose dolphins enjoy the spoils of their mud-ring feeding strategy in Florida Bay. Using its tail, one dolphin creates a concentric circle of mud around a school of mullet. Fearful of swimming into the mud wall, the fish jump nervously over the top—right into the mouths of the dolphins.

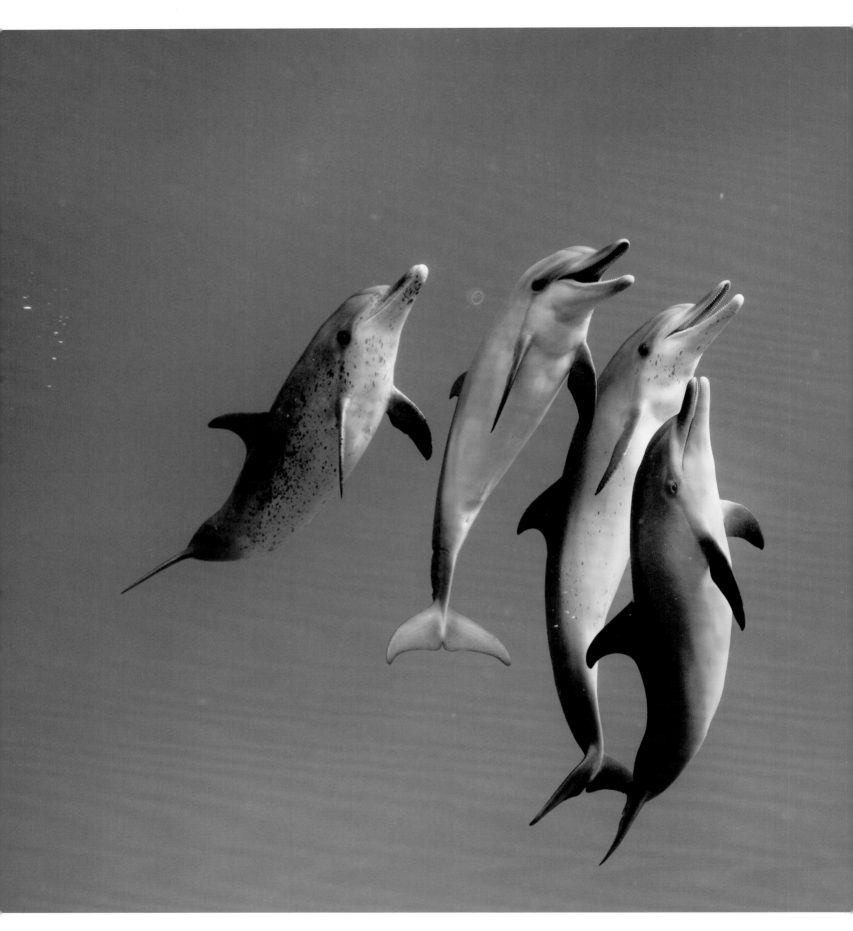

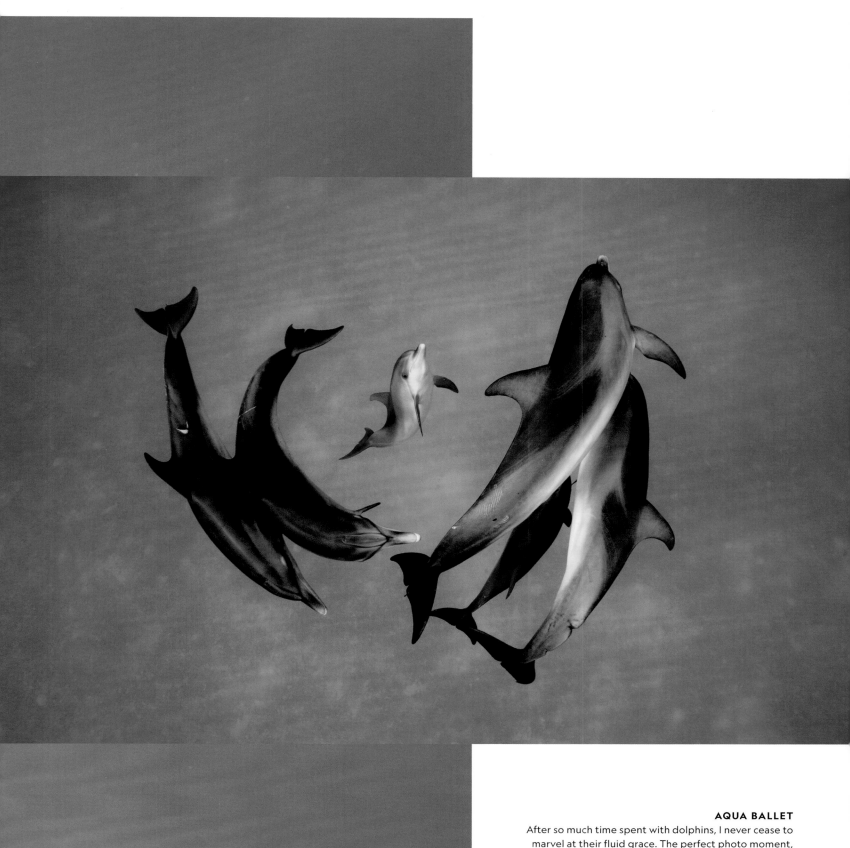

**AQUA BALLET**
After so much time spent with dolphins, I never cease to marvel at their fluid grace. The perfect photo moment, however, typically means countless hours of swimming and patiently waiting for a scene to align, as happened with these spotted dolphins. Opportunity meeting with preparedness: the definition of luck.

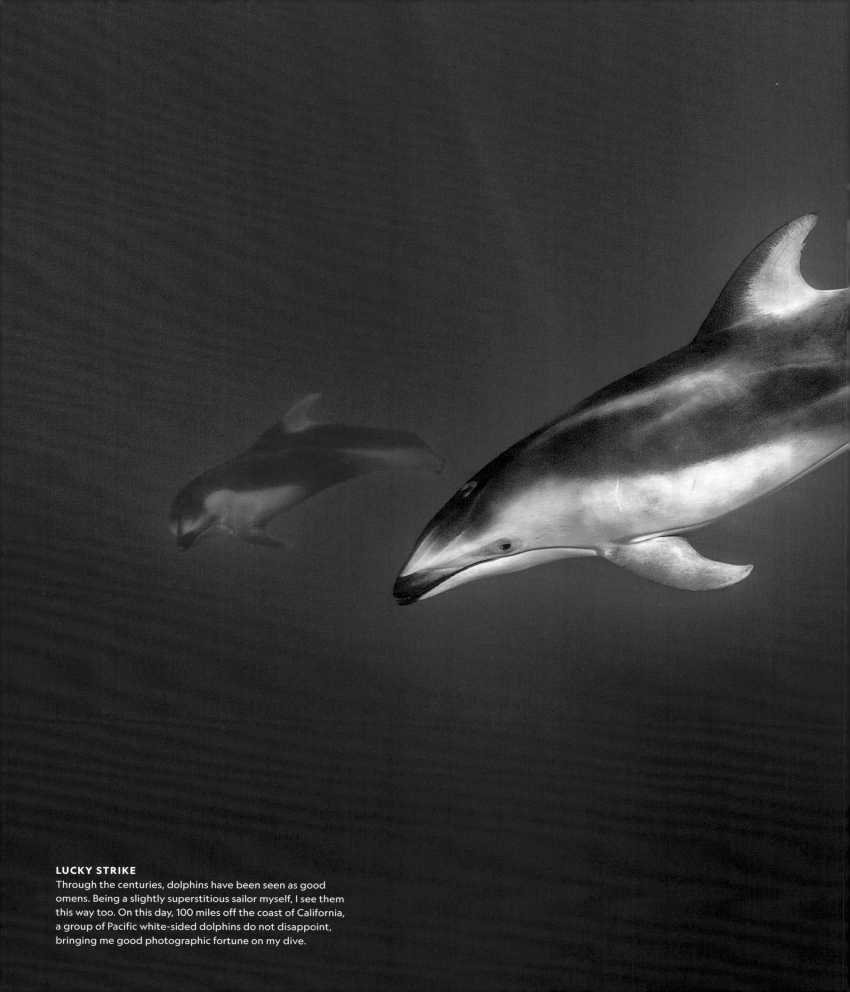

**LUCKY STRIKE**
Through the centuries, dolphins have been seen as good omens. Being a slightly superstitious sailor myself, I see them this way too. On this day, 100 miles off the coast of California, a group of Pacific white-sided dolphins do not disappoint, bringing me good photographic fortune on my dive.

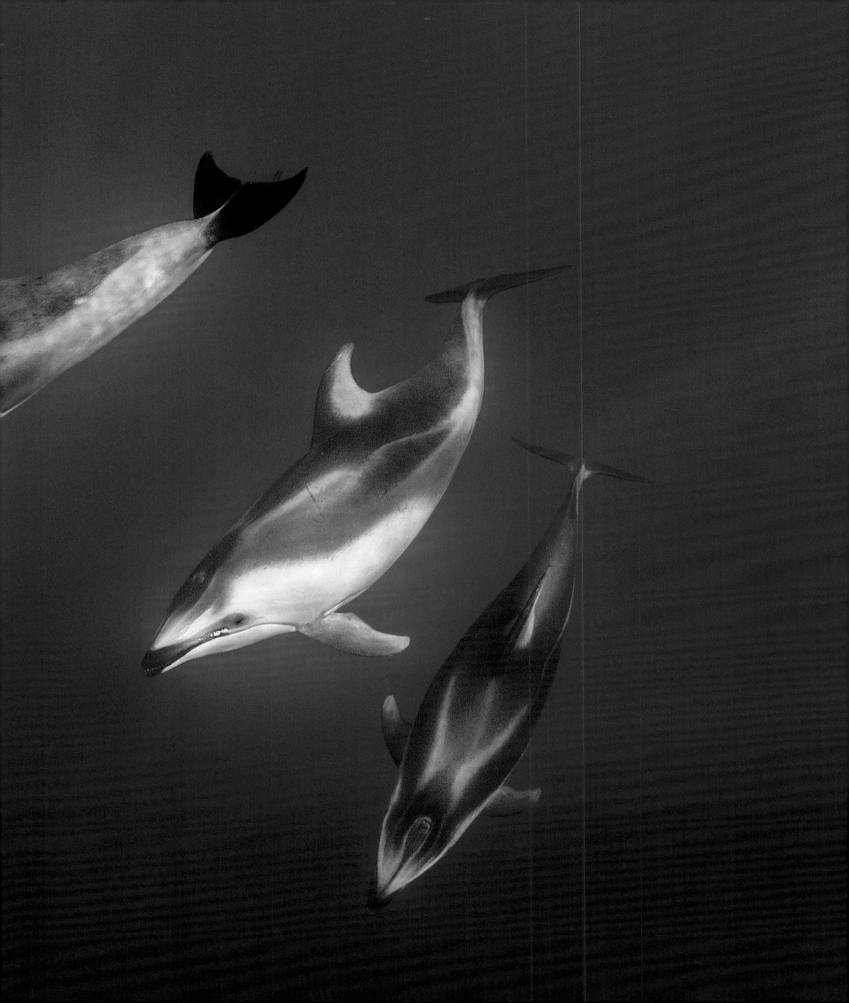

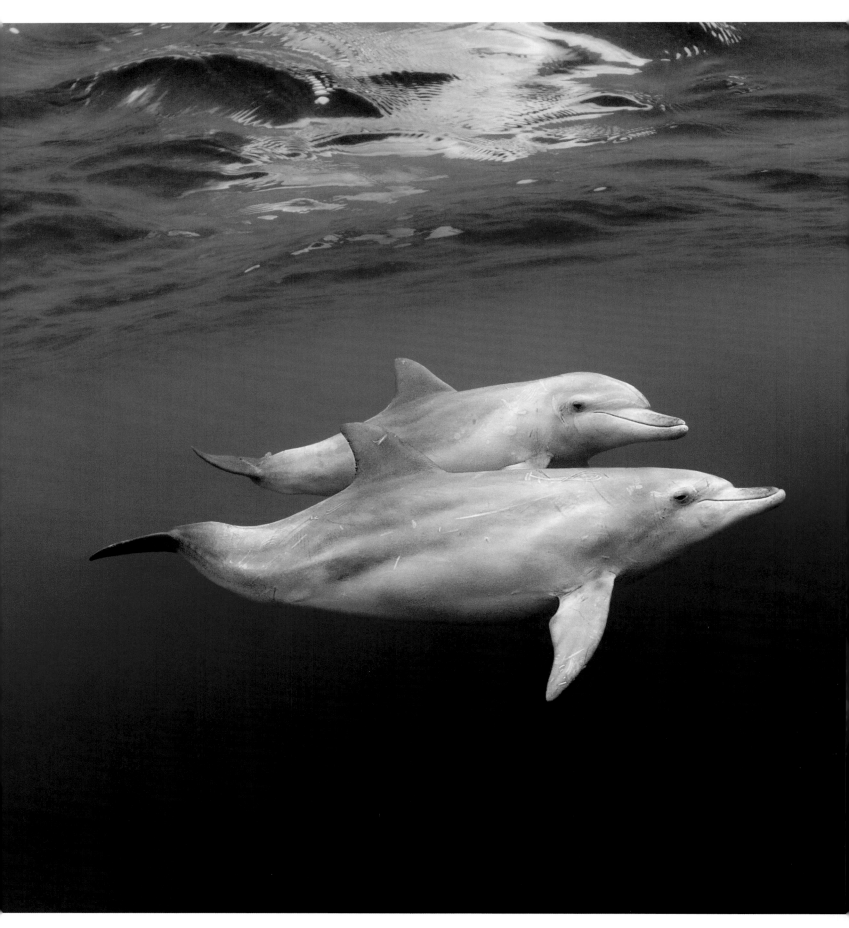

## THERE'S NO PLACE LIKE HOME

A pair of Indo-Pacific bottlenose dolphins off Jeju Island, South Korea. Members of this pod were illegally captured and kept in the Seoul zoo. In 2013, the captive dolphins were released back into the wild off Jeju and rejoined their birth pod. The IUCN classifies this species as Near Threatened.

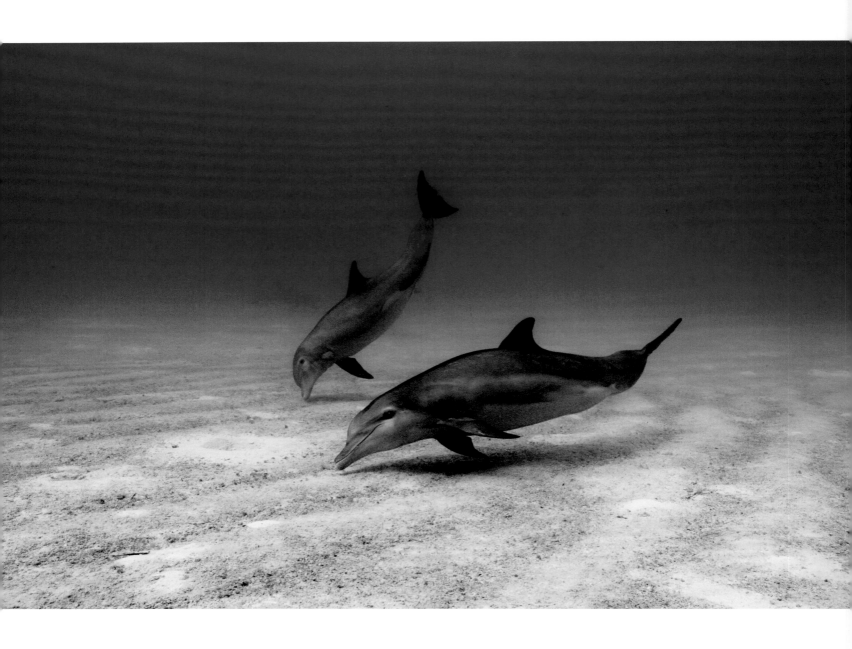

**SOUP'S ON**
These bottlenose dolphins use sonar to find fish hiding beneath the sand in the Bahamas. Once a fish is located acoustically, the dolphin inverts its body and uses its rostrum to grab the fish—another example of a creative feeding strategy that illustrates cognition and culture.

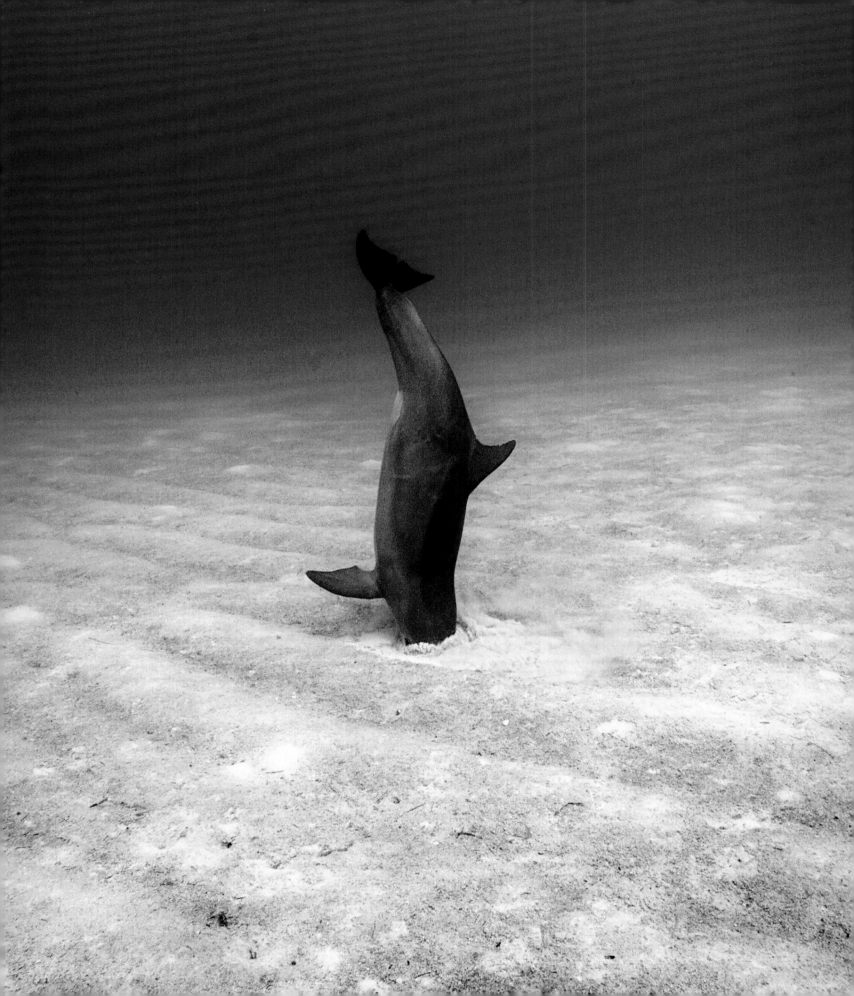

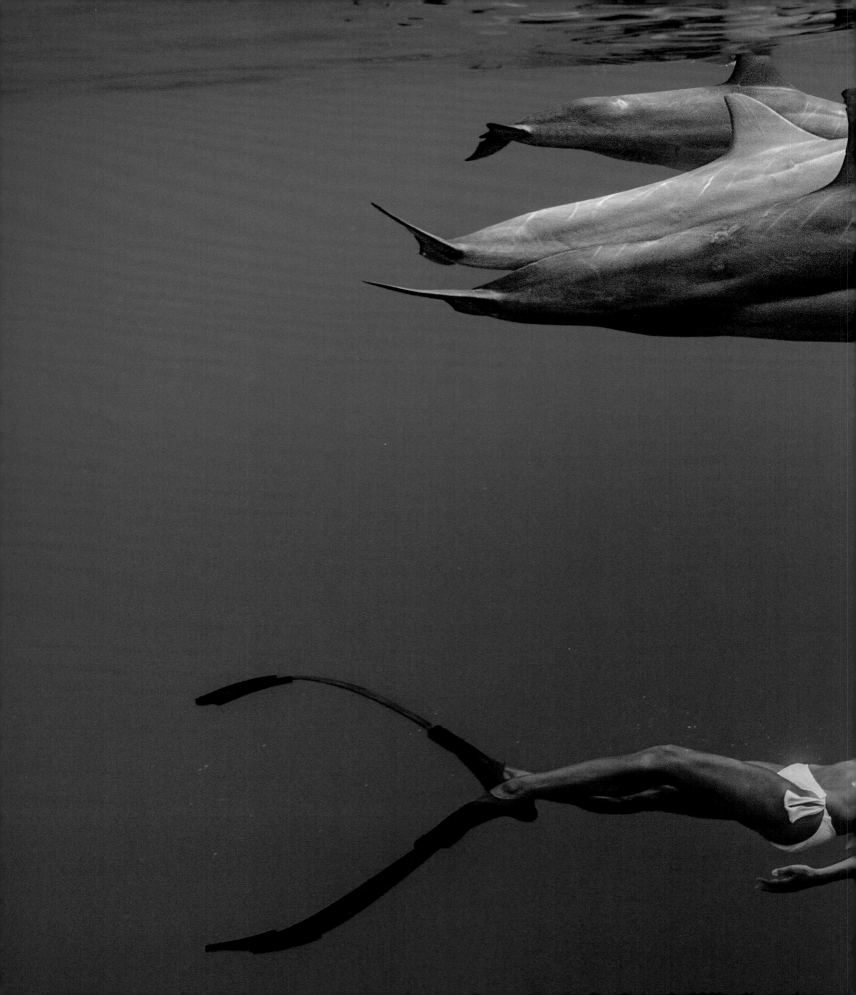

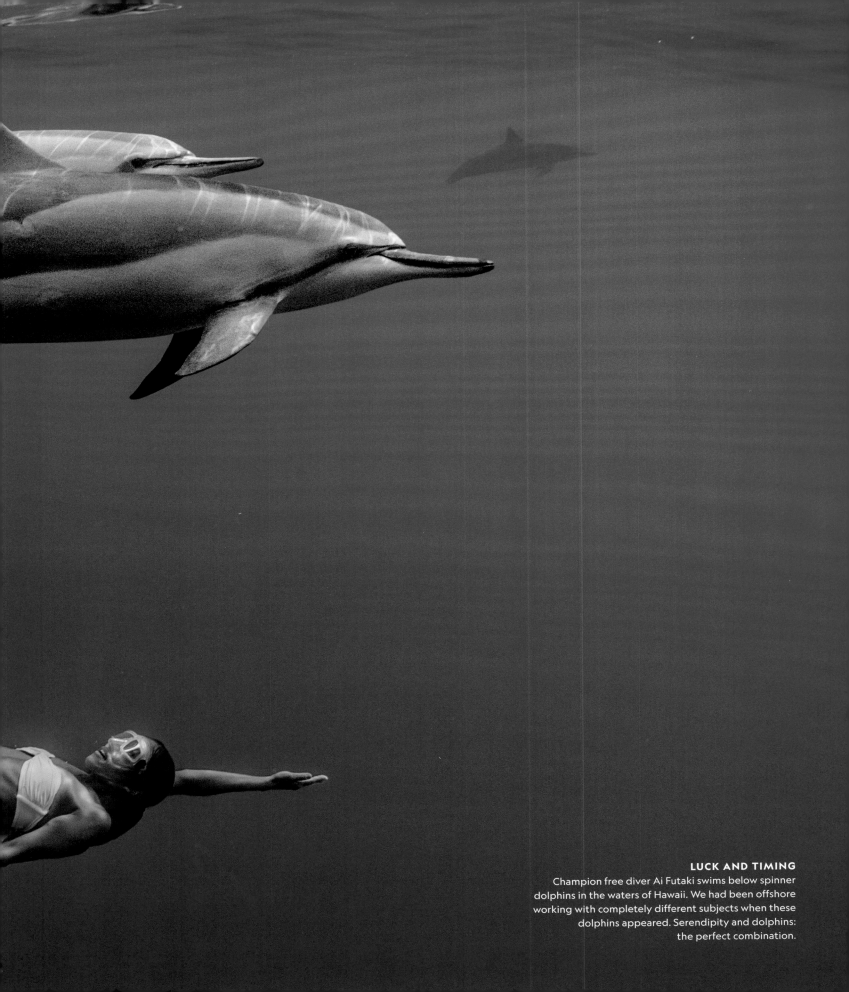

**LUCK AND TIMING**
Champion free diver Ai Futaki swims below spinner dolphins in the waters of Hawaii. We had been offshore working with completely different subjects when these dolphins appeared. Serendipity and dolphins: the perfect combination.

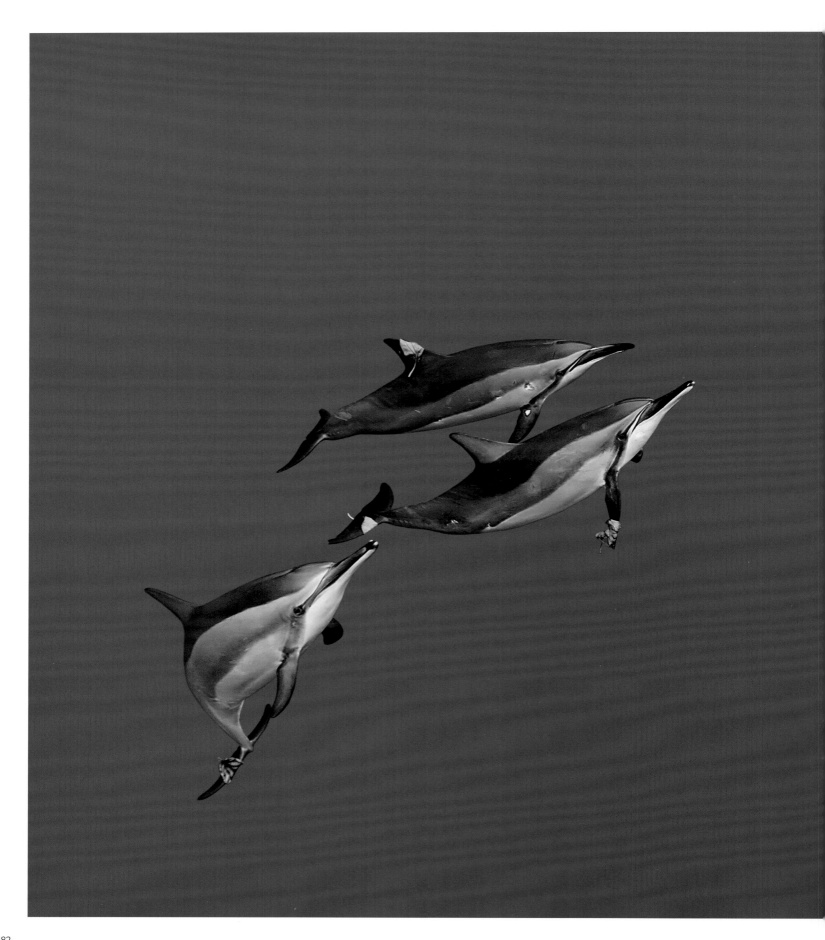

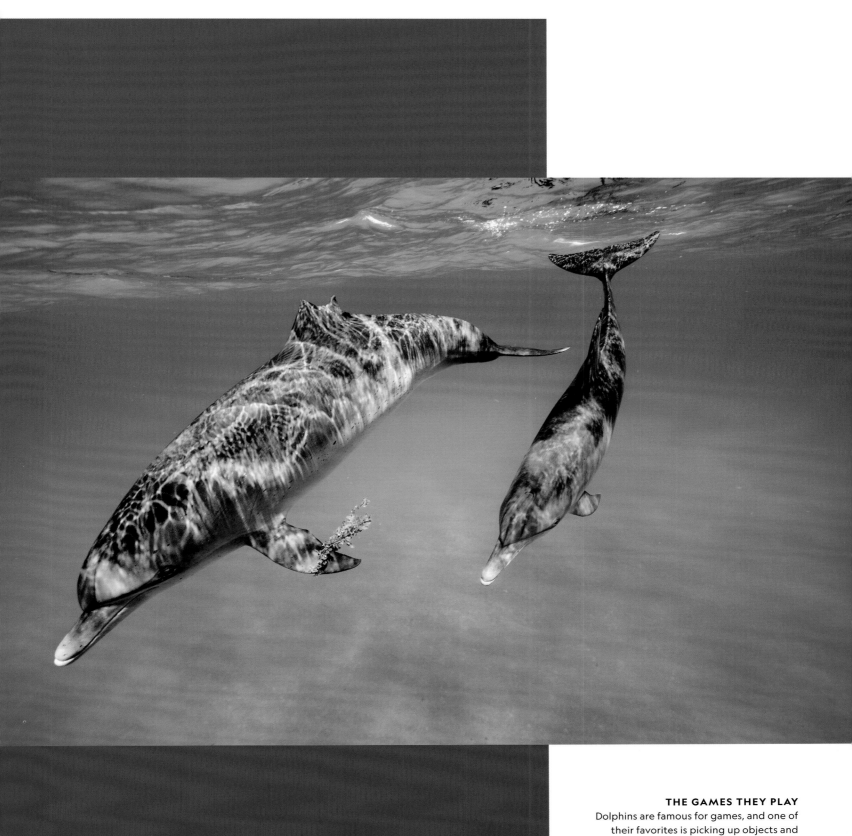

### THE GAMES THEY PLAY

Dolphins are famous for games, and one of their favorites is picking up objects and passing them to others. Early one morning in Hawaii, I found three spinner dolphins adorned with large leaves in a quiet bay (left). In the Bahamas (right), the object of choice for spotted dolphins is seaweed.

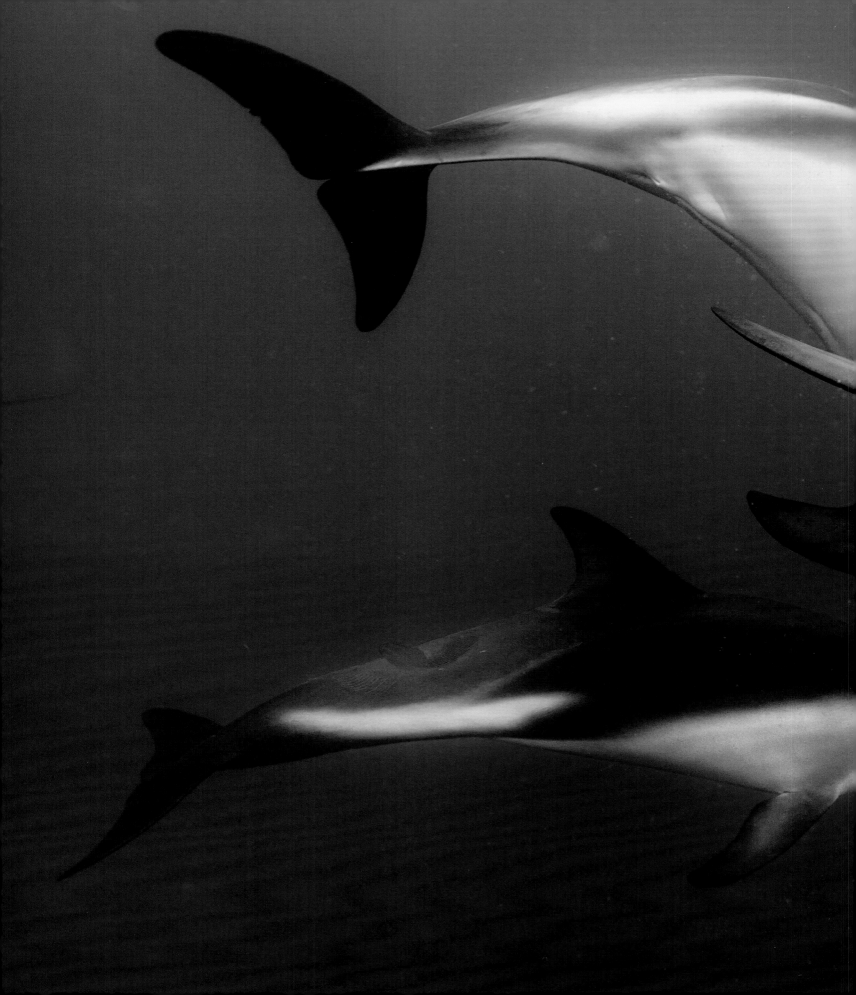

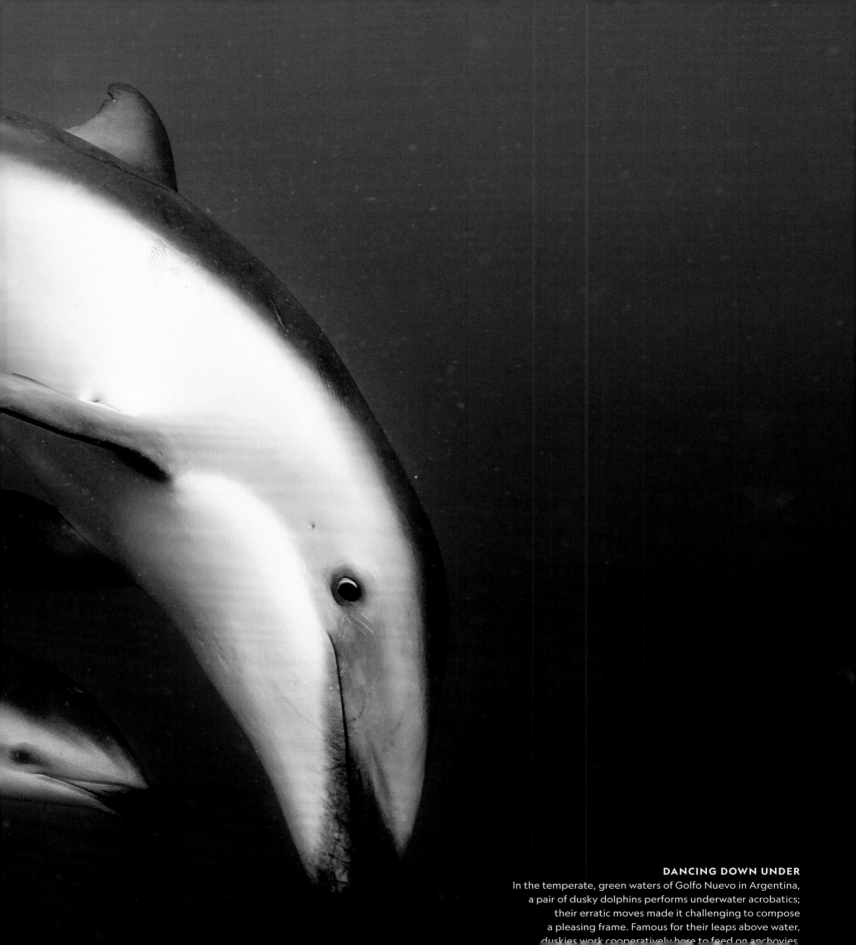

**DANCING DOWN UNDER**
In the temperate, green waters of Golfo Nuevo in Argentina,
a pair of dusky dolphins performs underwater acrobatics;
their erratic moves made it challenging to compose
a pleasing frame. Famous for their leaps above water,
duskies work cooperatively here to feed on anchovies.

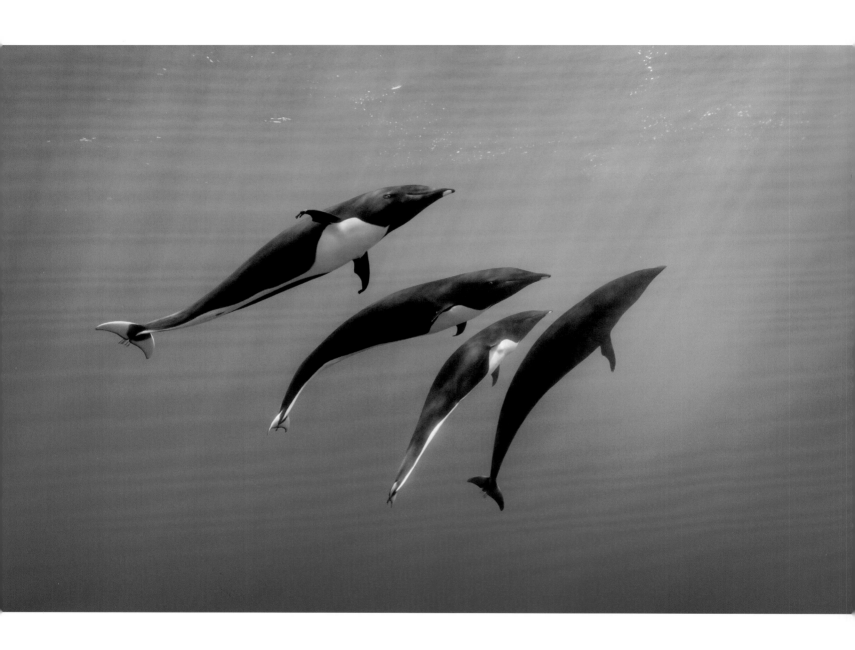

**UP CLOSE AND PERSONAL**
A rare meeting with northern right whale dolphins, 100 miles offshore in California. These delicate-looking animals with no dorsal fin appeared while I was on assignment on Cortes Bank.

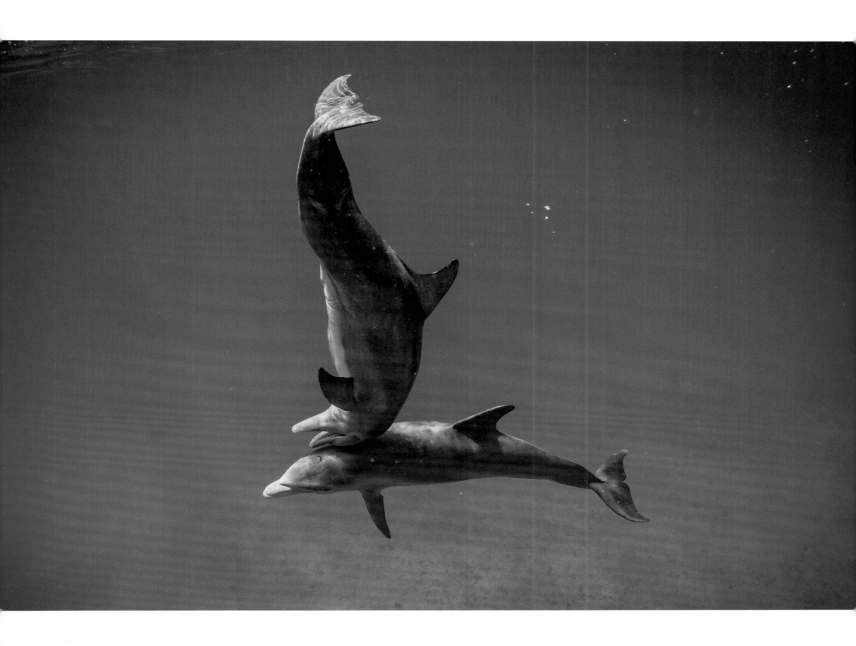

### HAPPY DANCE
Another unexpected encounter with bottlenose dolphins occurred in the waters off St. Croix in the U.S. Virgin Islands. With their ever present smile and antics, dolphins give the impression of being happy; though this cannot always be the case, repeated experiences nevertheless leave a lasting impression.

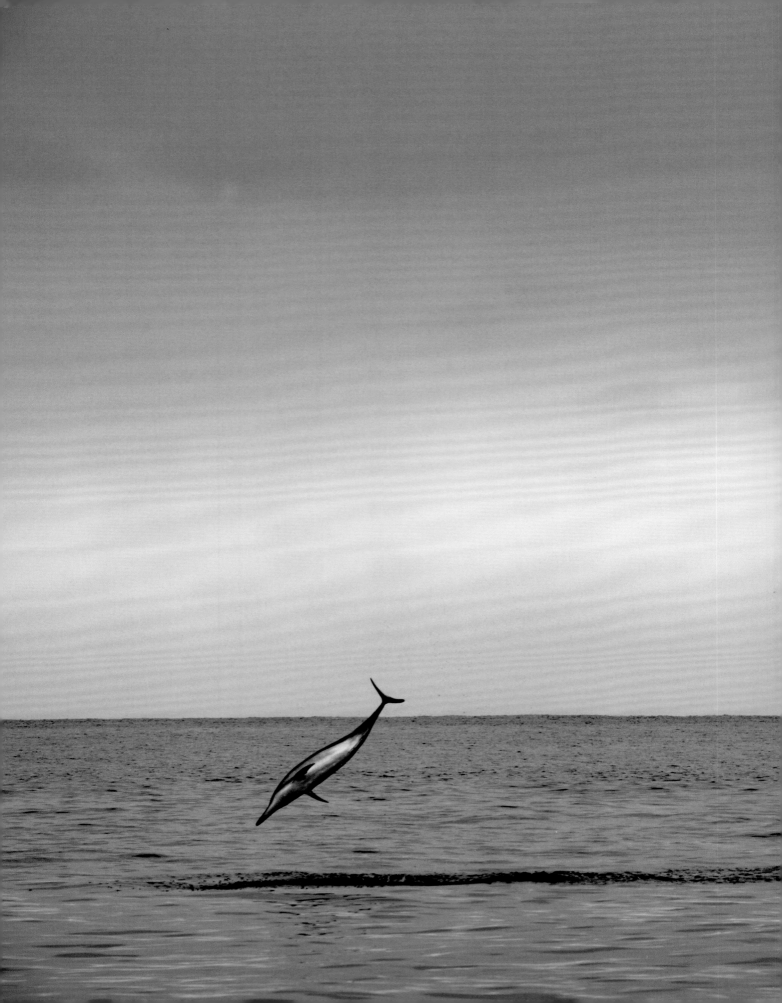

**OVER THE RAINBOW**
The morning did not offer much hope for a great day of making photographs; I was in a small inflatable boat, and rain was pouring down. As the squall began to clear, a rainbow appeared; I wished aloud for a spinner dolphin to leap. And it did.

# ACKNOWLEDGMENTS

**THIS BOOK IS DEDICATED TO MY FAMILY,
MARCIA, KATHERINE, AND CAROLINE—
ALL STRONG WOMEN WHO, LIKE THESE WHALE FAMILIES,
LEAD WITH WISDOM.**

A life spent in the company of wildlife, especially whales, is the stuff of dreams. But it could not have happened without the help of many people. Making everything possible is my wife, Marcia, whose love, stability, and decades of support gave me the strength to journey into unknowns time and again and face endless challenges. Marcia and my daughters, Kate and Caroline, are the foundation on which I build, and I thank them for their sacrifice and unwavering belief in this work. They bring me joy and peace, and because of this I am able to go into the field.

This book would not have been possible without the vision of Lisa Thomas and Hilary Black at National Geographic Books; I am deeply grateful for their passion, guidance, expertise, and continued support of my work. I am also thankful for the extraordinary editorial team with whom I had the privilege to work on *Secrets of the Whales,* including Melissa Farris, Libby Sander, Moriah Petty, Judith Klein, Mike Lappin, and Adrian Coakley.

In 1998, my dream of working for *National Geographic* magazine became reality, and that reality has exceeded my dreams. It begins with an idea, a seed planted in my mind from which the vision of a story grows. Being able to bring this to the extraordinary team at *National Geographic,* where each person adds talent and expertise, is rewarding beyond words. At National Geographic Partners, I am indebted to Gary Knell, Susan Goldberg, Whitney Johnson, Courteney Monroe, Geoff Daniels, Janet Han Vissering, and Pam Caragol.

At the National Geographic Society, I give immense thanks to Mike Ulica, Jill Tiefenthaler, Kaitlin Yarnall, Alex Moen, Rachael Strecher, Doug Bailey, and Will Thompson.

An entire book could be written to give proper thanks to Kathy Moran, the deputy director of photography at *National Geographic* magazine. Kathy has been my editor, partner, and my friend on nearly every story I have produced. Her knowledge of visual storytelling and wildlife is unparalleled, and her dedication to perfection remains immensely gratifying. May Kathy always know that I am one of legions of photographers and animals who are grateful for her work.

There is a story that Ernest Shackleton once posted an advertisement seeking a crew for his fateful Antarctic expedition; it described the job as a hazardous journey, constant danger, with low wages, bitter cold, and safe return doubtful. The story is most likely a myth, but it is a perfect introduction to imparting my deep thanks to the photo assistants who have worked with me on assignments. Our work may not be quite the stuff of this fictional ad, but it's not too far off. For their valuable help and talented contributions to my work with whales, I wish to thank Steve De Neef, Jeff Hester, Luis Lamar, Nansen Weber, and Jeff Wildermuth.

I have often described my work as an endeavor to "parachute into the world of scientists and bring visual context to their research." The work of science requires many skills; thanks to

their lifetimes devoted to these many disciplines, we can better understand our world. I am therefore thankful to the researchers who guide me in my quest with whales and help me in getting the story right. I give special thanks to Shane Gero, who inspired me with the concept of whale culture. I am thankful for his decades of work with sperm whales and look forward to many more revelations from Shane going forward.

For their knowledge, patience with my endless questions, and friendship, I also wish to thank the following researchers—Scott Baker, Moira Brown, Simon Childerhouse, Jim Darling, Asha de Vos, Laura Engleby, David Gruber, Philip Hamilton, Terry Hardie, Nan Hauser, Denise Herzing, Meagan Jones, Eve Jourdain, Richard Karoliussen, Amy Knowlton, Scott Kraus, Stan Kuczaj, Marilyn Marx, Stormy Mayo, Michael Moore, Diana Reiss, Roz Roland, Chris Slay, Jan Straley, Andy Szabo, Ingrid Visser, Hal Whitehead, Carlie Wiener, and Monica Zani.

Thanks also to the following people, vessel crews, and logistical operations staff that made this work possible through their help, support, and expertise: Hayes Baxley, Priscilla Brooks, Philip Burghard, Riaz Cader, Ryan Canon, Jasmine Carey, Mike Corrado, Anja Dietze, Melissa DiBartolo, Dive Dominica, Dan Evans, the crew of the vessel *Evohe,* Nick Fazah, Gretchen Freund, Sven Gust, Hidden Falls Hatchery, Darren Jew, Chris Johns, Hussain Aga Khan, Sarah Leen, Flip Nicklin, Mark Romanov, Rick Rosenthal, Brooke Runnette, Angie Salazar, Kina Scollay, Sea Lion Lodge, the crew of the vessel *Song of the Whale,* Mark Soares, Vikki Spruill, Phil Stephenson, the crew of the vessel *Ursa Major,* Deron Verbeck, Weber Arctic and Arctic Watch, Craig Welch, Roger Yazbeck, and Red Rock Films, particularly Brian Armstrong, Kevin Krug, Shannon Malone, Andy Mitchell, and Sari Wiener.

Finally, I give special thanks to the following companies and organizations that have been valuable partners in my work, especially the Conservation Law Foundation, the New England Aquarium, Nauticam, Nikon, the Phil Stephenson Foundation, and Reef Photo & Video.

Since 1888, the National Geographic Society has funded more than 13,000 research, exploration, and preservation projects around the world. National Geographic Partners distributes a portion of the funds it receives from your purchase to National Geographic Society to support programs including the conservation of animals and their habitats.

National Geographic Partners
1145 17th Street NW
Washington, DC 20036-4688 USA

Get closer to National Geographic explorers and photographers, and connect with our global community. Join us today at nationalgeographic.com/join

For rights or permissions inquiries, please contact National Geographic Books Subsidiary Rights: bookrights@natgeo.com

Library of Congress Cataloging-in-Publication Data

Names: Skerry, Brian, author, photographer. I Sander, Libby, author.
Title: Secrets of the whales / Brian Skerry with Libby Sander.
Description: Washington, D.C. : National Geographic, 2021. I Summary: "A look at the culture and wisdom of whales through the eyes of noted photographer Brian Skerry"-- Provided by publisher.
Identifiers: LCCN 2020038197 I ISBN 9781426221873 (hardcover)
Subjects: LCSH: Whales. I Whales--Pictorial works.
Classification: LCC QL737.C4 S498 2021 I DDC 599.5--dc23
LC record available at https://lccn.loc.gov/2020038197

Printed in China

20/RRDH/1

Photos of North Atlantic right whales on pages 32, 33, 34-35, 36, 37, and 44-45 and the humpback whales on pages 8-9, 134, and 156-157 were produced under permits issued by NOAA NMFS Office of Protected Resources.

Photos of spinner dolphins in Hawaii on pages 14-15, 182-183, and 188-189, and the bottlenose dolphins in Florida on pages 170-171 were produced under NMFS (NOAA) permit #17941.

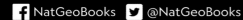 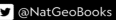